May 8th 1903. nest in high sea cliff 60 feet from top.

...21

...ting, Z.Z.S., M.B.O.U. 260-8/58⁵

...in Lot 260 on 8·5·1928

...lco pe...

4 egg...

...lichiha...

1936

...9... ...ECIES Peales Falcon

...ng peali

..."·2 downy young.

Q. C. Islds. B.C

...top a 200 ft. Cliff

...o nest material,

...h on ledge.

...LLECTED
...DATION OF VERTEBRATE ZOOLOGY
...LECTION

..., Aldea El chical

...rom nest

..., # 2 showing blood.

de Vaca" cactus by side

...a from aldea in

...arried both eggs in

OSU6...

incubation

Eggs in Set

...amia longicauda

EGG & NEST

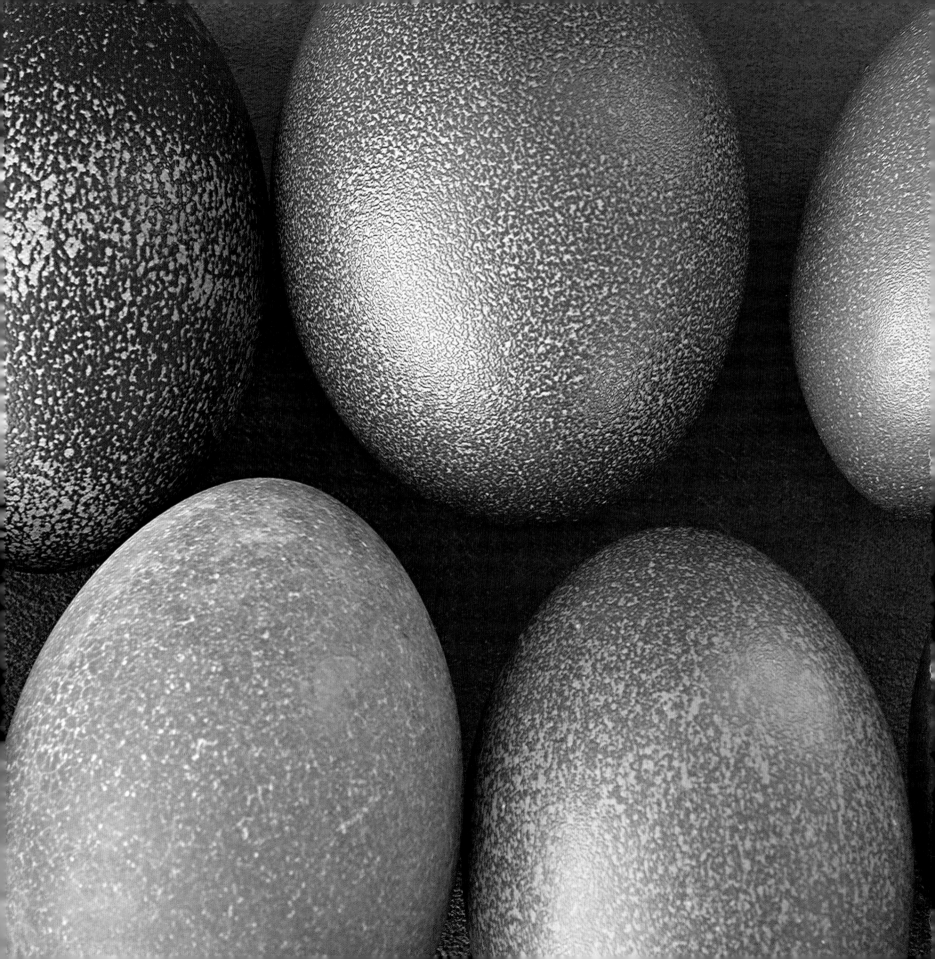

Egg & Nest

Rosamond Purcell
Linnea S. Hall
René Corado

The Belknap Press of
Harvard University Press

Cambridge, Massachusetts
London, England
2008

Title page photograph: Detail of Emu (*Dromaius novaehollandiae*) eggs
from the collections of the Western Foundation of Vertebrate Zoology

Dedication page photograph (at right): Close-up of egg of the Red-winged Blackbird (*Agelaius phoeniceus*)

Table of contents photograph: Nest of Loggerhead Shrike (*Lanius ludovicianus*)
(see page 44 for details)

Cataloging-in-Publication Data available from the Library of Congress

ISBN-13: 978-0-674-03172-2

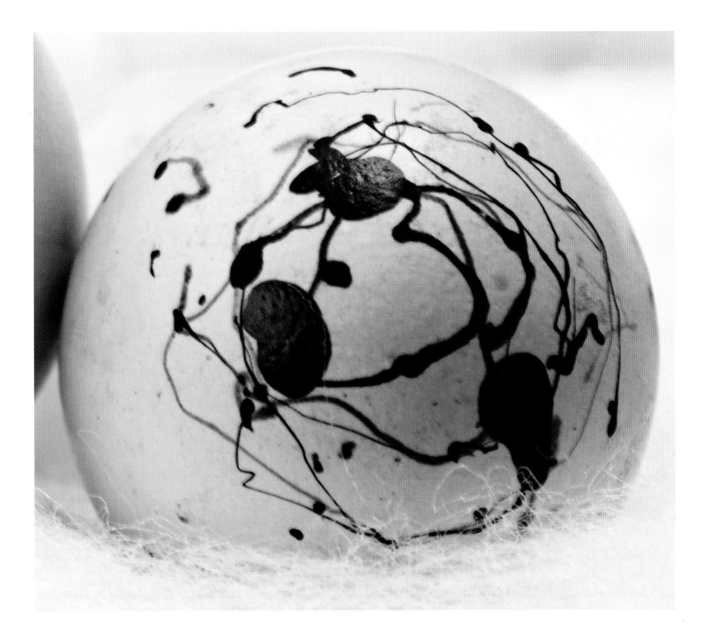

For Claudette Carter and Katharine Kindermann,
two bright birds gone

—ROSAMOND PURCELL

For Ed N. Harrison, who taught us to love birds' eggs
and nests

—LINNEA S. HALL and RENÉ CORADO

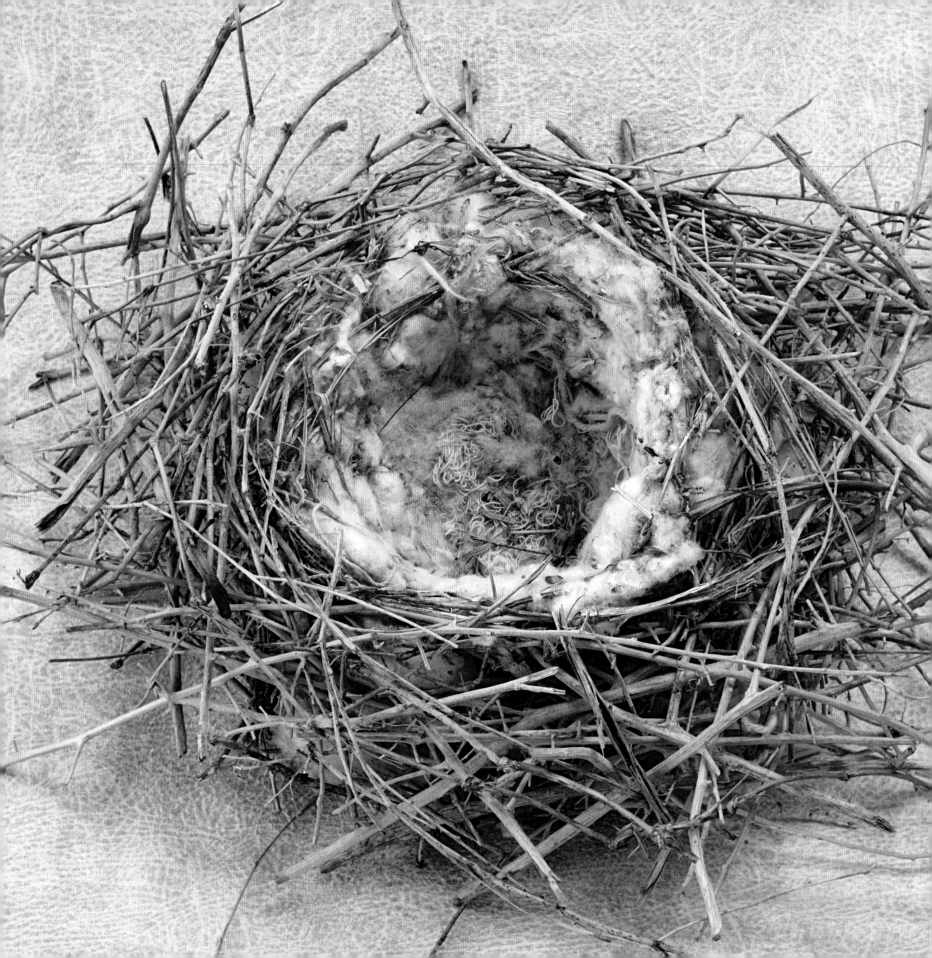

CONTENTS

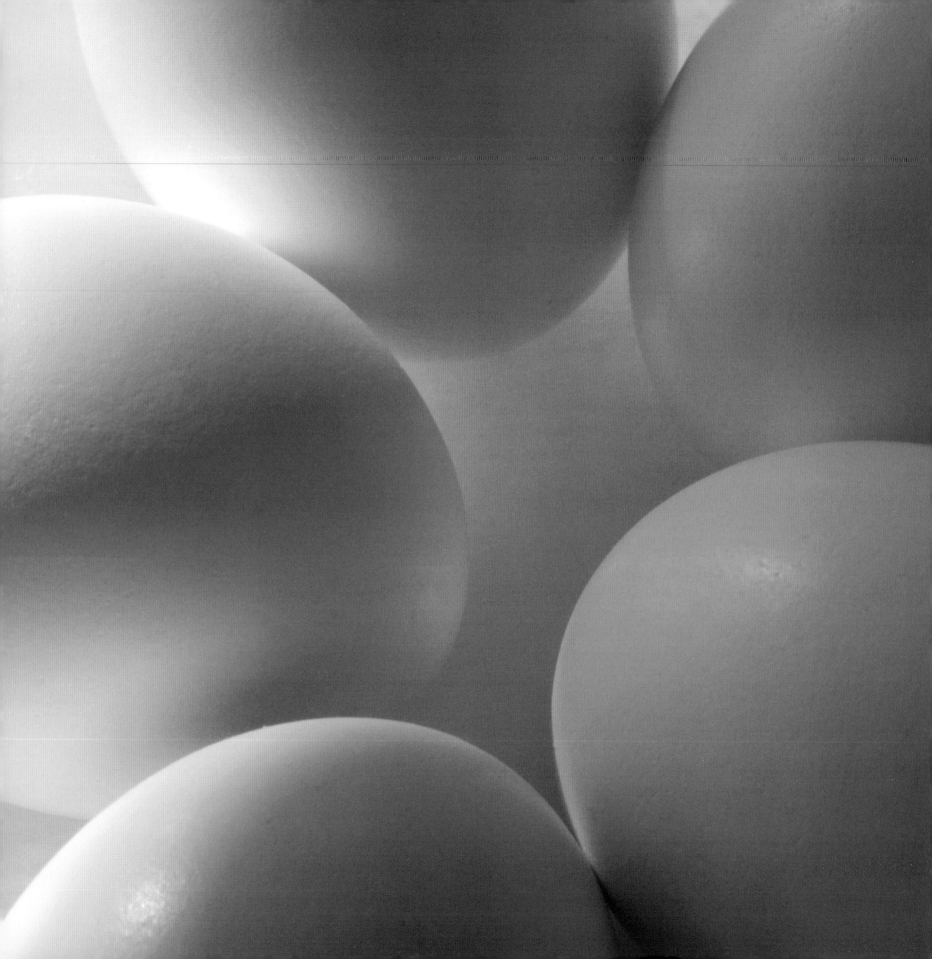

Introduction

THE ALLURE OF EGGS AND NESTS

EVERY ANIMAL STARTS LIFE as an egg, but only birds have evolved to enclose their egg in a hard shell, to stock it with massive amounts of nutrients, and to guard, incubate, and cradle it in a nest. Nests and eggs vary endlessly, and the innovations in their structure are a feast for the eyes and the imagination. *Egg & Nest,* by Rosamond Purcell, Linnea S. Hall, and René Corado, is a tribute to the natural wonders housed at the Western Foundation of Vertebrate Zoology (WFVZ) in Camarillo, California. The WFVZ has amassed the private collections of countless Victorian bird enthusiasts whose finds are captured here in Purcell's extraordinary images.

Many interesting stories lie below the stunning surfaces of eggs and nests. Each egg becomes a package of often enormous size relative to the mother, and laying it is the equivalent of a birthing event. There is a tradeoff between producing more than a dozen eggs per "clutch" (the number of eggs laid or incubated at a single time), as in most rails, quails, and ducks, and laying just one egg, as in the extreme case of the kiwi. As with vertebrate neonates, there is another tradeoff between the developmental stage of the young hatched from the egg and its size, though some birds with large clutches have young that can run soon after hatching.

The egg requires continual parental care until a second birthing, when it hatches. Birds whose young are unable to walk, run, or fly shortly after hatching must prepare an often elaborate nest before the eggs are laid. Although many

Eggs of the Long-eared Owl (*Asio otus*), detail.

(Photograph by Rosamond Purcell)

animals build nests, nowhere in the animal kingdom have both egg construction and nest building evolved to produce such lavish, beautiful, and diverse creations as among bird species.

A bird's nest is often as revealing of its species as its voice and its feathers, and the variety of birds' nests now provide evolutionists with proof that whole suites of complex behavior can be inherited. A Chimney Swift's (*Chaetura pelagica*) nest of tiny twigs glued together by saliva and plastered onto the wall of a hollow tree or chimney; a Brown Creeper's (*Certhia americana*) nest of twigs held together by spider webs and fastened under a loose flap of dead balsam fir bark; an oriole's bag nest woven out of milkweed fibers and placed at the tip of a drooping elm twig; a Bank Swallow's (*Riparia riparia*) loose, dry-grass nest at the end of a tunnel the bird has dug into a sand bank; a Hairy Woodpecker's (*Picoides villosus*) cavity excavated out of solid wood; or a Marsh Wren's (*Cistothorus palustris*) domed construction of woven grasses lined with feathers attached between upright cattails—all are products of precise behavior patterns unique to their species. But as you will see in the pages to come, in some instances nests may be woven almost entirely from exotic materials such as fishing line (in the case of orioles), possibly because these fibers are a "super stimulus" of the type of nesting material that the bird normally hunts.

Consider what a nest does. All nests help conceal and protect the eggs and the young from predators, but in some species, nests function to attract mates, and in still others they provide shelter for the parents and even the extended family. They mean the difference between reproductive success and failure. For birds raised in nests after hatching, a third birthing of sorts occurs when the fledglings first hop out of the nest.

All the tricks that birds have evolved to conceal their nests pose a challenge to their predators, as they did to the Victorian bird lovers who dedicated their lives to finding them. These collectors were driven by a passion to collect eggs and nests as a hobby that came to be known as "oology." Since nests are often camouflaged in diabolically species-specific ways, these early Victorian naturalists had to follow nesting birds through forests and swamps in order to locate well-hidden

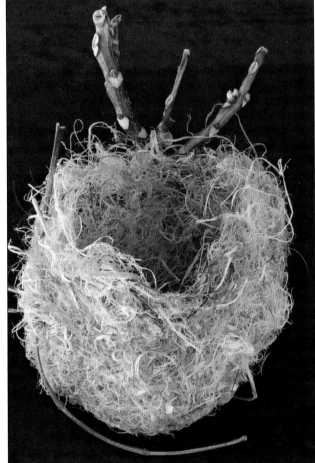

Nest of Bullock's Oriole (*Icterus bullockii*). (Photograph by Rosamond Purcell) (See detail page 84.)

nests. Along the way, they learned many details of birds' habitat preferences, movements, vocalizations, and courting behavior. In short, in the course of hunting nests and eggs, they became careful observers and often intrepid naturalists. They became, in effect, ornithologists, and their knowledge and passion ushered in the modern science of ornithology. The collections of museums such as the Western Foundation of Vertebrate Zoology deliver a treasure trove of rarities and a wealth of ornithological data.

The Victorian-era bird collectors' unstated objective was to document and embrace the variety of nature's marvels. Birds' eggs are icons and windows into the biology and behavior of birds, perhaps even more so than their nests. The number of eggs per clutch, as well as the shapes, sizes, and colors of the eggs, have biological meaning. They are ultimately limited by the area of the incubating parent's brood patch, the bare spot on the bird's underside where eggs make contact with bare skin and are warmed by the parent's body heat. The number of young is further constrained by the amount of food that parents can provide. Then again, birds whose young are capable of feeding themselves immediately after hatching—chickens are a familiar example—can also take care of more young. With conflicting selective pressures, such as those for either a few large or many small young, evolution may pivot on seemingly minor details, with interesting implications for natural history. For example, shorebirds, whose young forage "from birth," generally lay only four eggs, but these eggs are relatively enormous. Their large size is accommodated by egg shape and placement in the nest: the eggs are pyriform (pointed at one end) and fit neatly together into a four-pack, thus saving space

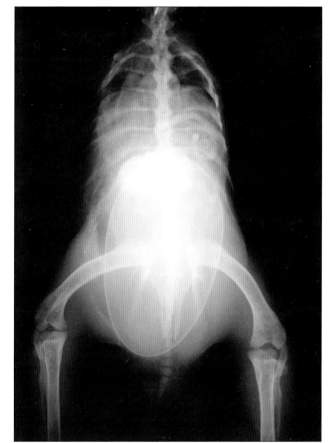

X-ray of a gravid kiwi. Kiwis are known to lay the largest eggs relative to their body size of any living birds. (Courtesy Bone Clones® Osteological Reproductions)

under the incubating parent. Pyriform shape is also useful to murres, which lay only a single egg per "clutch" onto narrow, bare-rock sea ledges. Here, the shape reduces egg loss because it allows the egg to spin when moved rather than to roll off the narrow ledge.

Many bird species occasionally abandon their eggs in the nests of other birds, and some have become parasites—they have given up nest building altogether and lay their eggs in the nests of others. Such egg dumping is best known among cuckoos and cowbirds, which use other bird species to care for their eggs and young,

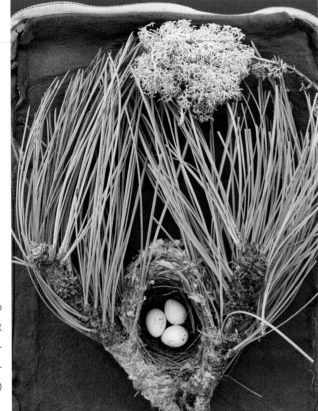

Warbling Vireo (*Vireo gilvus*), nest and eggs. (Photograph by Rosamond Purcell)

and to discriminate against others'. The great variety of egg coloration among densely colonial murres allows the birds to identify their own eggs in a crowd of many. Similarly, in some sociable weaverbirds that also have distinctly colored eggs, the odd-colored eggs (of cuckolding females) are often ejected. Robins' eggs painted to colors other than their natural blue are rejected, but only if the color contrast is great. Cowbirds deposit their brown-speckled eggs into robins' nests, but the robins eject them. In contrast, Common Ravens do not have nest parasites, and they readily accept red-painted hen eggs (and even rocks and flashlight batteries) among their green- and black-speckled eggs, ejecting them only after the young hatch.

The adaptive patterns in birds' nests and eggs are seldom easy to decipher because the birds' evolutionary arms race with both nest predators and nest parasites is not static. It may vary from place to place, and it is also overlaid by ecological adaptation. Furthermore, it is constrained and directed by phylogenetic characteristics. Thus, swifts may use saliva in nest construction and swallows mud. Wrens make domed nests and weavers fashion bag nests of plant fiber. Similarly, most Icterids have erratic squiggle markings on their eggs, warblers have brown spots on white, and thrushes commonly have blue eggs (which may or may not have spots).

The story of the variety of birds' nests and egg colors adds functional to visual beauty in ways the Victorian collectors, whose labors of love please the eye and tease the mind, likely never suspected. This book does justice to the remarkable innovations of the bird world, highlighting the weird, the sometimes bizarre, and the beautiful.

BERND HEINRICH

often at the expense of the host's young. But egg dumping also occurs within the same species, especially in waterfowl and some colonial birds. This form of parasitism could be more common than we know, for neither the hosts nor the human egg collector is likely to detect eggs that are conspecific, that is, from the same species. Many hosts have evolved mechanisms for reducing parasitism. For example, a bird that has eggs colored differently from the norm of the species might detect the presence of a stranger's eggs, which would stand out among its own. Indeed, some birds have learned to recognize their own uniquely colored eggs

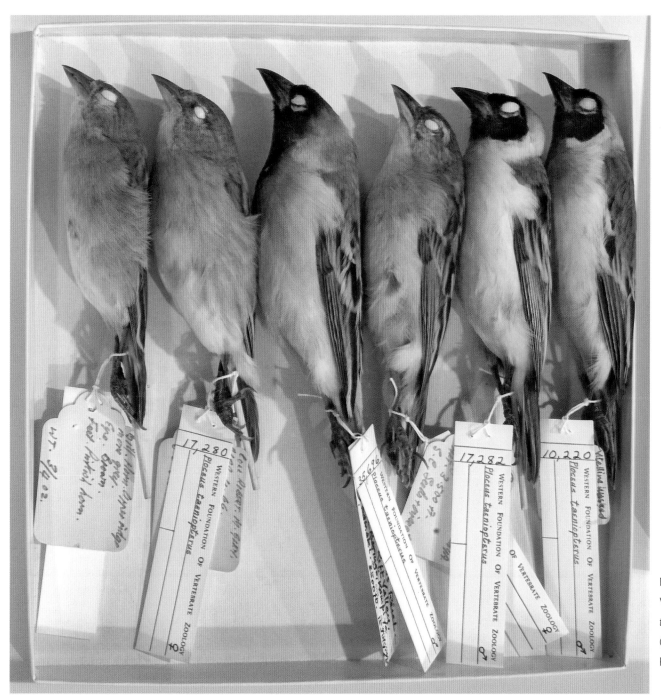

Northern Masked Weaver (*Ploceus taeniopterus*). (Photograph by Rosamond Purcell)

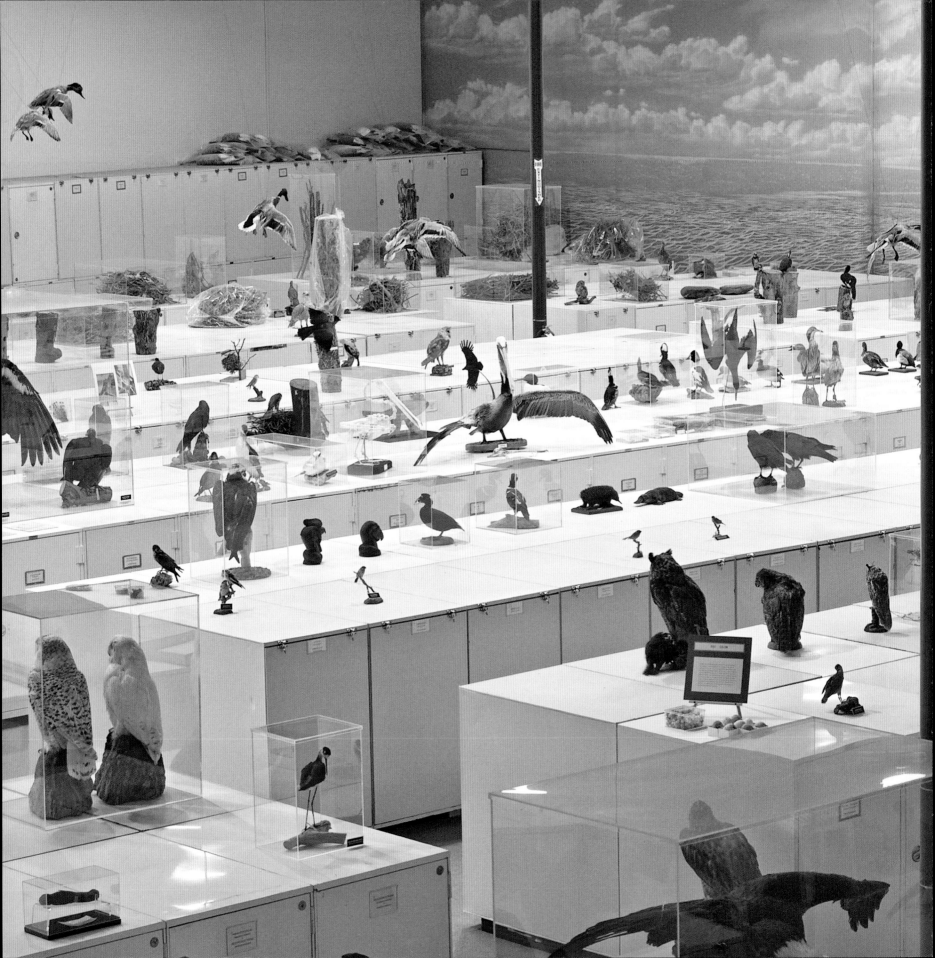

BIRD EGGS AND NESTS

Biology, Collections, and Uses

In 1953, Ed Harrison and Bill Pemberton were collecting birds' eggs in Kenya, Africa. According to Ed, on September 22, they located a large clutch of twenty-two Ostrich (*Struthio camelus*) eggs laid by different females in a single nest. Ed and Bill chose to collect the entire clutch, and while Ed settled in to blow the eggs, Bill left to look for other bird specimens—taking along the only gun. Soon after, several lions surrounded Ed. He recalled that his first thought at the time was, "Holy *$%! These lions are going to eat me!" But instead of doing something to save himself, he started to blow the contents out of the eggs as fast as he could. He reasoned that even if he was eaten, at least the eggs would be properly prepared for shipment back to the United States. Luckily, about that time Bill came back to check on Ed and helped scare off the lions. The eggs were successfully blown, packed, and shipped back to the United States.

THIS ANECDOTE ABOUT Ed Newton Harrison, creator of the Western Foundation of Vertebrate Zoology, is revealing: he was a consummate collector of bird specimens—passionate about all his avian materials and not afraid to take risks to acquire them. Ed was certainly not alone: from the early 1800s

Part of the current collections of the Western Foundation of Vertebrate Zoology, in Camarillo, California. The painted ocean mural on the far wall was commissioned by Ed Harrison. (Photograph by Dennis Purcell)

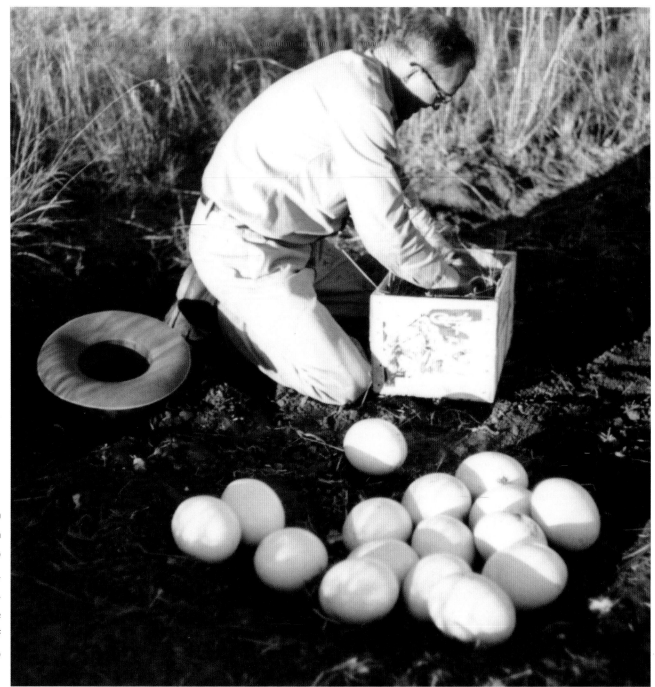

Ed Harrison collecting Ostrich (*Struthio camelus*) eggs in Kenya, September 22, 1953. (From the archives of the WFVZ)

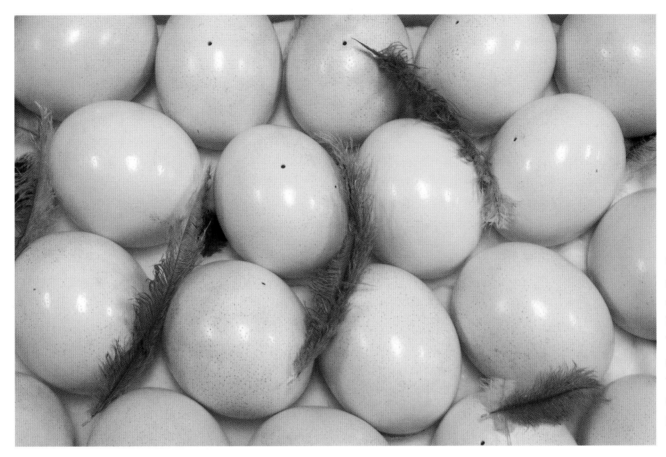

Ostrich (*Struthio camelus*) eggs collected by Ed Harrison near the Talek River, Kenya, on September 22, 1953. (Photograph by Rosamond Purcell)

until the mid-1900s, collecting birds' eggs and nests for private collections and museums was a popular pastime. Today the practice is strictly regulated and, in some countries, completely illegal. For this reason we need to look back in time to comprehend the lure of acquiring such collections.

So what is it about eggs and nests that called out to both professional and amateur ornithologists alike, inspiring them to spend large amounts of time in the field collecting the materials and endless hours organizing them in museums, despite the risk of going into debt, alienating their friends and family, and even losing their lives? The answers lie not only in the nature of old-time bird collectors, people who loved to amass rare, unique, and common specimens alike, but also in the nature of early ecologists, people with a passion for the natural world who found answers to questions about natural history and evolution in the shapes, colors, patterns, clutch sizes, and distributions of the eggs and nests of the world's birds. The answers lie, too, in the nature of the eggs and nests themselves—beautiful, fragile, unique, useful, and marvelous to behold.

SOME BIRD EGG BASICS

Ex ovo omnia—Everything comes from an egg.

WHICH CAME FIRST, the chicken or the egg? This timeless question is actually answerable in the context of the chicken: the egg came first. Animal eggs existed long before chickens were on the scene; reptiles and amphibians had been laying eggs for at least 100 million years before the first birds evolved. But birds' eggs had distinct advantages over the eggs of their ancestors, and they probably contributed to the relatively rapid expansion of bird species into all environments on the planet, from the most hospitable temperate regions to the most inhospitable deserts. Unlike amphibian eggs, which must be kept moist or wet so they do not dry out, birds' eggs are not tied to water; they carry their water with them, nurturing their developing embryos in fluid-filled amniotic membranes. Moreover, unlike the eggs of fish, amphibians, and some reptiles (turtles, lizards, and snakes), birds' eggs are covered with hardened shells. The increased calcification of bird eggs probably occurred in response to predation by soil invertebrates and microbes. This adaptation provided much better protection for developing embryos.[1]

The fact that birds could take their eggs with them allowed them to diversify greatly since they first appeared on the planet about 190 million years ago. In fact, at least 100,000 different species of birds have likely been present on the planet since then. Currently, however, only about 9,700 species remain, of 30 major lineages, or orders. Their demise is the result of ancient, massive extinction events and, more recently, human activity.

The types of eggs found among all the extant bird species vary widely—from the tiniest hummingbird egg weighing about 1 gram, to the largest bird egg, that of the Ostrich, weighing 1.5 kilograms. The color of eggs can also vary dramatically, from the white eggs of most cavity-nesting bird species, to the yellowish and intensely marked eggs of the Northern Jacana (*Jacana spinosa*), to the polished green eggs of the Elegant Crested Tinamou (*Eudromia elegans*).

These factors—size and color—are primarily determined by genetics, though diet and food availability can influence them as well. The shape of eggs is also controlled by genetics, but it can deviate from the typical oval shape (like that of a chicken's egg). Many owls' eggs, for example, are almost round, and birds such as Common Murres (*Uria aalge*) have pyriform eggs, which are pointed at one end and rounder at the other.

Nest types, too, vary among bird lineages: from the simple "scrape" nests of many sand-using bird species (made by birds literally scraping the dirt with their feet and bills, then laying their eggs directly on the sand), to the intricate "woven" nests of certain small, granivorous bird species in Africa.

The number of eggs produced by a female bird in a single clutch also varies by lineage of bird. For example, long-lived species such as condors and albatross usually lay just one egg per clutch, whereas other, more short-lived species, such as pheasants and quails, tend to produce very large clutches of between ten and twenty-five eggs. Poor food resources can also affect clutch sizes and may cause the number of eggs laid to decrease over some breeding seasons.

Overall, the 9,700 species of birds on the planet show remarkable diversity in form, color, and shape, as do

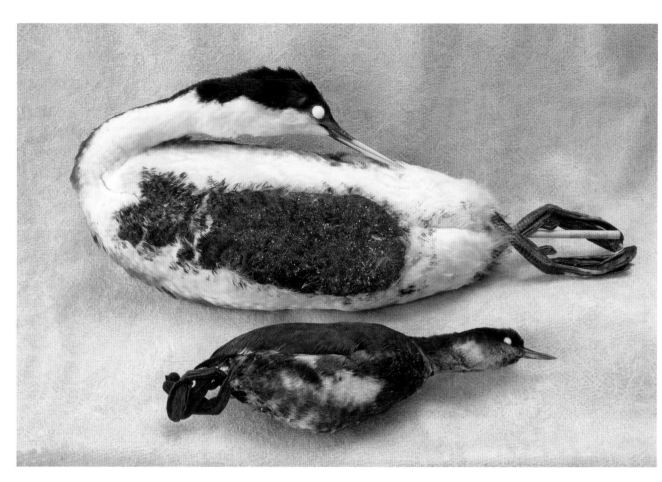

Western Grebe (*Aechmophorus occidentalis;* top) and Eared Grebe (*Podiceps nigricollis*), showing how oil from spills sticks to feathers and can lead to death. (Photograph by Rosamond Purcell)

their eggs and nests. Millions of years of interaction between birds and their environments have led to the beautiful forms we see today. These extraordinary creatures and their amazing adaptations have much to teach us about the natural world.

A BRIEF HISTORY OF BIRD COLLECTING

"We have not used the word 'collecting' as a mere euphemism for 'killing,' but rather as a verb that aptly summarizes the whole process of killing, preserving, labeling, and keeping [bird materials] . . . [If] you turn pale at the mere thought of killing birds or are shocked that collecting still continues, then we suggest that you take time to consider the extent to which you, personally, are causing the deaths of wild birds. Anyone who drives a car, uses products of the petro-chemical industries, owns a cat, has glass in the windows of their homes, buys

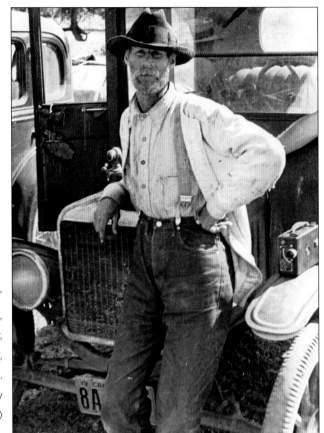

Fred "Kelly" Truesdale, field collector, in Shandon, California, 1933. (Photograph by Ed Harrison)

Front covers of *Ornithologist and Oologist* (December 1892) and *The Oologists' Record* (September 1927), two of the primary oology journals of the time. (From the archives of the WFVZ)

paper, or consumes electricity will be responsible for killing birds . . . Remember too that dead birds [and eggs] in museums are the only casualties that can be used to help the living."

B. MEARNS and R. MEARNS, *The Bird Collectors* (1998), p. xi

FOR THOUSANDS of years, people have collected wild and domesticated birds' eggs for food. Collecting eggs for something other than food, however, was essentially unheard of until the Victorian era (1800s through early 1900s), when elite gentleman collectors, naturalists, and hobbyists from England, Europe, and the United States made it a popular undertaking. During this period, government- and museum-sponsored expeditions to document unique species all over the world fueled the mania for collecting natural history.

Wealthy enthusiasts amassed large collections of bird (and other animal) materials. Lord Walter Rothschild of England, for example (who was wealthy enough to lend money to the National Bank of England at least twice during his lifetime), amassed the largest collection of bird materials of any private collector anywhere between 1880 and 1931—more than 300,000 specimens, collected from all over the world. He collected approximately 11,750 egg sets and 930 nests, which are now part of the British Museum of Natural History.[2] Allan Hume, an Englishman working in the Indian Civil Service, had the largest collection of Asiatic bird skins, eggs, and nests in the world—more than 100,000 specimens collected between 1862 and 1885, including approxi-

mately 4,000 egg sets.[3] In the United States, one of the largest private collections of eggs was amassed in the 1800s and early 1900s by J. Parker Norris and his son J. Parker Norris, Jr.: approximately 28,802 sets of eggs representing 3,827 species from all over the world. Many of these materials were acquired by Nelson Hoy, who lived in Pennsylvania, and were added to the collections of the Western Foundation in 1980.

These collectors contributed a great deal of useful information to the science of ornithology. Rothschild, for instance, created his own museum in Tring, England, and made his reference collection of bird skins and eggs, as well as his wonderful library of bird books, available to researchers. He and other collectors published regularly in scientific outlets such as *The Ibis* and the *Bulletin of the British Ornithologists' Club* in England, and *The Auk* and *The Condor* in the United States. Other periodicals including *The Oologist*, the *Journal of the Museum of Comparative Oology*, and *The Nidologist* regularly published descriptive studies of the eggs and nests discovered by collectors and by others referring to themselves as "oologists." In fact, as Frank Gill recounts, the study of bird eggs helped to develop early ornithology into a comparative science, since many of the nineteenth-century ornithologists published large and highly descriptive volumes of books detailing the eggs of birds collected from all over the world.[4]

From the late 1700s until the late 1800s, governments, wealthy collectors, and large museums such as the British Museum of Natural History, the American Museum of Natural History, and the Smithsonian commonly funded expeditions around the world to procure bird specimen materials, primarily to describe new species. These expeditions employed "field collectors" to acquire the materials and included famous naturalists like Charles Darwin and his contemporary Alfred Russel Wallace, who went on to publish their findings.

In the United States, the 1804–1806 survey conducted by Captains Meriwether Lewis and William Clark was the first to bring back birds from the western part of the country. In addition, Major Charles Bendire (1836–1897), who worked as an officer of the U.S. Army for more than twenty years, was known for his collections of birds' eggs and for the detailed notes

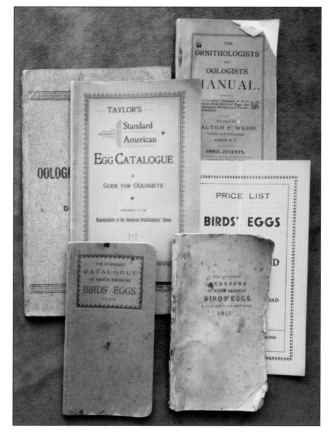

Oology catalogs and trade lists in the library of the Western Foundation. (Photograph by Rosamond Purcell)

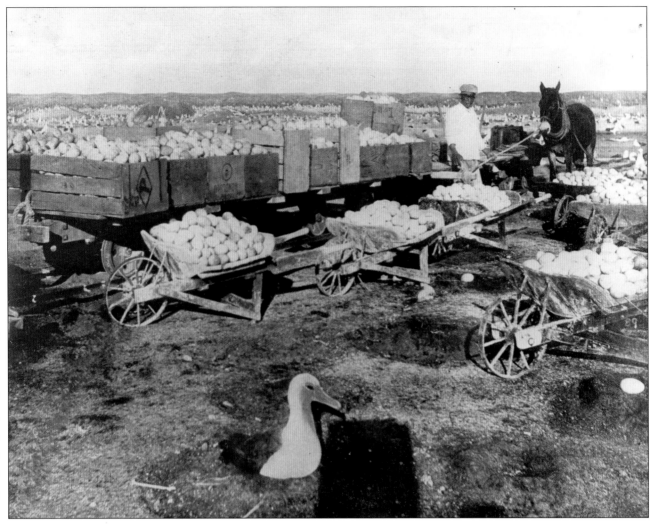

Mass collecting of eggs at a Laysan Albatross (*Phoebastria immutabilis*) colony, Pacific Ocean. (From the archives of the University of Hawaii)

he took on them and their nests. He donated approximately 8,000 sets of eggs to the Smithsonian, all collected in the western United States from Mexico to Canada, and he was the first curator of the oology collection for that museum. According to a famous story about the perils of collecting eggs in the field, in 1872 Bendire was up in a tree in Arizona collecting the egg of a Zone-tailed Hawk (*Buteo albonotatus*) when Apaches fired on him. To protect the egg, he put it into his mouth. He was then chased back to his camp. At the camp, he found that he couldn't get the specimen out of his mouth. It took several men to extract the egg—and a tooth—without breaking it! The egg is still held, unbroken, at the Smithsonian.[5]

In addition to naturalists, hobbyists, too, collected birds' eggs and nests. In the United States until the 1940s, it was legal for a private individual to collect and sell bird materials without a permit. Eggs were said to have been collected with "devotion akin to that seen among today's birdwatchers."[6] The hobby probably even surpassed that of stamp collecting. In the United States, for example, numerous catalogs advertised wild bird eggs for sale and for trade.

Some famous egg and nest "hobbyists" included T. Gilbert Pearson, who was president of the National Audubon Society in 1920 and founded the International Council for Bird Preservation, now BirdLife International; President Teddy Roosevelt; and President Franklin D. Roosevelt. Less famous than the presidents was Ralph Handsaker (1886–1969) of Iowa, who collected several hundred sets of eggs from his state and also seems to have purchased or traded eggs from around the world. By the time of his death, Handsaker had approximately 500 species of birds represented in his collection of 800 sets.[7] Although he apparently never wrote for scientific publications, he did take the time to record detailed information on all the sets, thus making them a valuable contribution to science. Even amateur collectors often understood the potential value of their materials for ornithology.

Some hobbyist collectors, of course, were more interested in how many eggs they could get and how rare they were than in their ultimate value for science. These individuals eventually gave "oology" a bad name and led to the publication of books such as *Ethics of Egg-Collecting,* by Eric Parker (1935), as well as numerous letters and articles in professional ornithological journals debating the pros and cons of continued

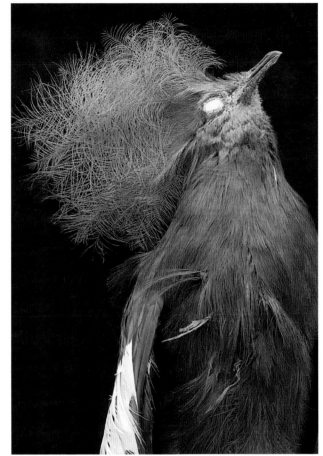

Study skin of a Southern Crowned Pigeon (*Goura scheepmakeri*). (Photograph by Rosamond Purcell)

egg collecting. Another group, whom we refer to as the "market collectors," collected eggs to sell on the mass market to as many types of buyers as possible. In the late 1800s and early 1900s their impact on some bird species—including penguins off the coast of Africa and Laysan Albatrosses (*Phoebastria immutabilis*), the whites of whose eggs were used in the photo industry— may have contributed to their declines, especially when coupled with the impacts of habitat alteration and the use of bird parts (such as feathers) in ladies' fashions.

Between 1850 and 1900, market collectors took about 10 million Common Murre eggs from the Farallon Islands off the northern Californian coast to sell to markets and restaurants in San Francisco.[8] Conscientious egg collectors usually took egg clutches early in a field season so that the birds could re-lay; in contrast, destructive egg collectors took all the eggs of all the birds in a locality, such as a nesting colony, throughout the entire breeding season. This type of collecting, combined with the detrimental effects of the millinery trade on birds, caused outrage among ornithologists and concerned people from around the world. In response, laws were enacted in the early twentieth century limiting bird and egg collecting to those specimens needed only for scientific purposes.

The impact of irresponsible egg collecting and continued professional debate over the scientific value of the discipline of oology led to a decline in the popularity of this pursuit among professionals and amateurs alike. By the 1940s, private collecting of wild birds' eggs was restricted in the United States by legislation, and some scientific institutions decided not to increase (or even keep) their egg holdings. The time was ripe for a safe repository for egg collections. It was at this point that Ed Harrison created the Western Foundation of Vertebrate Zoology.

Illegal collecting of eggs is rarely a problem anymore in the United States, but the situation is different in England, where "notorious" egg collectors are still caught and fined. David Schwartz called such illicit collecting a "uniquely English preoccupation."[9] For example, Colin Watson—who died in May 2006 after falling from a tree while investigating a bird's nest—was arrested in 1985 when more than 2,000 egg sets were discovered in his home, all apparently taken illegally.[10] In 2005, another seven egg collectors in England were sent to jail for three months, and in January 2007, the collector Greg Wheal was jailed for his fourteenth illegal egg-collecting conviction since 1987.

ED HARRISON AND THE WESTERN FOUNDATION OF VERTEBRATE ZOOLOGY

BORN IN CODY, WYOMING, in September 1914, Ed Harrison moved with his family to southern California when he was about thirteen years old. There they lived on land that today forms part of the campus of the University of California, Los Angeles. In the early 1930s, Ed spent much of his time collecting birds' eggs, nests, skins, fossils, minerals, Native American artifacts, and other natural history materials. He was especially passionate about birds, and through the mentorship of his friend, the ornithologist and geologist J. R. "Bill" Pemberton, Ed collected many specimens for his own personal collection.

From the 1930s through the 1950s, Ed and Bill spent time in the field filming California Condors, producing from thousands of hours of footage one of the only known films of wild condor behavior. Ed also accompanied other notable biologists in the field, including Carl Koford, who studied California Condors in the 1940s and 1950s for his dissertation work at the University of California at Berkeley. Koford published one of the first detailed studies of the ecology of condors, a work instrumental to the development of the current captive-breeding program. Ed and Bill apparently each

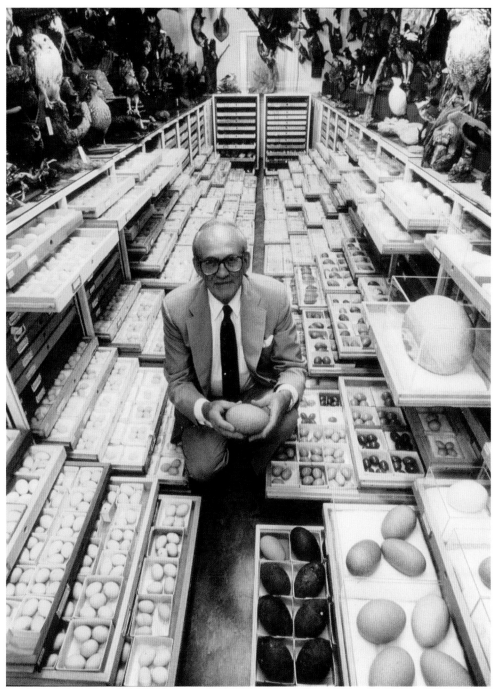

Ed Harrison in the museum behind his house in Brentwood, California, 1987. Ed was seventy-two years old. (Photograph © Frans Lanting / www.lanting.com)

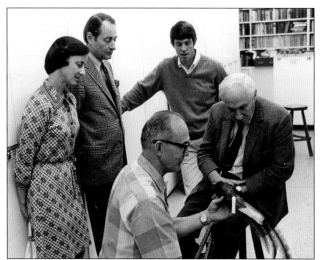

Ed Harrison showing a Resplendent Quetzal (*Pharomachrus mocinno*) skin to Louis S. B. Leakey (sitting), with Lloyd Kiff (standing in back) looking on, 1970s, in the Brentwood Museum. (From the archives of the WFVZ)

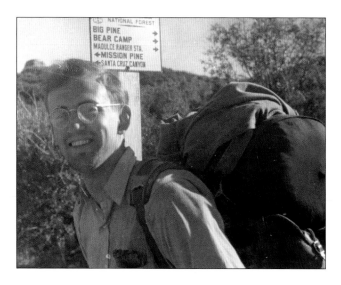

Ed Harrison (top right) and Carl Koford (bottom right), circa 1940, in the Los Padres National Forest, California, hiking into the backcountry to work with condors. (From the archives of the WFVZ)

paid half of Koford's fieldwork costs for the first few years of his project because they believed it was so important.

Ed also photographed and filmed wildlife in natural settings in Africa and Mexico, as well as fantastic geological marvels, resulting in films including *Song of the Land,* shown in Hollywood in the early 1950s (and including footage taken over a seventeen-year period). In 1956, Ed's passion for eggs led him, Frances Roberts, Bill Pemberton, and William Sheffler, an ornithologist from the Los Angeles area, to start the Western Foundation of Vertebrate Zoology as a private nonprofit corporation. Their idea was to create a safe place for their own materials as well as a national repository for egg and nest collections that were either "orphaned" upon the deaths of collectors or deaccessioned by institutions no longer interested in curating eggs. In addition, Ed clearly saw the usefulness of eggs, nests, and bird skins to the conservationists' efforts to save bird species around the world, and he thought it would be a shame for science to lose such materials. Shortly after

the founding of the WFVZ, Ed contributed approximately 11,000 egg sets, 2,000 nests, and 1,750 bird skins from his personal collection of avian materials.[11] After Sheffler's death in 1968, his relatives donated an additional 4,000 egg sets and 300 nests to the Western Foundation.[12]

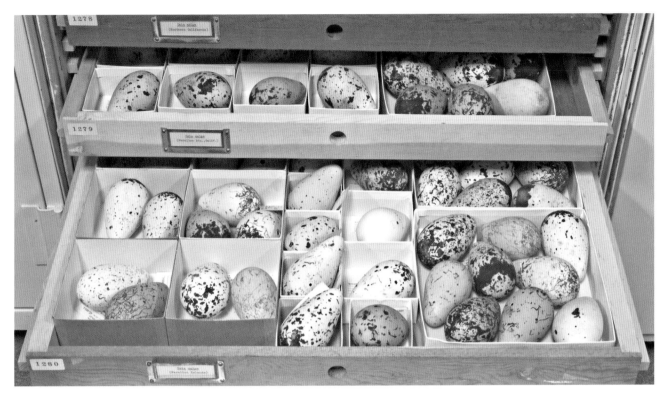

Drawer of Common Murre (*Uria aalge*) eggs in the collections of the Western Foundation. (Photograph by Rosamond Purcell)

From 1956 until the early 1990s, all the WFVZ bird materials were stored in a "museum" behind the Harrison family home in Brentwood, California, and in the basement of an office building Ed owned in Westwood, in Los Angeles.

In 1968, Ed hired Lloyd Kiff to curate the collection, and between 1968 and 1994, Lloyd arranged all the materials taxonomically, oversaw the daily management of the museum, and assisted in the procurement of egg and nest collections from around the world. During this time, Ed personally funded (or obtained funding for) collecting expeditions to Alaska, American Samoa, Argentina, Chile, Costa Rica, East Africa, Ecuador, Guatemala, Kenya, New Caledonia, the Philippines, Uganda, Madagascar, Mexico, and Sabah (East Malaysia). He also financed field studies on particular bird species in Arizona; Ellesmere Island, Canada; and Greenland. In addition, Ed financed the WFVZ's acquisition of more than 40 sizeable private egg and nest collections, including those of Nelson Hoy and J. Warren Jacobs in Pennsylvania; Robert D. Etchecopar of France; and George Brem, Nelson Carpenter, Fred Truesdale, and Colonel L. R. Wolfe of California. Additional egg and nest collections were donated or given as permanent loans to the WFVZ by nearly twenty institutions, including Louisiana State University, the Los Angeles County Museum of Natural History, the San Diego Natural History Museum, and the Santa

Egg data card for a nest and one egg collected by Ed Harrison near Baja California in 1938. (Photograph by Rosamond Purcell)

Field notes of the ornithologist N. John Schmitt, June 1983, during a collecting expedition to Sabah, Malaysia, funded by the Western Foundation. (Photograph by Rosamond Purcell)

Barbara Museum of Natural History.[13] Most of the materials donated dated from the mid-1800s to World War II.

As many people can attest, working with Ed was both inspiring and entertaining. He was a consummate storyteller, and his egg-collecting trips were always the primary subject. He often reminisced about the time he carried a whole Elephant Bird (*Aepyornis* sp.) egg on his lap on a plane trip from the East Coast to California, joking that he held up the plane's departure for hours until they agreed to let him hold it instead of storing it in the cargo bay. Ed also talked about the time he was out in the field in Africa on a collecting expedition, outside of radio contact, when one of his traveling companions developed a high fever. After many logistical challenges, the team was able to radio for help, and a medical plane was dispatched. The only way to land the plane, however, was for Ed's group to make a landing strip by driving a car through the herds of ungulates surrounding them. They did so, and the plane landed and took off—with their companion—successfully. The doctor on the plane told Ed that his treatment of his colleague before help arrived was "damned good shotgun medicine!" that probably helped save the man's life.

Ed was also extremely generous. From the inception of the WFVZ in 1956 until just a few years before his death in 2002, he personally paid for, or found the money to cover, everything at the foundation—all staffing, supplies, travel expenses, bills, and, of course, collection acquisitions. His generosity also extended to his staff. When René Corado was newly hired to the WFVZ in 1987, Ed discovered that he did not have a car, and promptly gave him his daughter's car (much to the daughter's surprise!), along with a year of insurance.

In typical fashion, Ed gave his daughter a replacement car that she liked even better than the first. Another time, Ed offered to pay for René's airfare to Guatemala on a personal matter if René would skin a freezer full of ducks. René agreed, but after days of preparing hundreds of duck specimens, he wondered who had received the better deal.

On one occasion, an egg collector's widow was negotiating with Ed on the disposition of her late husband's collection. The widow asked for a price that would be enough to put her children through college. Ed agreed to pay an undisclosed amount to the woman until her children had completed their educations. Egg and nest collections were a primary focus of Ed's life, so no price was too great.

Yet Ed also led an active life outside of the egg-collecting world. In addition to his work on behalf of the WFVZ, he was also involved in many other ornithological and natural history organizations. He served as member, trustee, and officer of the boards of the Natural History Museum of Los Angeles County, the San Diego Natural History Museum, the Santa Barbara Museum of Natural History, the L. S. B. Leakey Foundation (which he helped to found), as well as the California State Advisory Committee on Conservation. He also helped create the Page Museum at the Rancho La Brea Tar Pits in Los Angeles. He held lifetime memberships in the Cooper Ornithological Society (for which he also served as president for a term) and the California Academy of Sciences. He was an elected fellow in the American Ornithologists Union. He also co-founded the California Trout Association and served as chairman of Trout Unlimited in the southern California chapter. He served as a trustee of the Marlbor-ough School, one of the largest private girls' secondary schools in the western United States; was a member of the board of Pepperdine University; and was a founding member of the Pepperdine University Associates. He was awarded an honorary Doctor of Laws degree from Pepperdine in 1978.

Ed was an extraordinary man who passionately believed that birds, nature, and people had value and thus were worth treasuring. His passing in 2002, only a month after Linnea Hall started as executive director of the WFVZ, was a blow not only to the Western Foundation but to all egg and nest enthusiasts.

THE WESTERN FOUNDATION OF VERTEBRATE ZOOLOGY TODAY

IN 1992 WFVZ employees René Corado, Clark "Sam" Sumida, and other members of the staff moved 600 cabinets full of bird eggs, nests, and study skins to the present location of the foundation, about one hour north of Los Angeles, in Camarillo, California (without breaking any eggs!).

From 1995 to 2007, the WFVZ acquired additional egg and nest collections from James Calder, Elliott Mc-Clure, the Kern County Natural History Museum, and the Bower Museum in California (the H. A. Arden collection), as well as from the Philadelphia Academy of Natural Sciences and the Bowman Hills Wildflower Preserve in Pennsylvania (the C. Platt collection). To date, more than 400 different collections have been incorporated into the holdings of the WFVZ. They include more than 190,000 sets of eggs (totaling more than one million individual eggs), 18,000 nests, and

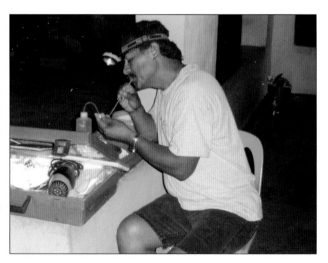

Linnea S. Hall preparing a specimen at night in the field in central Guatemala, June 2006. (From the archives of the WFVZ)

René Corado blowing eggs collected at night in the field in central Guatemala, June 2007. (From the archives of the WFVZ)

54,000 bird skins. The nest collection is the largest of its kind in the world, and the egg collection is one of the largest, rivaled only by those housed at the British Museum of Natural History (approximately 800,000 individual eggs), the Smithsonian (approximately 47,500 sets), and the Delaware Museum of Natural History (nearly 35,510 sets).[14] The holdings of the WFVZ also include a "broken egg" collection containing thousands

of eggs, with data, that can be used for analyses requiring the destruction of eggshells; and a "no data" egg and nest collection containing thousands of specimens that can be used for display and teaching purposes.

USES OF EGGS AND NESTS

SO WHAT GOOD are a bunch of whole but empty eggshells and a lot of old, dried nests? The answer, simply, is a great deal, especially when the materials are accompanied by documentation; in fact, they are priceless for science, whether they were collected by professional ornithologists or by schoolboy hobbyists. Collection data reveal important details about the natural environment. Locality information (such as country, state, county, city, street, and house number) helps us track over time and space the distributions of particular birds and the environments they use. This kind of information has allowed us to form a picture of what California was like at the turn of the twentieth century, including knowing what kinds of birds used to nest in the Los Angeles Basin when it had free-flowing rivers lined with dense riparian (waterside) trees. Such information will be especially valuable as our global climate changes over the next 100 years; researchers will be able to compare historic, current, and future nesting localities of birds to see how they move around in response to variations in temperature, precipitation, and plant species distributions throughout the world.

In addition to the data that accompany birds' eggs, characteristics of the eggs themselves help us understand the basics of avian reproduction. The texture of eggs; the size, kind, and number of pores in the eggshell;

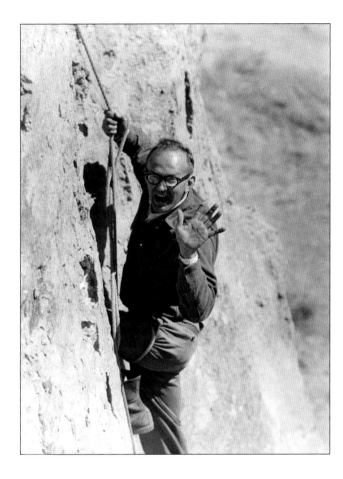

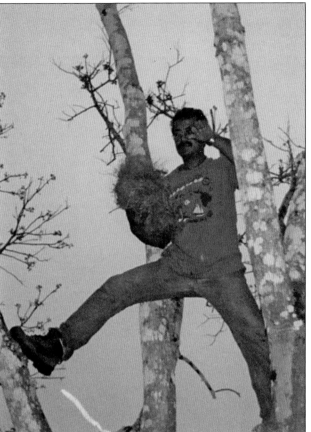

and the thickness of the shells themselves have been studied widely by oologists since the 1800s. The studies reveal much about the physiology and embryonic development of birds. Such research has led to the recovery of some bird species that were in decline as a result of reproductive problems. Moreover, questions and theories about the number of eggs per clutch and the timing of breeding have led to major advances in our understanding of avian ecology, embryology, physiology, and evolution, which even enhance our knowledge of human development.

Max Schonwetter's *Handbuch der Oologie* (Handbook of Oology), published in Germany between 1960 and 1988, is one example of an important publication on wild birds' eggs that documents basic measurements and other information gathered in museum collections in Europe. Eggs and nests at institutions like the WFVZ and the British Museum of Natural History have been used in studies of the life history of birds that detail how, where, and when eggs are laid, and how and why birds make nests the way they do. Such information helps us to appreciate both the differences and

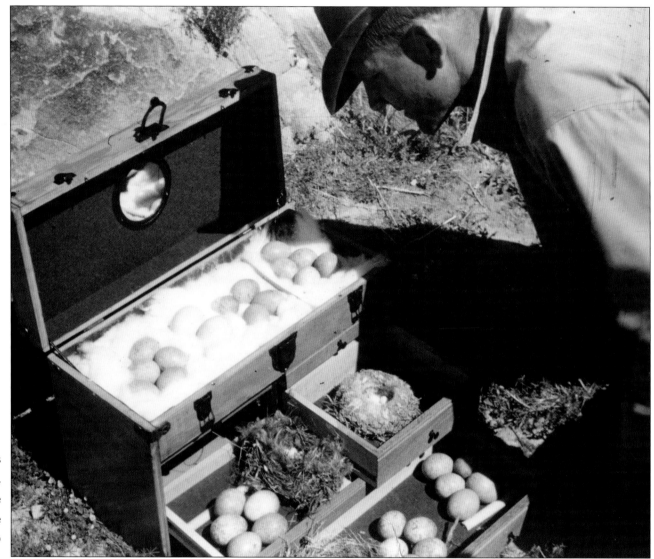

Fred Truesdale's collecting box, 1946. (From the archives of the WFVZ)

the similarities in nesting strategies among lineages. Nests and eggs have also been used to study the evolutionary relationships among birds, as well as to test hypotheses about the adaptive consequences of different nest and egg designs. Studies have shown which kinds of nests and which color or pattern of eggs are best for defense against predation.

Eggs in private and museum collections around the world have figured prominently in studies of eggshell thinning resulting from contaminants such as DDT, heavy metals, and PCBs in predatory bird species such as Brown Pelicans (*Pelecanus occidentalis*), Bald Eagles (*Haliaeetus leucocephalus*), and Peregrine Falcons (*Falco peregrinus*). Information gained from the studies was critical to the recovery of these species. In the mid-1960s, using eggs still held in private collections in England, Derek Ratcliffe determined that eggs collected before the first use of DDT in 1946 were thicker than eggs collected after the pesticide was introduced.[15] This finding spurred further research in the United States and around the world, and ultimately contributed to the ban on DDT manufacturing in the United States in 1972, and in other countries after that. Eggs held at the WFVZ, in particular, helped settle an important court case in 2001 against the last U.S. manufacturer of DDT. Nonetheless, PCBs, DDT, and other, similar compounds still occur in many of the waterways of the United States. Significant thinning of eggshells and reproductive problems are still being observed in birds such as the White-faced Ibis (*Plegadis chihi*).[16]

Bird nests can be used to study not only the distributions of species over time and in different locations but also behaviors such as nest construction and habitat use; host-parasite relationships (bird nests are often filled with parasites during the raising of a brood); and the distribution of plants (many birds use vegetation materials in the construction of their nests). Anthropologists have even identified the eggs of birds in Native American middens, and historians have used the notes of egg collectors to study the geography, climate, and culture at the time the eggs were collected. Thus, though collecting birds' eggs and nests is now highly regulated in the United States and elsewhere in the world, specimens collected in the past have greatly benefited countless bird species and have provided a wealth of information for many scientific disciplines, including conservation biology, ecology, physiology, and systematics. In addition, active egg- and nest-collecting projects such as those currently sponsored in Central America by the Western Foundation of Vertebrate Zoology continue to add to our understanding of the nesting ecology of wild birds.

Today, as technological advances enable researchers to analyze new properties such as ultraviolet reflectance of egg surfaces and DNA in shell membranes, there is a revival of scientific interest in eggs. Thus the collections of eggs and nests in museums around the world remain vital and useful for understanding the biology of birds.

THE BASICS OF EGG AND NEST COLLECTING AND CURATION

It takes a lot of experience, time, and dedication to locate and collect the nests and eggs of birds and then prepare them for shipment back to a museum. People unfamiliar with fieldwork may not realize that re-

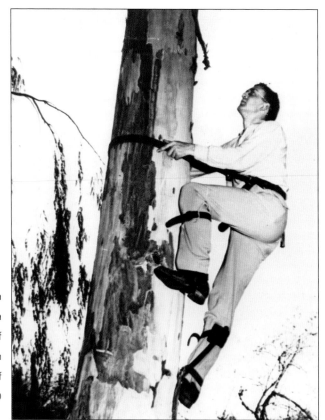

Ed Harrison, circa 1950, climbing a tree in search of a nest. (From the archives of the WFVZ)

searchers might spend hundreds of difficult hours searching for a particular specimen. This makes sense, of course, given that birds have spent millions of years learning how to avoid predators. In addition, it takes many hours of careful work to catalog and maintain the specimens once they arrive at their destination.

Some of this fieldwork is quite dangerous. Expeditions to the Antarctic between 1901 and 1904, sponsored by the British Museum of Natural History, led to the deaths of three naturalists who were trying to collect the eggs of Emperor Penguins (*Aptenodytes forsteri*). In the end, only three penguin eggs and embryos were returned to England, after the naturalists endured unimaginable struggles in the Antarctic winter.[17] More common, of course, are the daily struggles of field naturalists: waking before first light to try to see birds come off their nests or to catch them taking food to their nestlings, thus revealing the location of the nest; working in highly uncomfortable temperatures, often with flesh-eating insects and flesh-tearing plants; and staying up late after the fieldwork is done to prepare specimens and write field notes by the light of a lantern or headlamp.

The actual act of collecting eggs and nests from a tree can be quite challenging, even when not life-threatening. Ed Harrison created his own folding metal climbing ladder which he hung onto the side of cliffs when attempting to collect the eggs of cliff-nesting species. More recently, René has routinely had to carry the eggs of various species in his mouth at one of our research sites in Guatemala, because both hands are needed to navigate down the spiny cactus and acacia trees in which the nests lay protected. Ropes and tree-climbing spikes are also popular tools of the trade, though they have been known to fail and result in the death of a collector.[18]

Once eggs are collected, they have to be transported delicately to a place where they can be cleared, or "blown," of their contents. In the field (and at the WFVZ), "blowing" consists of using a small drill tip (in the early days it was a dentist's drill) to make the smallest hole possible at the center of the long side of the egg, and then using a "blow pipe"—a metal "straw" with a narrow, curved end—to force air and water into the hole. The action of the air and water forces the contents out through the tiny hole, often very slowly. This

labor-intensive method was, and is, used for at least three reasons: (1) the smaller the hole, the more "perfect" the egg looks to a collector; (2) the smaller the hole, the less likelihood of weakening and breaking the eggshell; and (3) the smaller the hole, the less material is lost for later analysis.

Once the eggs are blown of their contents, they are carefully dried and then individually wrapped in cotton or other soft material for shipment. In the past, some collectors fashioned their own special shipping boxes, whereas others used generic cigar-type boxes to protect the eggs.

Data for each egg or set of eggs were often recorded on personalized data cards. Collectors also wrote directly on the eggs themselves, near the "blowhole," in case the egg was separated from its set. In the 1700s and 1800s, eggs and nests were sent back to private and museum collections via ship, horseback, and wagon (it's amazing that any of the fragile materials ever survived such journeys). Today, eggs and nests may be transported by airplane, car, or boat—still perilous journeys for such delicate items.

Once eggs and nests make it to the WFVZ, whether they were recently collected in the field, received from captive breeding programs, or acquired from a private collector or museum, they are all processed in the same way. If the eggs are unblown, they are blown (nowadays often saving the yolk and albumen, or whites, for later analysis), and then dried. The nests are temporarily put into freezers to kill any parasites. All materials are then catalogued into the "main" collection if they have data, or into the "no data" collection if they don't. Cataloging consists of ensuring that the species is correctly identified on the eggs or nest, entering the data into the WFVZ database and making cards for the card catalog, assigning individual catalog numbers, and then packing the specimens into individual acrylic boxes lined with cotton. Labels are placed into each box defining the date, location, species, and other pertinent information for each specimen. The materials are then shut away into air-, light-, and humidity-tight cabinets, custom-made for our collection.

Each year the WFVZ receives more than 100 requests for information on its egg, nest, and skin specimens. Visitors from all over the world come to measure or otherwise analyze the materials. We furnish data electronically, in the form of photocopies of original data cards and collectors' field notes, and as photographs. Curating such a collection is time-consuming, but it is also infinitely rewarding, as we have the privilege of working with some of nature's most beautiful artifacts.

TODAY, BIRDS' EGGS and nests are collected on a limited basis and, legally, only for well-justified research purposes. Old-time hobbyists, by contrast, collected eggs and nests for their beauty, variety, and pleasing forms. Their fragility, rarity, and often inaccessibility made them a prize. Whatever the reasons for their collection, bird eggs and nests continue to delight scientists and the general public alike. We hope that the images in this book will inspire readers to appreciate both their delicate beauty and their important contributions to the understanding of bird species around the world. Now, on to the photographs!

LINNEA S. HALL and RENÉ CORADO

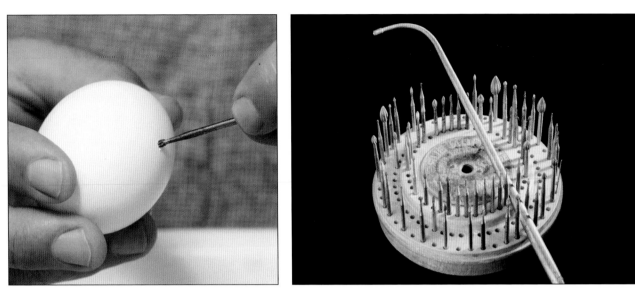

Chicken egg with egg drill used to make a single small hole in the eggshell. (From the archives of the WFVZ)

Egg drills and brass blow pipe. (From the archives of the WFVZ)

NOTES

1. G. C. Packard and M. J. Packard, "Evolution of the Cleidoic Egg among Reptilian Antecedents of Birds," *American Zoologist,* 20 (1980): 351–362.

2. Personal communication, January 2008, Douglas Russell, curator of the egg and nest collection at the British Museum of Natural History, Tring, England.

3. B. Mearns and R. Mearns, *The Bird Collectors* (San Diego: Academic Press, 1998), p. 286.

4. F. B. Gill, *Ornithology,* 3rd ed. (New York: W. H. Freeman and Co., 2007), p. 399.

5. D. M. Schwartz, "Nabbing the Bad Eggs of Birding," *Smithsonian* 22, 1 (1991): 50–62.

6. Ibid., p. 53.

7. C. L. Henderson, *Oology and Ralph's Talking Eggs: Bird Conservation Comes out of Its Shell* (Austin: University of Texas Press, 2007), p. 8.

8. A. A. Schoenherr, C. R. Feldmeth, and M. J. Emerson, "The Farallon Islands," in *Natural History of the Islands of California* (Berkeley: University of California Press, 1999), pp. 366–376.

9. Schwartz, "Nabbing the Bad Eggs of Birding," p. 52.

10. M. Wainwright, "The Day Britain's Most Notorious Egg Collector Climbed His Last Tree," *The Guardian,* May 27, 2006

11. L. F. Kiff, "A History of the Western Foundation of Vertebrate Zoology, 1956–1994," in *Memoirs of the Nuttall Ornithological Club,* no. 13 (2000): 183–228.

12. Ibid., p. 189.

13. Ibid., pp. 190–193.

14. L. F. Kiff, "Bird Egg Collections in North America," *The Auk,* 96 (1979): 746–755.

15. Schwartz, "Nabbing the Bad Eggs of Birding," p. 56.

16. K. A. King et al., "DDE-Induced Eggshell Thinning in White-Faced Ibis: A Continuing Problem in the Western United States," *The Southwestern Naturalist,* 48, 3 (2003): 356–364.

17. Personal communication, February 2007, Douglas Russell.

18. W. Raine, "Bird-Nesting in North-West Canada" (Toronto: Hunter, Rose, 1892), in Henderson, *Oology and Ralph's Talking Eggs,* pp. 109–110.

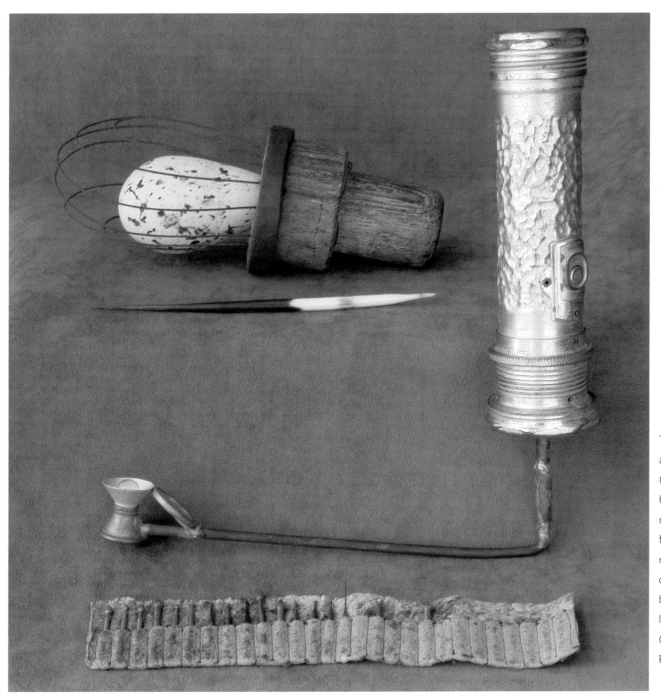

Tools for collecting and preparing eggs (from top): egg holder; quill for marking eggs; flashlight with mirror for looking into cavities; egg drill bits in a handmade leather pouch. (Photograph by Rosamond Purcell)

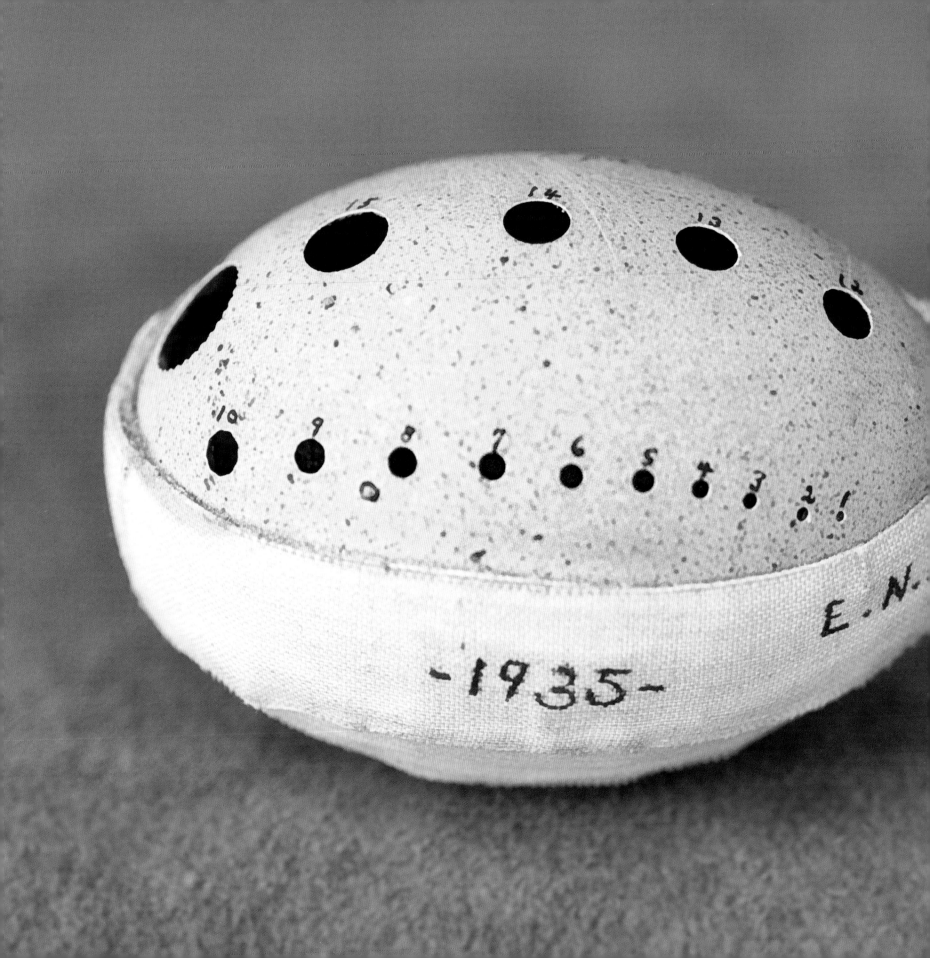

Plates

A NOTE ON SIZES

Measurements for eggs and nests are given in the captions. The egg of the Broad-billed Hummingbird (pp. 196–197) is the only specimen deliberately depicted at its actual size. Elsewhere, accurate correspondence in size between eggs and nests of individual species occurs only by coincidence.

Ed Harrison's "sample egg" demonstrating the holes made by different-sized hand drill bits.

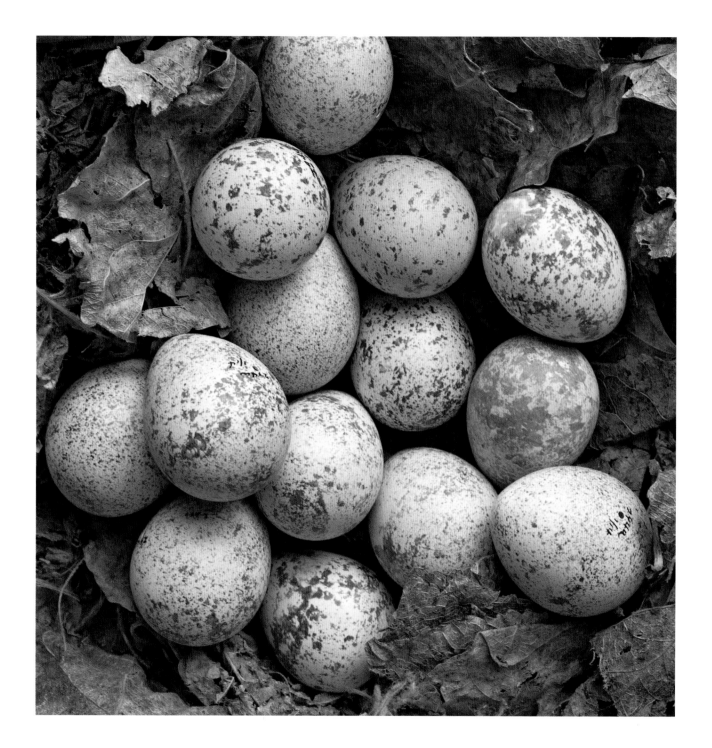

One

EGG, NEST

BIOLOGISTS CAN LEARN many things about bird species from their eggs and nests, including details about the physiology and behavior of the species, as well as the long-term effects of environmental and genetic changes. Whether the specimens are 100 years old or current, they serve as windows to a more complete view of birds, enhancing our perspective on the natural world.

California Quail (*Callipepla californica*), large clutch in nest
Collected on the San Jacinto River, Riverside Co., California, on April 16, 1939, by K. E. Vorce. Eggs are 31 × 24 mm. The nest is a shallow hollow lined with vegetation (here, leaves). Quail usually lay 12–17 eggs per clutch, sometimes as many as 28.

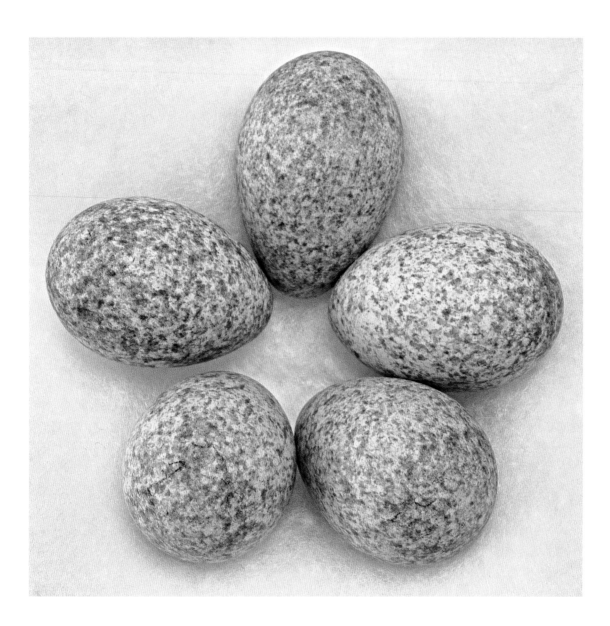

Yellow-headed Blackbird (*Xanthocephalus xanthocephalus*), eggs

Collected in Rock Lake, Platte Co., Wyoming, on May 30, 1923, by J. A. Neilson.

Eggs average 26 × 18 mm.

Yellow-headed Blackbird
(*Xanthocephalus xanthocephalus*), nest
Collected in Waukegan, Lake Co., Illinois, on May
27, 1956, by Charles Platt, Jr. Nest is 140 × 150 mm,
attached to cattail stems. This blackbird species
breeds in colonies among tule, reeds, and cattails
growing in and around bodies of water. The nest is
a deep cup composed of partially decayed grasses
lined with dead leaves and grass.

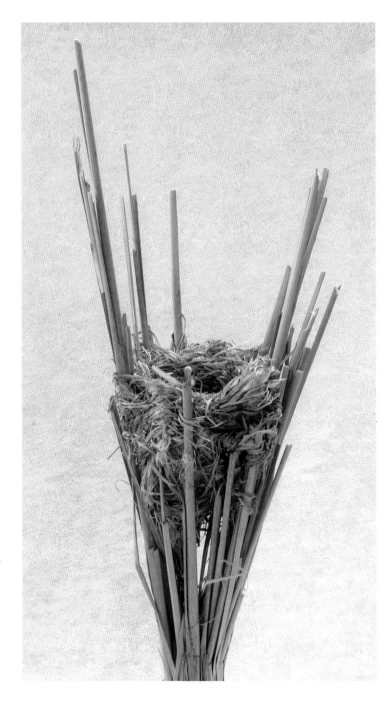

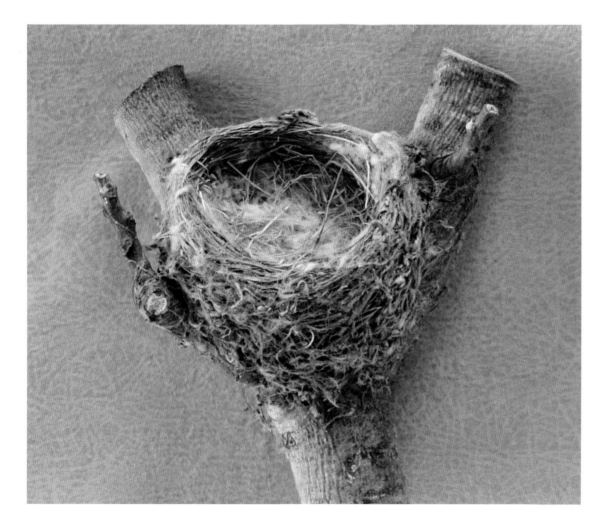

Western Wood Pewee (*Contopus sordidulus*), nest

Collected in Sespe, Ventura Co., California, on May 22, 1938, by S. B. Peyton. Nest is 90 × 70 mm. The Western Wood Pewee usually nests in coniferous woodlands and in trees near creeks and streams. The nest straddles a large branch or rests in a fork. It is composed of plant down and dry grasses, with lichens on the outside.

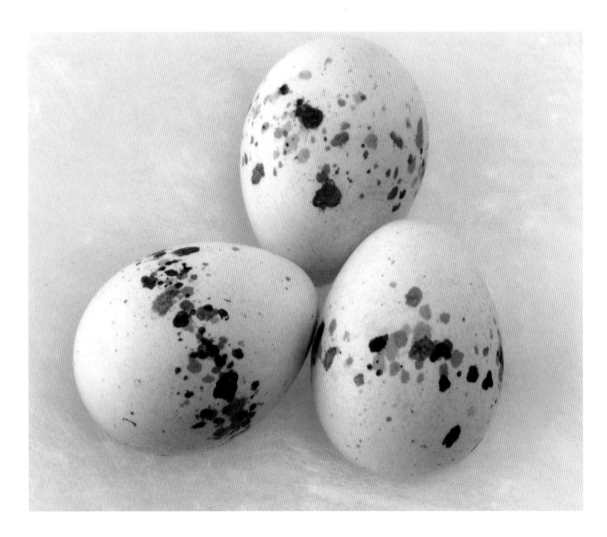

Western Wood Pewee (*Contopus sordidulus*), eggs
Collected in Danville, Contra Costa Co., California, on
July 10, 1898, by C. A. Cummings. Eggs are 18 × 14 mm.

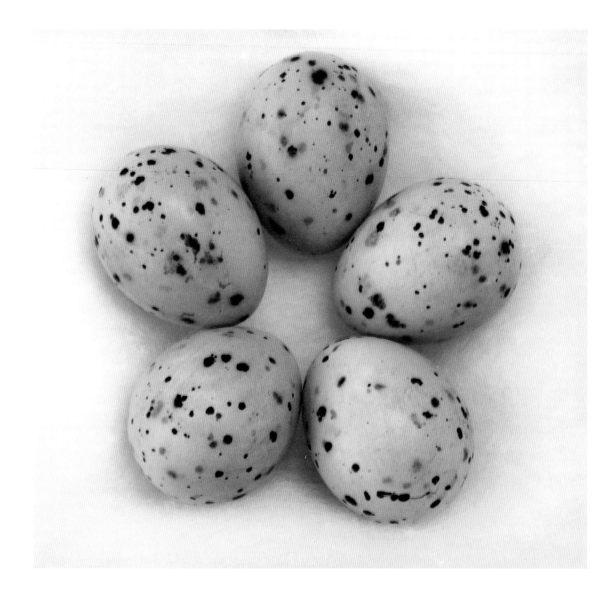

Bohemian Waxwing (*Bombycilla garrulus*), eggs

Collected in Anchorage, Anchorage Co., Alaska, on June 5, 1961,

by S. B. Peyton. Eggs are 25 × 17 mm.

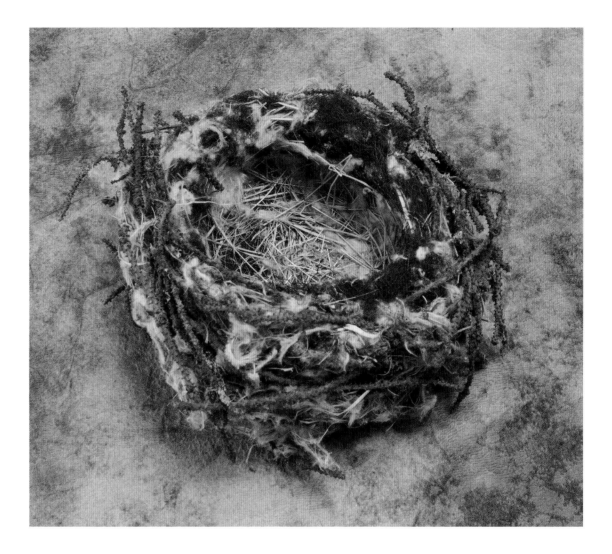

Bohemian Waxwing (*Bombycilla garrulus*), nest
Collected in Anchorage, Anchorage Co., Alaska, on
May 28, 1960, by W. E. Griffee. Nest is 170 × 80 mm.
This bird species nests in coniferous forests and
birch forests.

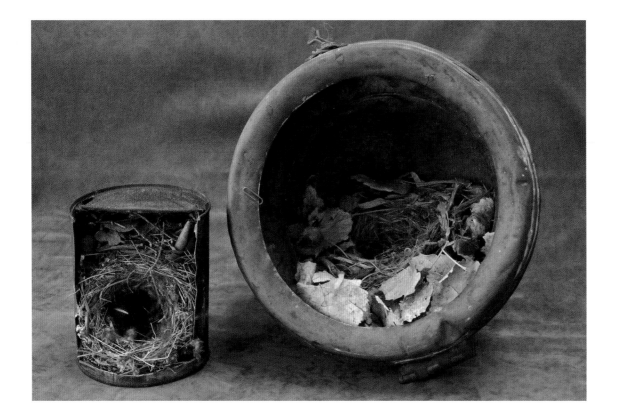

Bewick's Wren (*Thryomanes bewickii*), nests in can and pipe

Can: Collected in La Jolla, San Diego Co., California, on March 24, 1935, by T. W. Harvey III. Pipe: Collected in Placerita Canyon, Los Angeles Co., California, on May 17, 1921, by A. van Rossem. Bewick's Wrens nest in cavities of all kinds, both natural and constructed. In a given breeding season they may also build "extra" nests in which no eggs are laid. Adults use these nests to roost and, possibly, to deceive predators (Hall and Morrison 2003).

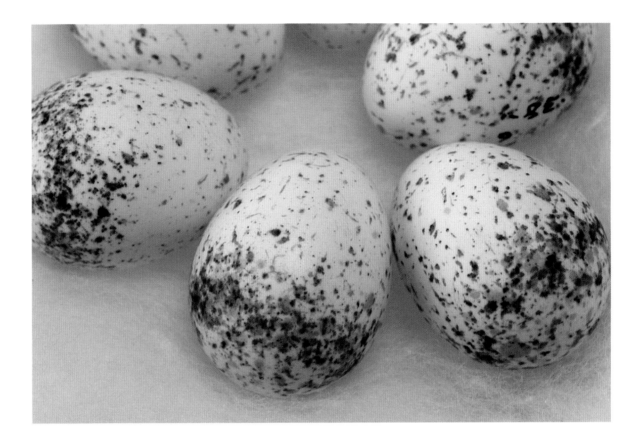

Bewick's Wren (*Thryomanes bewickii*), eggs
Collected in Murfreesboro, Rutherford Co., Tennessee,
on March 22, 1938, by H. O. Todd, Jr. Eggs are 16 × 13 mm.

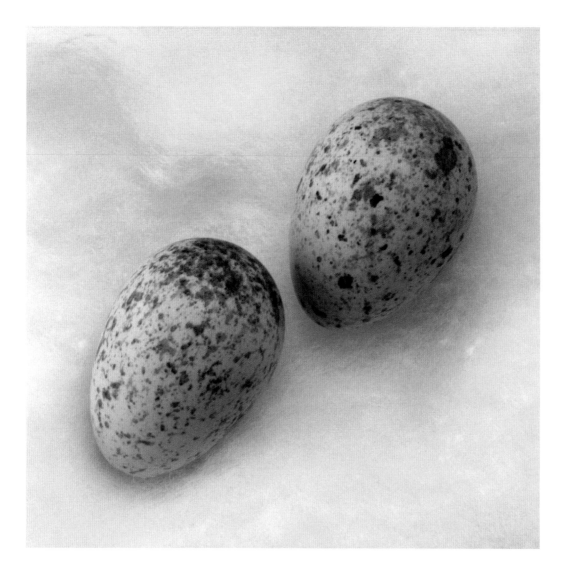

Spotted Nightingale-thrush (*Catharus dryas*), eggs

Collected, with nest on facing page, in Cerro Baul, Oaxaca, Mexico,
on May 26, 1968, by R. J. Galley. Eggs are 28 × 19 mm.

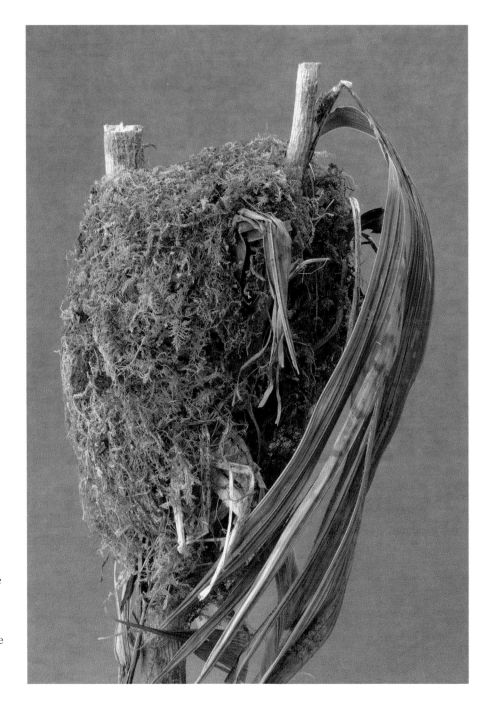

Spotted Nightingale-thrush
(*Catharus dryas*), mossy nest
Collected, with eggs on facing
page, in Cerro Baul, Oaxaca,
Mexico, on May 26, 1968, by R. J.
Galley. Nest is 160 × 110 mm. The
camouflaging properties of this
nest are impressive: the green of
the moss blends well in the shade
of a dense tropical forest.

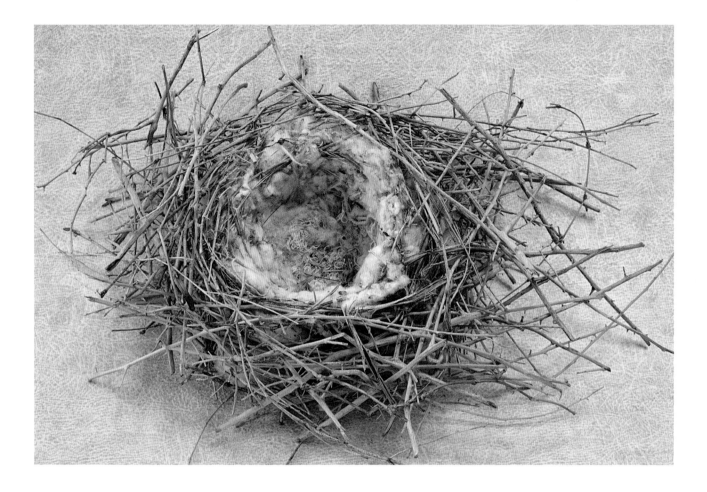

Loggerhead Shrike (*Lanius ludovicianus*), nest

Collected in Seely, Imperial Co., California, on March 14, 1924, by L. M. Huey.
Nest is 150 mm in diameter. This species of bird breeds in open country with
scattered trees or shrubs. The nest contains long twigs, weed stems, and rootlets
and is lined with feathers, down, and fine plant materials.

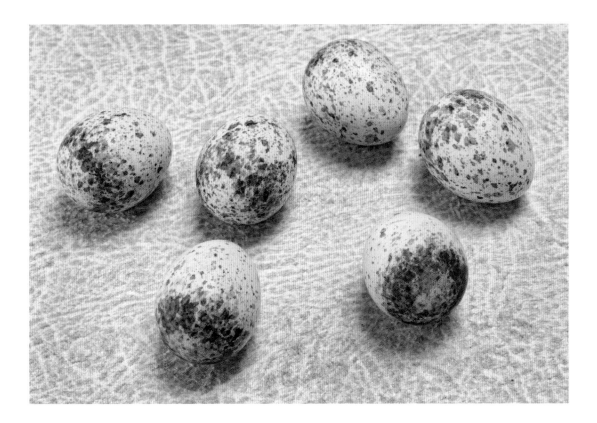

Loggerhead Shrike (*Lanius ludovicianus*), eggs
Collected near McKittrick, Kern Co., California, on
March 2, 1951, by L. R. Howsley. Eggs are 24 × 19 mm.

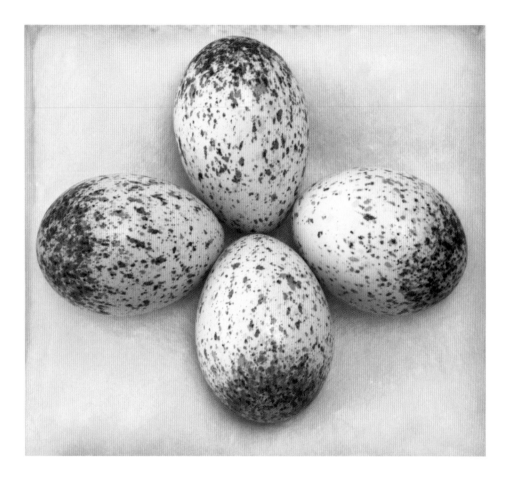

Gray Jay (*Perisoreus canadensis*), eggs

Collected in Big Lake, Alaska, on March 24, 1952, by W. Stribling.

Eggs are 29 × 21 mm.

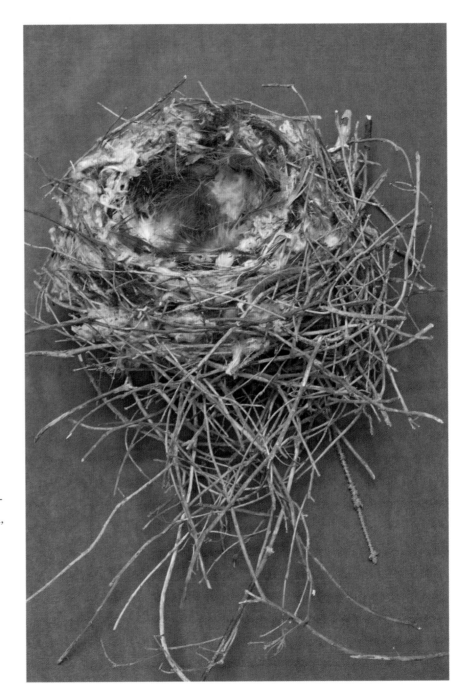

Gray Jay (*Perisoreus canadensis*),
nest lined with down

Collected near Wasilla, Matanuska-Susitna Co., Alaska, on April 8, 1961, by L. J. Peyton. Nest is 150 mm in diameter. This bird species breeds mainly in coniferous forest, sometimes in mixed woodland. The nest is made of small sticks and other soft materials; the cup is lined with feathers and fur.

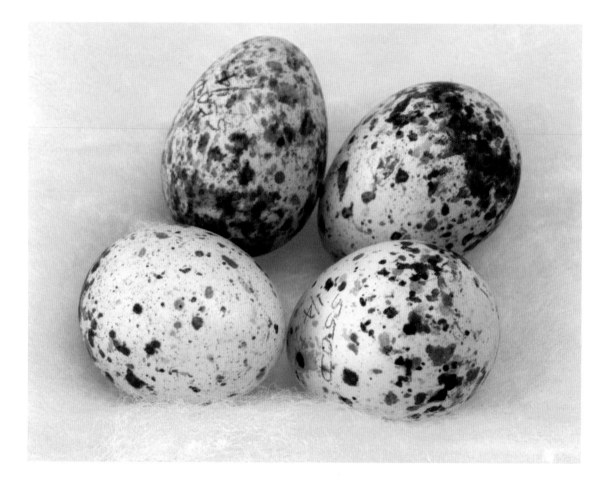

Seaside Sparrow (*Ammodramus maritimus*), speckled eggs
Collected in Chatham Co., Georgia, on May 10, 1915,
by G. R. Rossignol, Jr. Eggs are 21 × 16 mm.

Seaside Sparrow
(*Ammodramus maritimus*), nest
Collected in Beach Haven,
Ocean Co., New Jersey, on June
13, 1920, by T. E. McMullen.
Nest is 100 mm in diameter.
This species of sparrow breeds
in salt marshes and freshwater
habitats. The nest is made of
grass or rush stems and is lined
with fine grasses. The subspecies
A. m. nigrescens, the Dusky
Seaside Sparrow, from southern
Florida, is extinct as of 1987, as
a result of marsh draining,
pollution, and pesticide use
(Ehrlich et al. 1988: 571, 573).

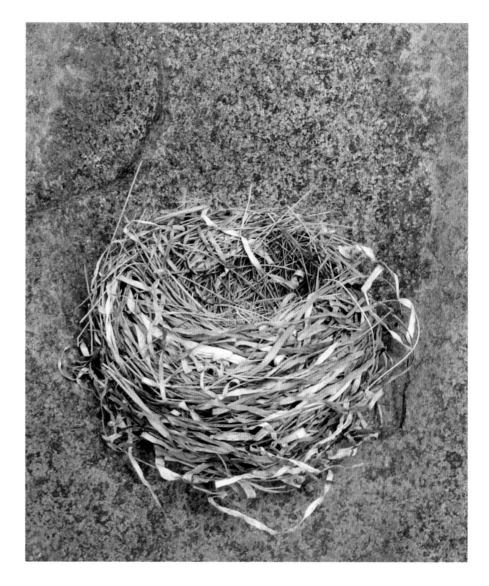

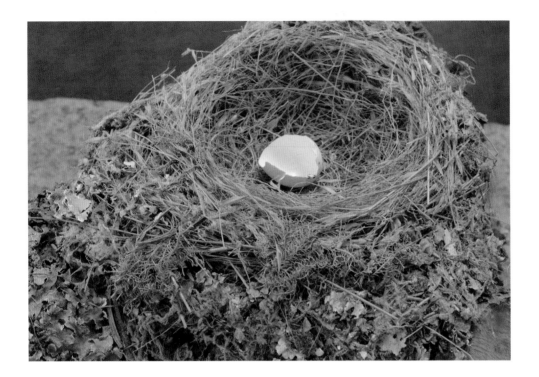

Greater Pewee (*Contopus pertinax*), eggshell in nest

Collected in Ramsey Canyon, Huachuca Mountains, Arizona, on June 25, 1910, by F. C. Willard. Eggs are 21 × 16 mm. This species of pewee breeds in pine-oak woodlands. The nest straddles a branch or rests in a fork. It is composed of grass, weed fibers, moss, and dead leaves; covered with lichens on the outside; and lined with grasses.

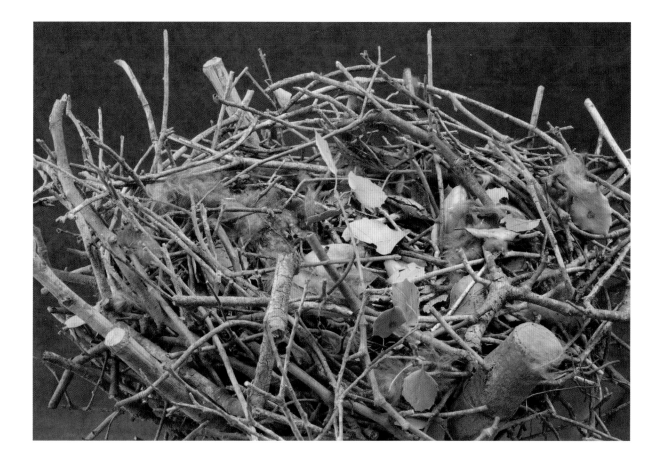

Long-eared Owl (*Asio otus*), twiggy nest

Collected near Bonsal, California, on February 27, 1933, by E. N. Harrison. This owl species nests mainly in coniferous forest or mixed woodland, inhabiting nests that are made by other birds or squirrels, or using natural tree cavities or hollows on the ground. This nest is composed of sticks and is 290 × 350 mm. In general, the nests of raptorial birds do not offer much comfort to the young— perhaps such conditions serve to toughen these fierce predators.

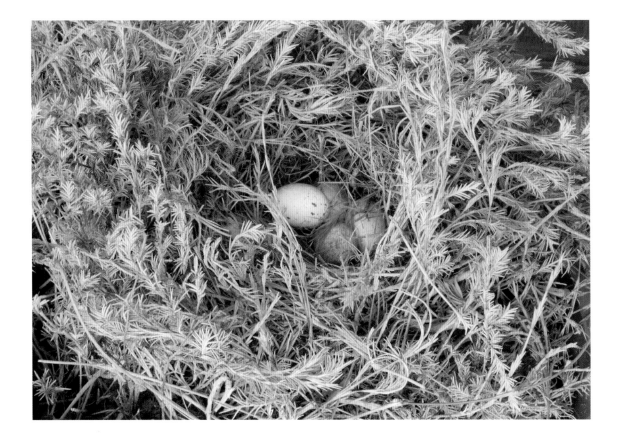

Western Meadowlark (*Sturnella neglecta*), eggs in nest

Eggs and nest collected from Newport Bay, Orange Co., California, on May 10, 1961, by R. Quigley. Eggs are 28 × 21 mm; nest is 200 mm in diameter. This species of bird breeds in open grassland, open woodland, pastures, and cultivated areas. The nest is "domed," that is, the birds construct a roof over the nest to shield it from the weather and predators. Meadowlarks commonly build long tunnels through the grass to deter predators from following them to their nests. As a result, it can sometimes take researchers hours to determine the exact location of a nest.

Rock Ptarmigan (*Lagopus muta*), eggs with feathers in nest Collected on Kaluk Lake, Kodiak Island, Alaska, on June 21, 1956, by W. K. Clark. Eggs are 43 × 31 mm; nest is 260 mm in diameter. The Rock Ptarmigan breeds on the rocky arctic tundra. The nest is a lightly lined scrape, usually in an open or slightly sheltered site. This nest is made of moss and a few twigs.

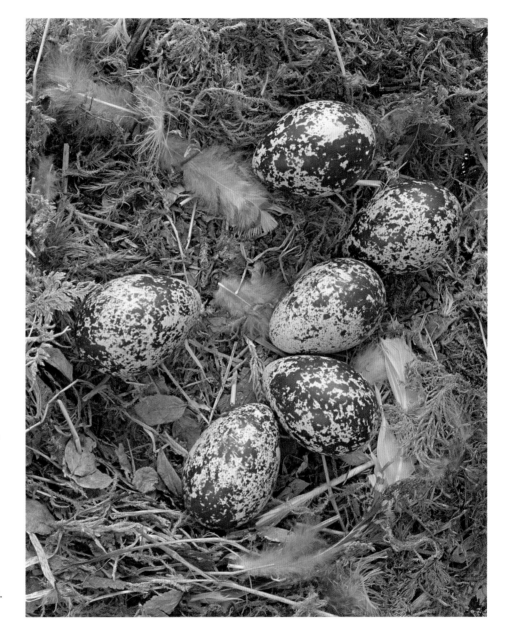

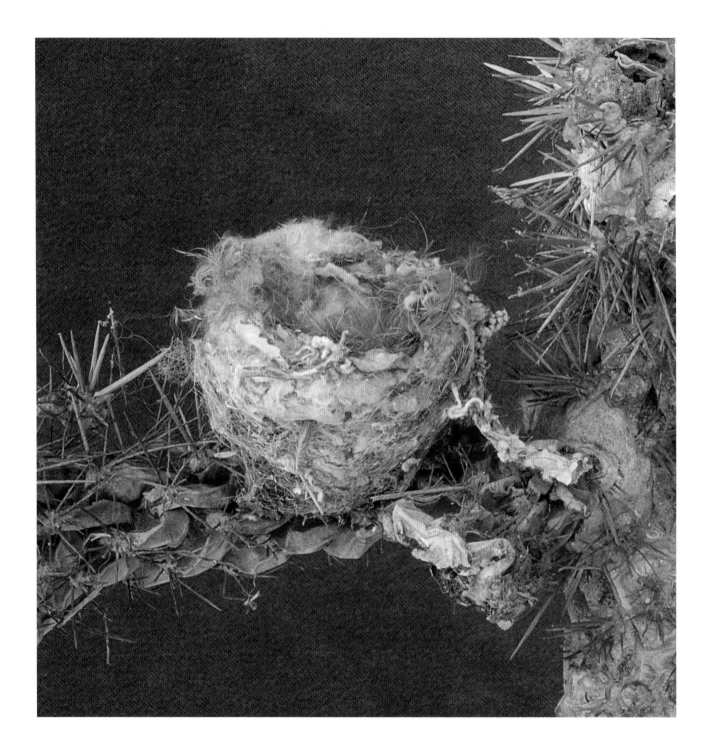

Two

STRATEGY

NESTS PROTECT EGGS and young from predators, provide thermal insulation from extreme temperatures outside the nest, and serve as a "staging area" for young birds before their first flights. Particular nest locations and composition vary widely among species, but general nest types (for example, scrapes, cups, holes, domed nests) are often shared within bird families. Of course, there are always exceptions—such as the tremendous variability among flycatcher nests—and these tend to be the most interesting to study.

Costa's Hummingbird (*Calypte costae*), nest on cholla cactus
Collected from Rose Canyon, San Diego Co., California,
on April 16, 1916, by A. M. Ingersoll. Nest is 50 x 30 mm.

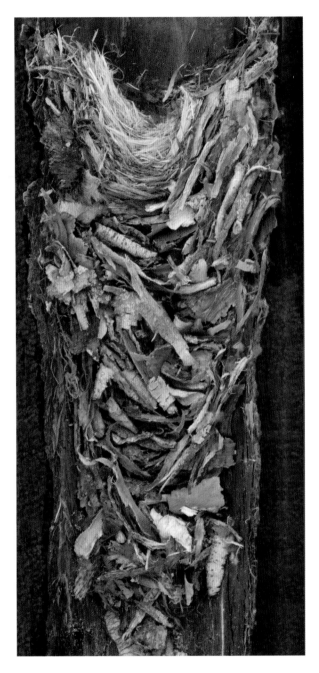

Brown Creeper (*Certhia americana*), nest

Collected from Virginia Lake, Mono Co., California, on
June 16, 1948, by E. N. Harrison. The nest, including the
stacked materials below, is 250 × 130 mm. Brown Creepers
nest behind protruding pieces of bark on pine trees. This is
an impressive strategy—no other bird species in temperate
North America readily utilizes such locations. Creepers
have these sites all to themselves.

Common Raven (*Corvus corax*), twiggy nest with "cotton"

Collected near Lancaster, Los Angeles Co., California, on March 24, 1988, by L. F. Kiff. This nest is 300 × 810 mm and is lined with cotton or polyester batting. Birds in the family Corvidae tend to build open-cup nests of twigs and sticks lined with soft materials. Nests are usually located in trees or shrubs, or on ledges.

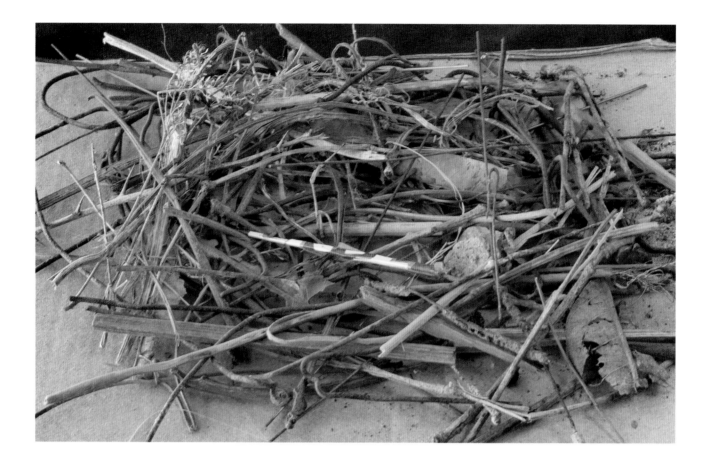

Rock Pigeon, formerly Rock Dove (*Columba livia*), nest with metal and fireworks plugs

Collected May 10, 2003, in Guatemala City, Guatemala, by R. Corado. At first glance the nest appears to be made of sticks, but a closer look reveals that it is actually composed of about 75 percent nails, other pieces of metal, and fireworks parts. The pigeons clearly sought out stick-like objects, but since the pair lived in the heart of the city with very little remaining natural vegetation, they used whatever was available. This is an interesting example of how birds will use whatever they can find to make a nest, even if the material is not optimal. (See detail page 203.)

Yellow-throated Vireo (*Vireo flavifrons*), teacup-shaped nest

Collected from Ladies Island, Beaufort Co., South Carolina, on June 11, 1942, by E. J. de Camps. Note that this nest has literally been constructed around the supporting branch. This is a common strategy used by vireos, and it makes the deep, open-cup nests very stable in a tree. The nest is composed of plant fibers and spider webs, covered with lichen, and lined with grass.

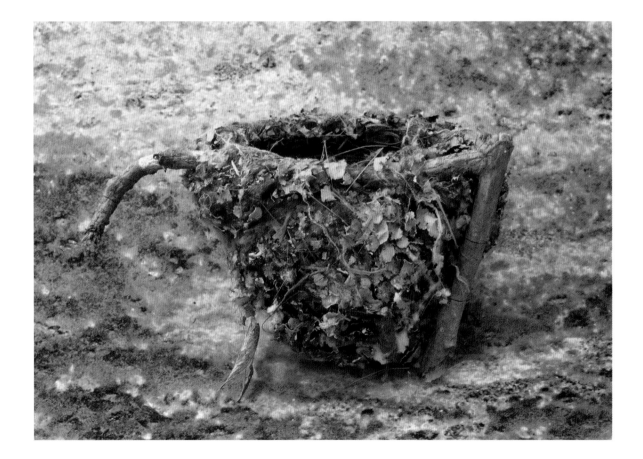

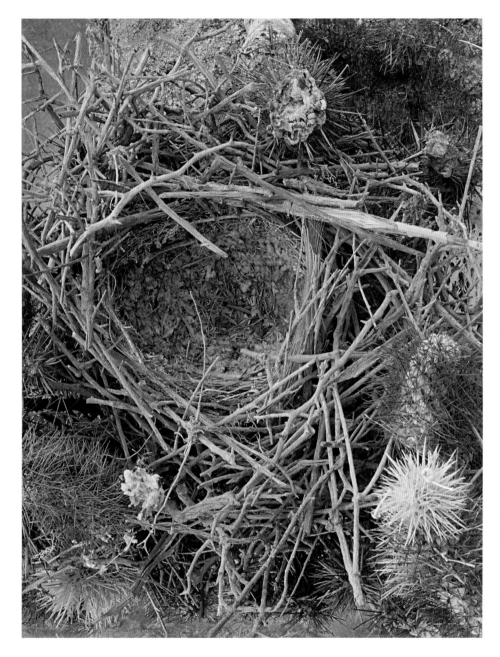

Le Conte's Thrasher (*Toxostoma lecontei*), nest of gray twigs

Collected near Victorville, California, on April 24, 1920, by W. M. Pierce. Many birds living in the southwestern part of the United States and in desert regions throughout Central and South America use cactus or other spiny plants to protect their nests. The cholla cactus is a particularly good defense against large predatory animals—the cactus is usually referred to as "jumping cholla" because the spines "jump" out at the slightest contact and grab hold wherever they land.

Yellow Warbler (*Dendroica petechia*),
nest with "cotton" rim

Collected from Lakeside, California, on
May 10, 1901, by A. Ingersoll. This cup-
shaped nest (very typical of New World
warblers) is lined with soft cottonwood
fibers. The softness of this nest is ideal
for the nestlings (and the eggs!), and the
density of the plant fibers makes a very
warm nest. This may be one reason the
nests are usually located in the shade of
tall trees in riparian (waterside) areas.

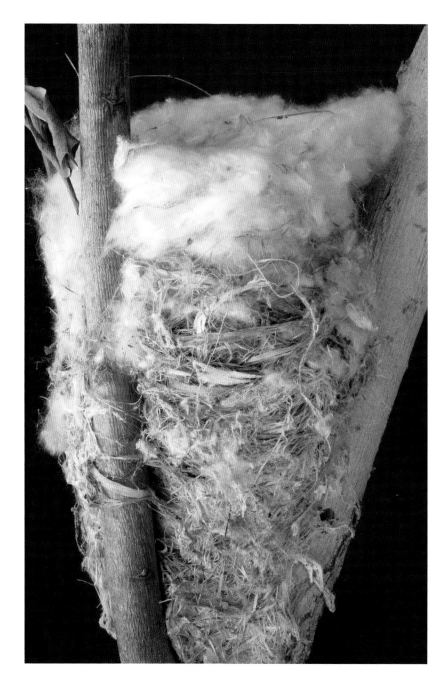

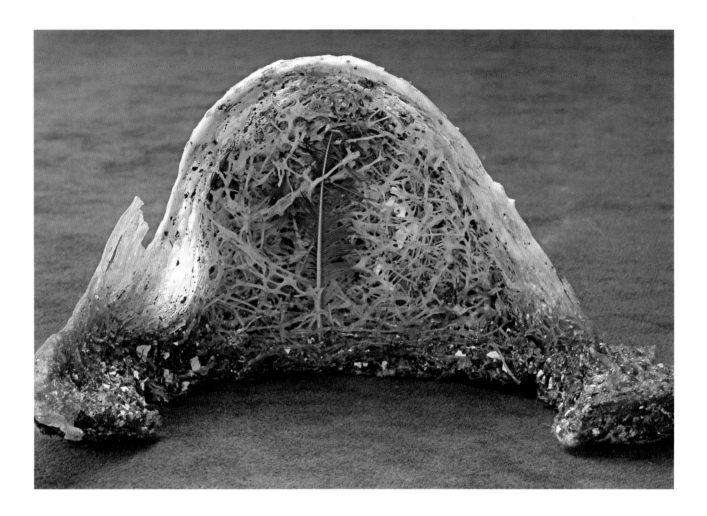

Edible-nest Swiflet (*Aerodramus fuciphagus*), interior view of nest

Collected in east Malaysia (Sabah), on June 20, 1983, by C. Francis. The bird that
makes this nest is a slender, sparrow-sized brown bird with a slightly forked tail.
The male produces gelatinous strands of condensed saliva from his salivary
glands, which he then winds into a half-cup nest and bonds to a vertical surface.
This nesting strategy is not only interesting but also very practical: the birds' nest-
building is not constrained by the availability of materials in the environment.

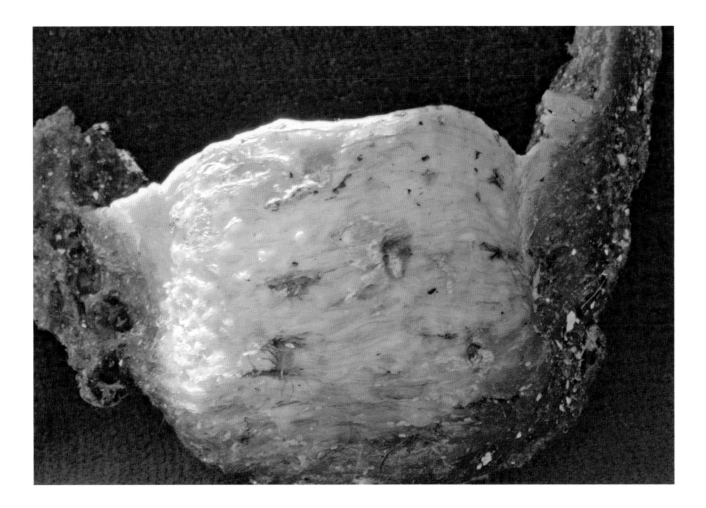

Edible-nest Swiflet (*Aerodramus fuciphagus*), exterior view of nest

This nest-building technique may have developed at a time when mud or other nesting materials used by birds in the family Apodidae were scarce. Unfortunately, the species is declining in many areas, as a result of harvesting for soup-making. The nests are thought to be an aphrodisiac, which makes them much sought-after. Currently, the population of Hong Kong is believed to be the largest consumer of edible bird nests. Hong Kong imports about a hundred tons every year, at a price of about $25 million (Chantler 1996).

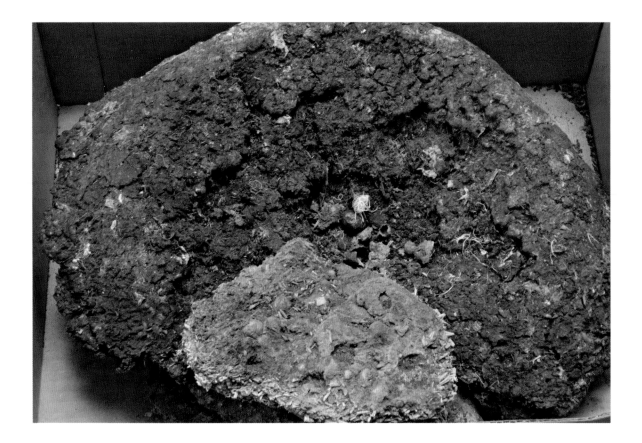

Oilbird (*Steatornis caripensis*), guano nest

Collected in Alchipichi, Pichincha Province, Ecuador, on July 18, 1990, by M. Marin and R. Corado. This specimen weighs approximately 10 kilograms (22 lbs.). Oilbirds—odd, nocturnal, cave-dwelling birds found from Panama to Peru—feed entirely on fruits that they gather at night, mostly from palm trees. The fattiness of their food makes the birds extremely fat themselves. This is particularly true of the young, which have historically been collected and killed for their oil. The birds nest colonially in caves, and their nests are made of hard, thick piles of droppings that accumulate over years, as can been seen in this photograph. Oilbirds are also unusual in that they use a form of echolocation to navigate through their caves (Thomas 1999).

Oilbird (*Steatornis caripensis*), study skin
Collected in Morona-Santiago Province,
Ecuador, on August 4, 1987, by I. Mora.

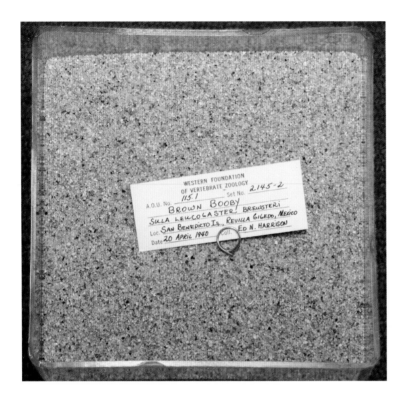

Brown Booby (*Sula leucogaster*), "anti-nest"

Collected on San Benedicto Island, Mexico, on April 20, 1940, by E. N. Harrison. This is an example of a "scrape" nest in sand, which consists of a substrate only. It is essentially no nest at all. Scrapes are used by bird species that nest on coastlines, islands, in deserts, or in dry river washes, where rocks or sand provide the most common form of nest substrate. The sand or ground is often warm enough to keep the eggs incubated and the young from getting cold. The main problem with these nests is that temperatures can get too high, so that parents have to provide extra shade for their eggs and young, or even to soak their own breast feathers with water to cool them. Cryptic coloration of the eggs is vital in scrape nests.

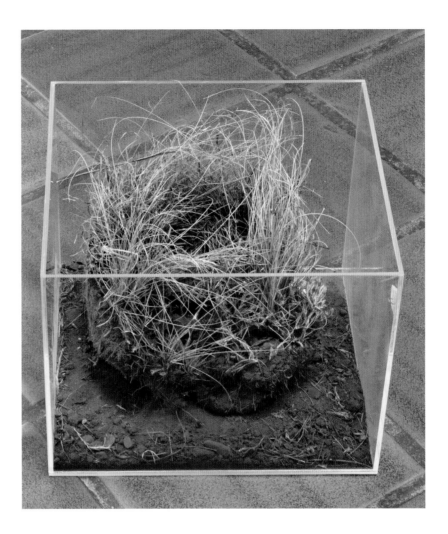

Horned Lark (*Eremophila alpestris*), nest in clear box

Collected from Lake Henshaw, San Diego Co., California, on May 18, 1933, by E. N. Harrison. Note the way Ed collected this beautiful nest: he dug down into the dirt around it to make sure the entire structure was preserved. This kind of nest-collection method is very useful for scientific study, because it allows researchers to see all the details of the nest, including the soil type selected by the bird for the nest's placement.

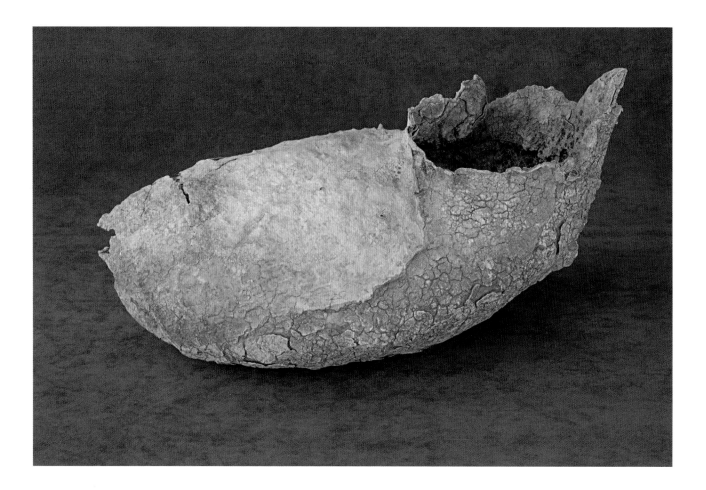

Gila Woodpecker (*Melanerpes uropygialis*), "wooden shoe" nest

Collected from a saguaro cactus. (No other collecting data available.)
Gila Woodpeckers commonly excavate their nests in living saguaros,
which protect themselves by surrounding the cavity with tissue that
later hardens (as seen here). The nest cavities are not suitable for use
by the birds until the walls have dried this way.

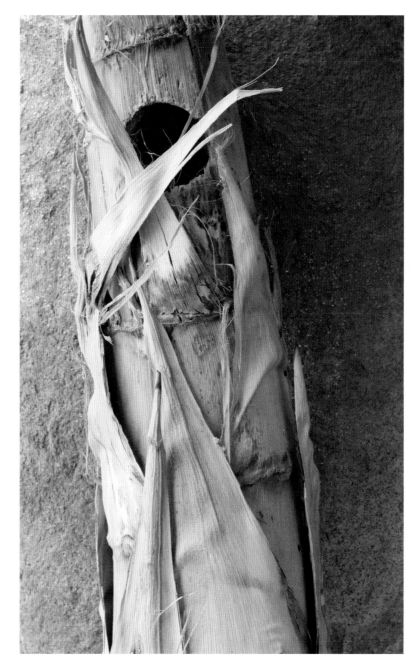

Woodpecker (family Picidae),
nest in giant reed
From the C. Platt, Jr., collection.
(No other collecting data
available.)

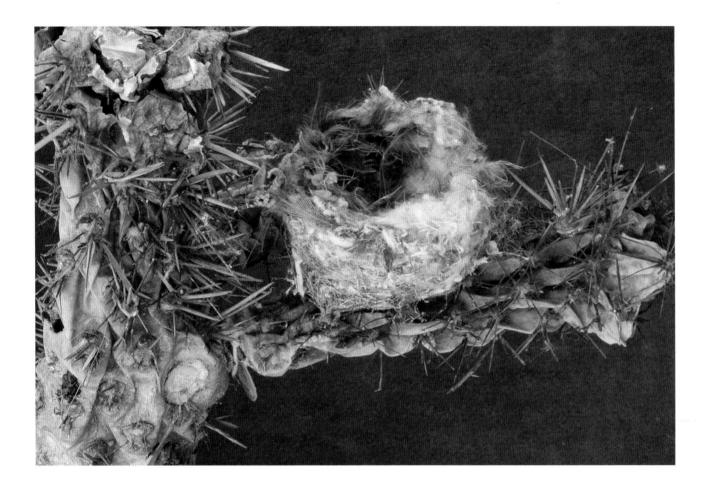

Costa's Hummingbird (*Calypte costae*), nest on cholla cactus

Collected from Rose Canyon, San Diego Co., California, on April 16, 1916, by A. M. Ingersoll. Nest is 50 × 30 mm. Note again the bird's use of cholla cactus for protection.

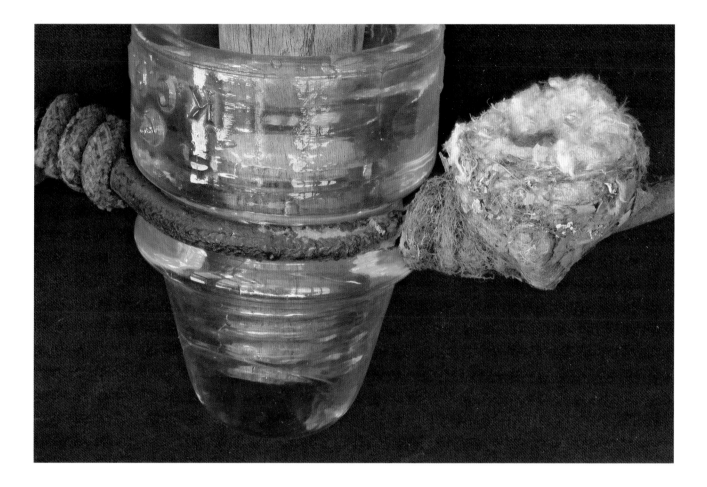

Anna's Hummingbird (*Calypte anna*), nest on glass insulator

Collected in Santa Monica, Los Angeles Co., California, on May 3, 1903, by G. Chambers. The nest, 40 × 40 mm, is made of plant down.

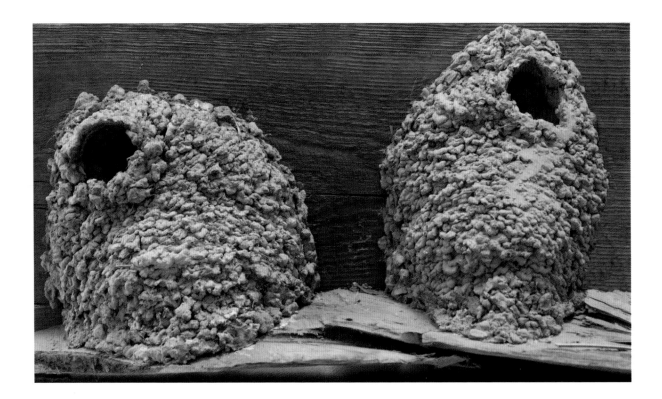

Cliff Swallow (*Petrochelidon pyrrhonota*), mud-drip nests

Typical Cliff Swallow nests made of mud. (No other collecting data available.)
Each little bump on the nests is a single mouthful of mud carried by an individ-
ual swallow and plastered in place. Cliff Swallows nest in areas where mud is
readily available (for example, on bridges over rivers or in well-watered rural
areas), but of course, changes in habitat and in rainfall patterns can quickly
affect the availability of such material, as well as the supply of insects that
these swallows depend on to feed their young. Cliff Swallows sometimes
reuse their nests (often adding more mud to nests that have been damaged),
but the used nests tend to contain many parasites (mites, chewing lice),
which can sometimes lead to the death of the nestlings. This is one
reason many birds make new nests.

Pale-legged Hornero (*Furnarius leucopus*), nest

Collected in Ecuador on March 14, 1991, by L. Kiff, R. Corado, and J. Ingels. Nest is 200 mm in diameter and weighs a hefty 12 kilograms (26 lbs.). The nest was 4 m (12 feet) high at the top of a leafless, dead tree located along a fence. In this area many individual Horneros had placed nests along the tops of fence posts, a common practice in the neotropics. This species of bird builds its oven-shaped nest out of mud and plant fibers, making it highly durable.

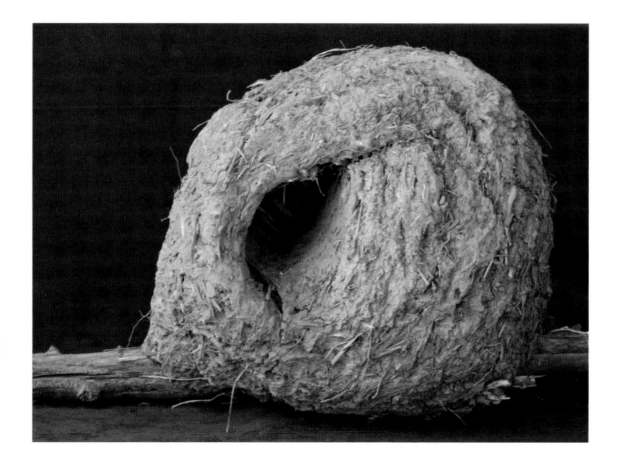

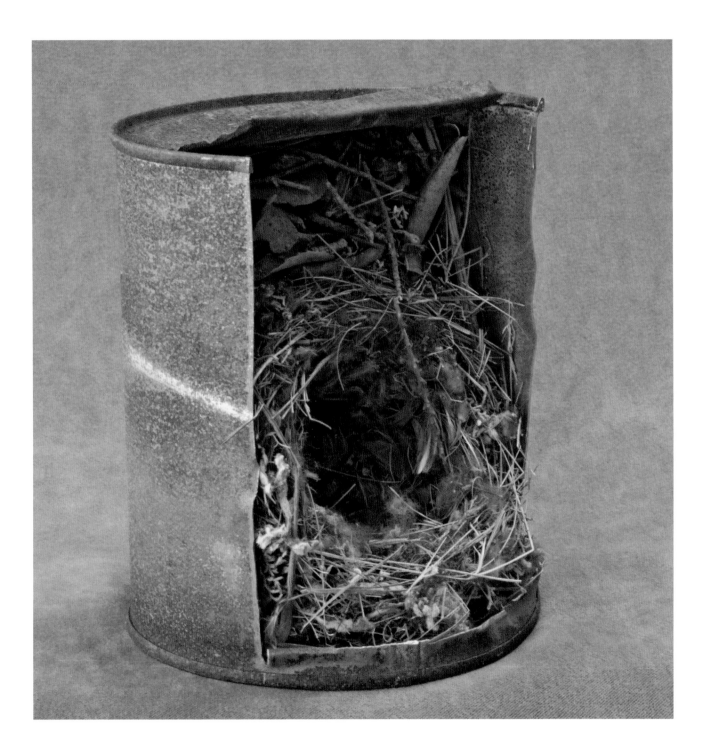

Three

THE READY-MADE NEST

MANY BIRDS ARE opportunistic in their use of human-made items and structures for their nests. Cavity-nesting species, for example, may co-opt all kinds of "crevices" that resemble natural holes, which are often very limited in nature. Other species may be forced to use human-made materials because their preferred nesting substrates or composition materials have been lost over time as a result of habitat conversion.

Bewick's Wren (*Thryomanes bewickii*), nest in can

Collected in La Jolla, San Diego Co., California, on

March 24, 1935, by T. W. Harvey III. The can is 135 × 100 mm.

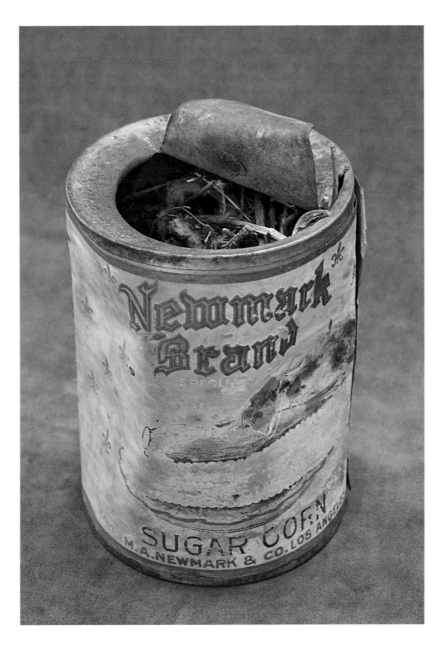

Bewick's Wren (*Thryomanes bewickii*),
nest in sugar corn can

Collected near San Antonio Canyon,
Los Angeles Co., California, on April 26,
1918, by W .M. Pierce. Wrens (family
Troglodytidae) nest in a variety of ways.
Many North American species nest in
cavities, such as those found in trees
or nest boxes or even in containers
discarded by humans, like this can,
but some species also build their own
domed nests, which resemble large
footballs made of grasses and sticks.
Still others nest among rocks.

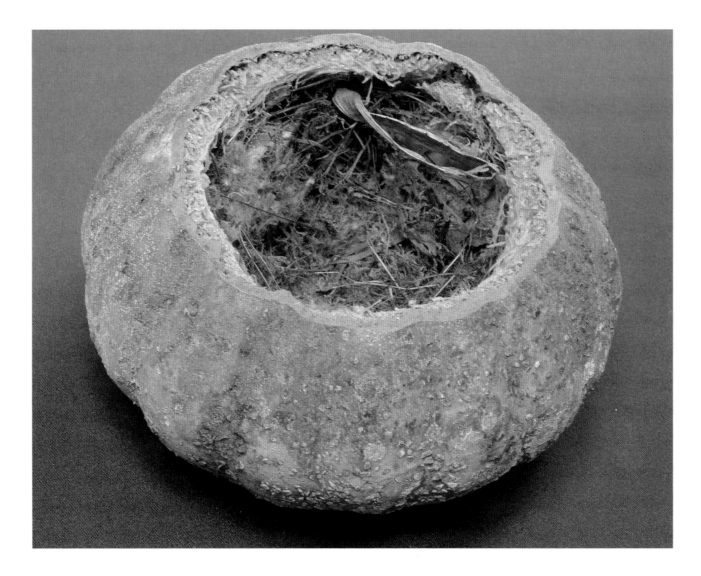

Carolina Wren (*Thryothorus ludovicianus*), nest in gourd

Gourd is 140 × 70 mm. (No other collecting data available.) This species of wren breeds in woodlands with low cover and along banks of streams or in swamps. It nests in small niches and cavities, using fine grasses, roots, hair, feathers, and similar materials for the nest lining.

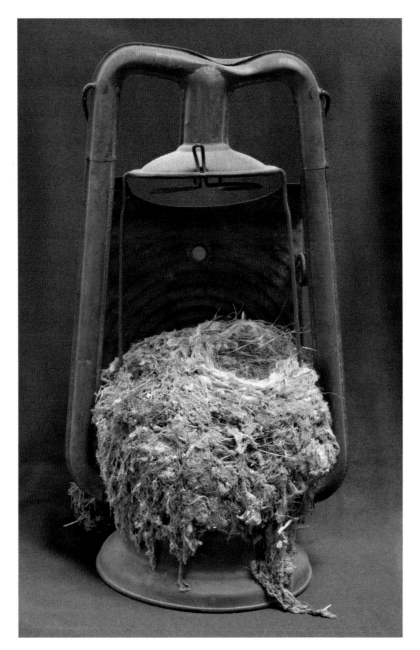

Say's Phoebe (*Sayornis saya*), nest in hurricane lamp

Nest is 158 × 100 mm. (No other collecting data available.) This species of bird breeds in open, semi-arid country, building nests on sheltered ledges and crevices, in holes in steep banks, cavities in trees, or human-made sites. It also reuses the nests of other perching birds (passerines). Nests are made of fine materials including grasses, weed stems, moss, and hair.

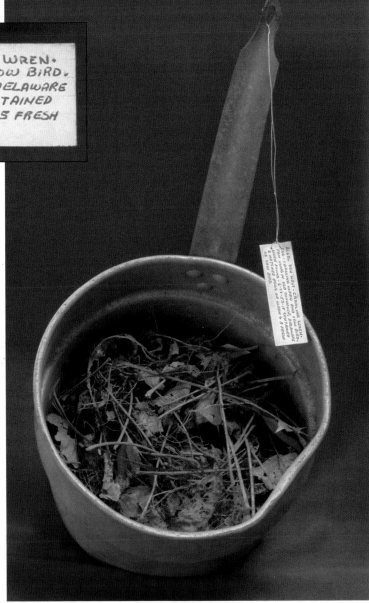

ALUM. PAN NEST - CAROLINA WREN. EGG - CAROLINA WREN AND COW BIRD. PAN HUNG IN OLD OUTHOUSE, DELAWARE WHEN FOUND - 6-22-53. IT CONTAINED 2 HATCHED EGGS OF WREN & 5 FRESH OF COW BIRD.

Carolina Wren (*Thryothorus ludovicianus*), nest in saucepan

Collected in an old outhouse in Delaware, on June 22, 1953, by an unknown collector. This is an interesting example of a human-made "crevice" used by a wren. Note that this nest has been parasitized by a Brown-headed Cowbird (*Molothrus ater*). Female cowbirds lay their eggs in the nests of other bird hosts, who either reject the eggs or chicks or incubate and raise them, depending on the species. As a result of environmental changes, Brown-headed Cowbirds have been able to colonize areas of the United States that they did not originally occupy, to the detriment of bird species that have not learned to eject cowbird eggs.

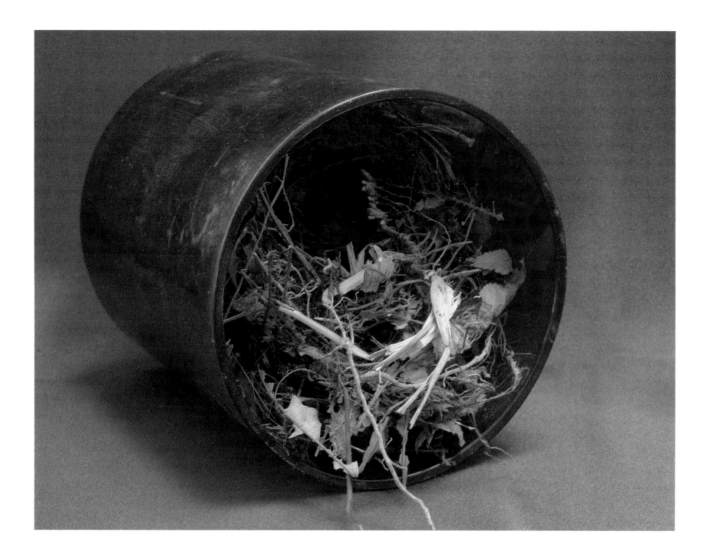

Carolina Wren (*Thryothorus ludovicianus*), nest in can

Collected from Gainsville, Alachua Co., Florida, in 1985 by D. G. Matthiesen.

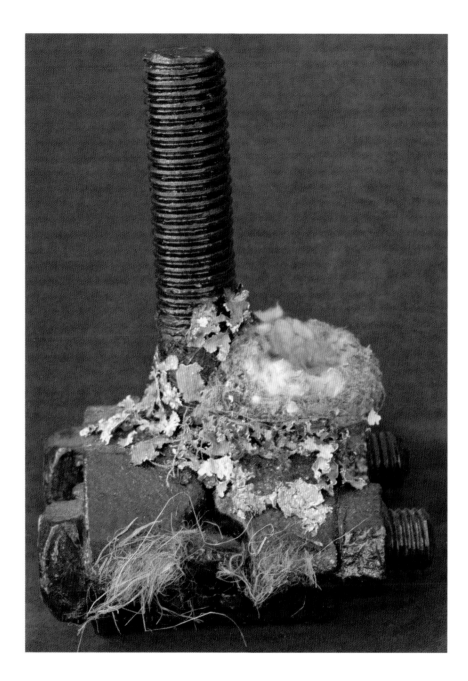

Anna's Hummingbird (*Calypte anna*),
nest on metal bolt
(No other collecting data available.)

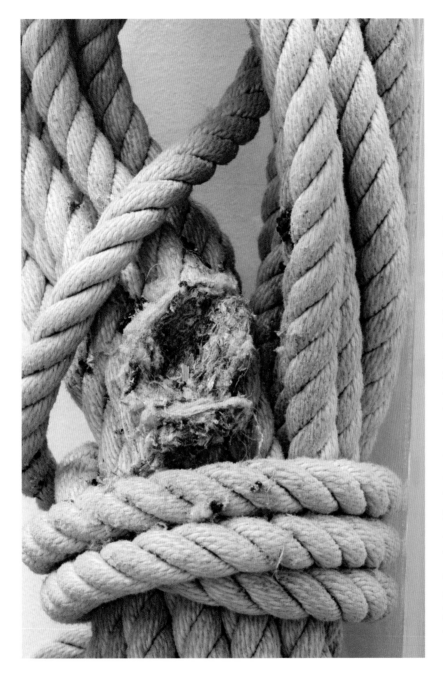

Anna's Hummingbird (*Calypte anna*),
nest on rope knot

Collected in Marina del Rey, Los Angeles Co., California, on June 24, 1989, by E. N. Harrison. The nest contained two young and was located on a yacht docked offshore and scheduled to leave port the next day. Ed Harrison bought the rope fom the yacht owner, cut off the section that contained the nest, and moved it back to the shoreline. He fastened the rope to the top of a cement post on the dock and tied a red ribbon on the nest. He also tied a red ribbon halfway down the dock toward the ocean. When the female hummingbird returned, she spotted the first red ribbon and then the second on the newly situated nest, and thus was led back to her young. She successfully fledged the nestlings a week later, after which Ed officially collected the nest.

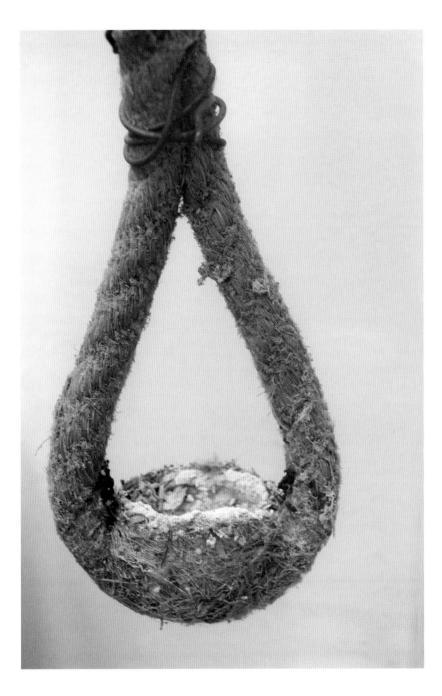

Broad-tailed Hummingbird (*Selasphorus platycercus*), nest on rope "swing"

Collected on July 22, 1990, by E. N. Harrison at his Rio Blanco Ranch in Rio Blanco Co., Colorado. The nest is 50 mm in diameter. This was the third year in a row that a nest was collected from the same hummingbird pair after they finished fledging their young. The nest was located in an old cabin on the White River in northwest Colorado. The cabin had three rooms, and what may have been the same pair of hummingbirds nested in all three rooms over the years, on different pieces of rope.

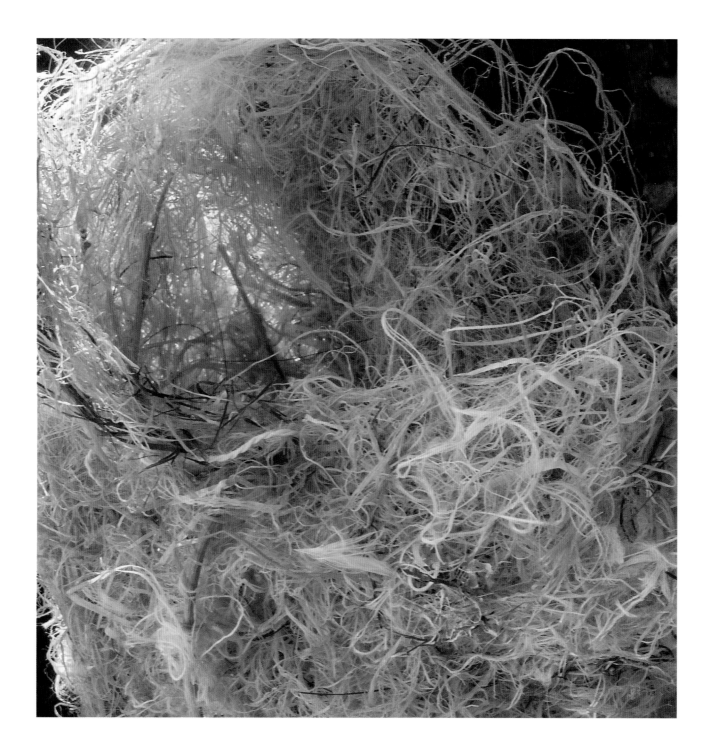

Four

FEATHERING THE NEST

BIRDS WILL USE nearly all available items that fit their "search image" for appropriate nesting materials. Before humans manufactured items that birds could incorporate into their nests, plant and animal materials were most commonly used in nest-making. Today we are much more likely to find nests containing all manner of synthetic fibers that mimic natural materials, sometimes to the detriment of the chicks.

Bullock's Oriole (*Icterus bullockii*), detail of "excelsior" nest shown on page 2
Collected in the Carrizo Plains, San Luis Obispo Co., California, on December 8, 1991, by N. J. Schmitt. This oriole nest is composed almost entirely of plastic.

Great Crested Flycatcher (*Myiarchus crinitus*), nest with snakeskin

Collected from Keystone, Pawnee Co., Oklahoma, on May 30, 1919, by J. R. Pemberton. A great deal of variation exists among flycatcher nests and eggs. Some flycatchers nest in cavities; others build small cup-shaped nests; still others build large, complex nests. Some, as in this species, incorporate snakeskin and other animal parts, whereas others have more typical nests made of sticks.

Brown Booby (*Sula leucogaster*), mummified chicks in nest

Nest contents collected from George Island, Mexico, on April 21, 1925, by G. Bancroft. Diameter of container is 260 mm. Birds in this genus generally make a depression in the ground for their eggs, then stand on the eggs to incubate them. Note the remains of at least 3 young chicks in this nest.

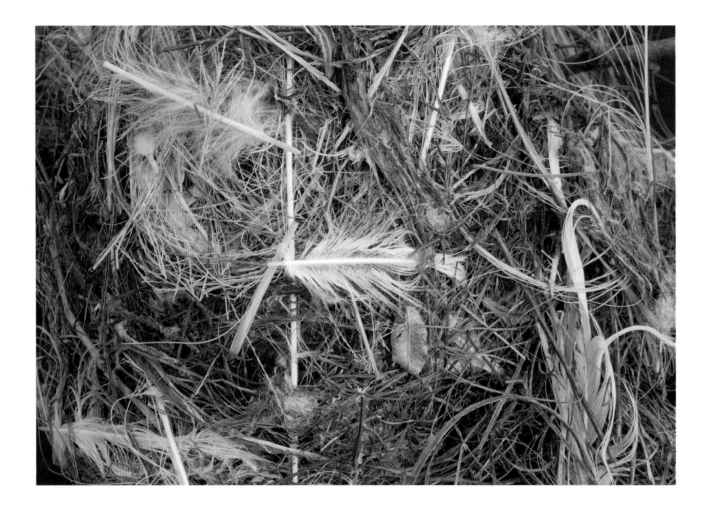

Social Flycatcher (*Myiozetetes similis*), detail of nest shown on page 101
Collected from Guayas Province, Ecuador, on March 23, 1991,
by L. F. Kiff and J. Ingels.

Barn Owl (*Tyto alba*), nest contents

Collected from Rosarito Beach, Baja California, Mexico, on March 1, 1926, by G. Bancroft. These nest contents were collected from a cavity that the bird used as a nest. Note the predominance of small mammal bones.

Red-winged Blackbird (*Agelaius phoeniceus*),
detail of nest shown on page 96
Collected south of Round Rock, in
Travis Co., Texas, on May 12, 1940,
by F. F. Nyc, Jr.

Bullock's Oriole (*Icterus bullockii*), detail of nest shown on page 2
This nest is 260 × 100 mm. (No other collecting data
available.) Note the green plastic strips and the string
worked into the nest.

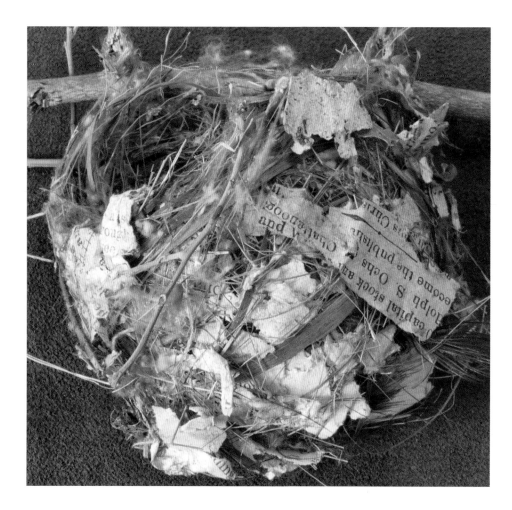

Bell's Vireo (*Vireo bellii*), nest with newspaper

Collected in San Antonio, Bexar Co., Texas, on May 28, 1898, by P. W. Smith, Jr. Nest is 70 mm in diameter. This species of bird breeds in dense, shrubby growth and woodland edges, riparian thickets, mesquite, and hedgerows. The nest is usually suspended from a horizontal twig fork and made of fine grasses and weeds. Breeding populations in north and central California (*V. b. pusillus*) have been eradicated, and the subspecies *V. b. arizonae* has all but disappeared from the Lower Colorado River Valley of California and Arizona.

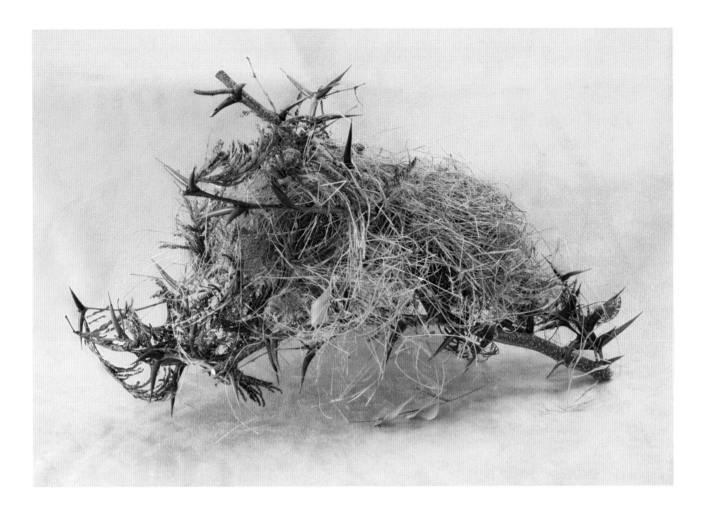

Banded Wren (*Thryothorus pleurostictus*), nest

Collected in Los Tablones, in the Department of El Progreso, Guatemala, on May 12, 2006, by R. Corado. Note that the nest is surrounded by 1-inch thorns, which at the time of collection were full of ants that provided additional protection for the nest.

Bullock's Oriole (*Icterus bullockii*), detail of nest

Collected in San Bernardino Co., California, in 1983 by L. Kiff. Many oriole species (family Icteridae) incorporate colorful materials into their basketlike nests, including brightly colored strings and ribbons, as well as plastic strands of Easter basket grass (shown here), plastic tarps, and plastic hay-baling rope.

Altamira Oriole (*Icterus gularis*), detail of nest shown on page 200
Collected in Morazán, in the Department of El Progreso, Guatemala, on May 6, 2001, by R. Corado. The nest is large: 470 × 180 mm. Note the colorful strands of plastic string, as well as vegetation, used in this nest.

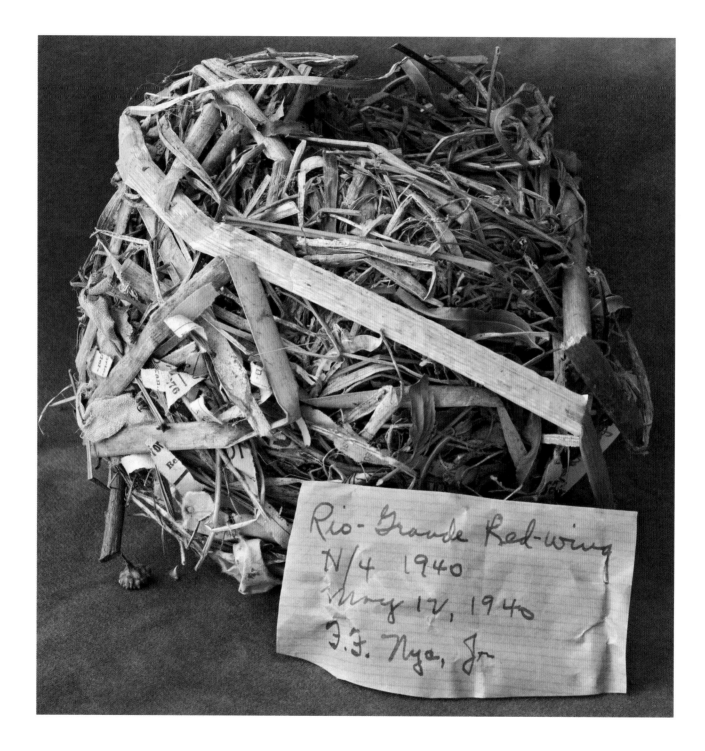

Five

BUILT BY BEAK AND CLAW

MANY BIRD SPECIES expend a significant amount of energy on the construction of their nests, particularly perching birds in the order Passeriformes. Some species, such as the true weavers (family Ploceidae), literally weave their nests, using complicated loops, knots, and "looming" techniques to give the structures shape and rigidity. Other species, such as orioles and blackbirds (family Icteridae), make nests that look woven but actually do not require such advanced techniques.

Red-winged Blackbird (*Agelaius phoeniceus*), nest with label
Collected south of Round Rock, in Travis Co., Texas,
on May 12, 1940, by F. F. Nyc, Jr. (See detail page 90.)

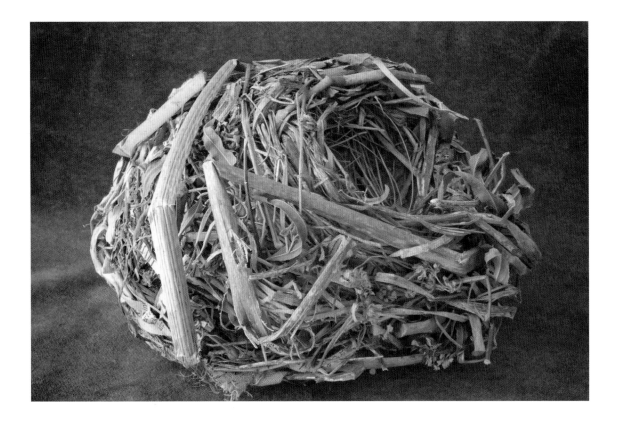

Red-winged Blackbird (*Agelaius phoeniceus*), nest
Collected south of Round Rock, in Travis Co.,
Texas, on May 12, 1940, by F. F. Nyc, Jr.

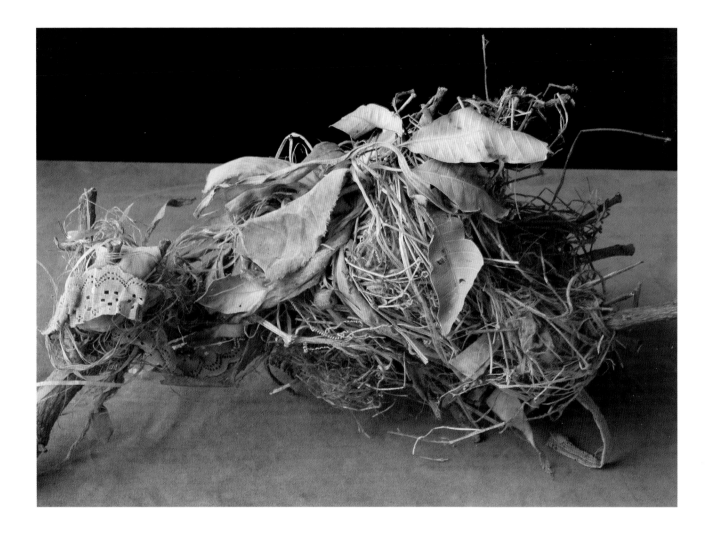

Great-tailed Grackle (*Quiscalus mexicanus*), nest with eyelet lace
Collected from Chinautla, Guatemala, on March 13, 2002,
by R. Corado. Nest is 33 × 22 mm. Note the pieces of fabric
and string incorporated into this nest. (See detail page 200.)

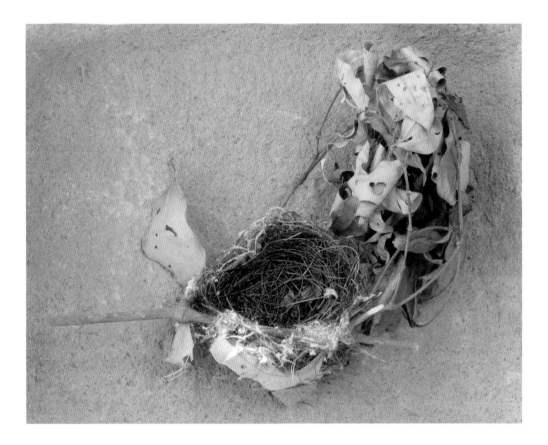

Long-tailed Manakin (*Chiroxiphia linearis*), nest

Collected from Cerro Baul, Oaxaca, Mexico, on May 14, 1967, by R. J. Galley.
The nest is 75 mm in diameter and is composed of black rhizomes attached
to the fork by horse hair. The outside is covered with dead leaves.

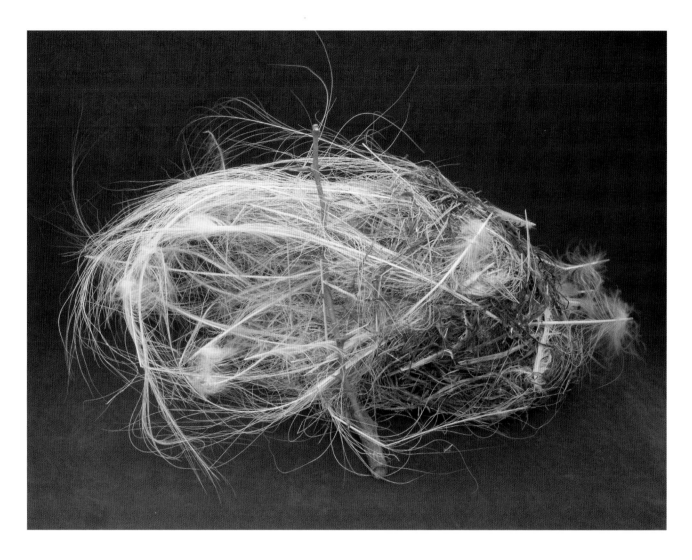

Social Flycatcher (*Myiozetetes similis*), nest
Collected from the Guayas Province, Ecuador, on March 23, 1991, by
L. F. Kiff and J. Ingels. The nest is 270 × 170 mm. It is dome-shaped with
a side entrance made of straw and moss; the inside is lined with fresh
grass heads. The flycatchers have incorporated Great Egret (*Ardea alba*)
plumes from a nearby egret colony into the nest. (See detail page 88.)

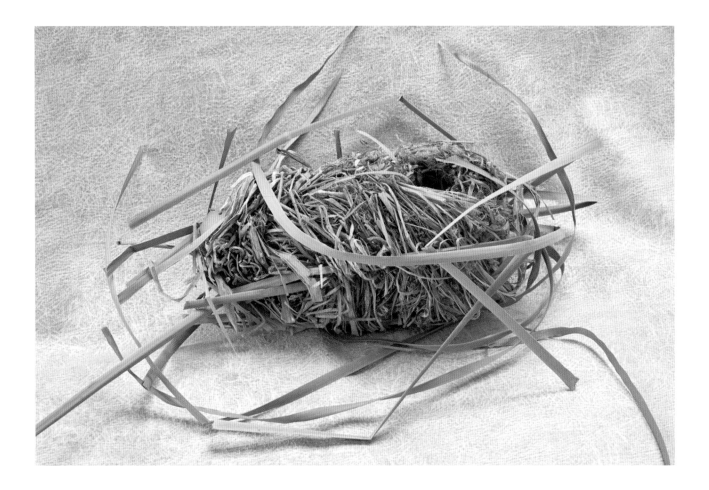

Marsh Wren (*Cistothorus palustris*), nest of tightly rolled grass

Collected from the Salton Sea, Imperial Co., California, on May 29, 1971, by R. Quigley and T. Hall. The nest is 16 × 12 mm. Composed of grass, sedge stems, and long leaves, the nest typically hangs upright, supported between two or more stems. It is lined with fine plant materials and sometimes feathers.

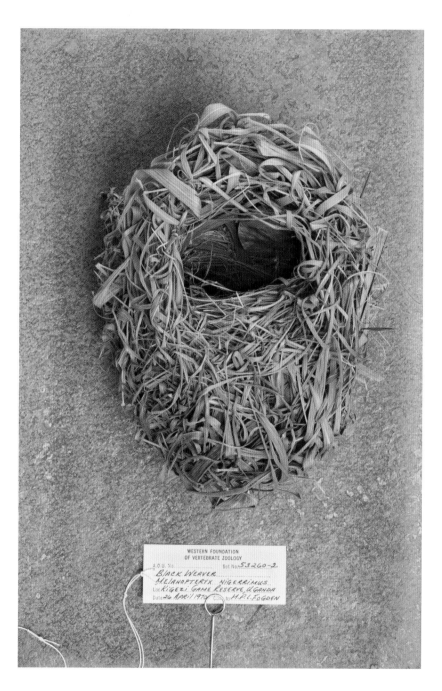

Vieillot's Weaver (*Ploceus nigerrimus*), nest
Collected from the Kigezi Game Reserve,
Uganda, on April 26, 1970, by M. P. L.
Fogden. The nest is 150 × 110 mm.

Common Tailorbird (*Orthotomus sutorius*), detail of nest

Collected from Songkhla, Thailand, on March 5, 1962, by J. H. Brandt.
Tailorbirds make "purse nests" by literally sewing the margins of green
leaves together with stitches made of spider silk, caterpillar silk, or plant
down. They use their bills as needles.

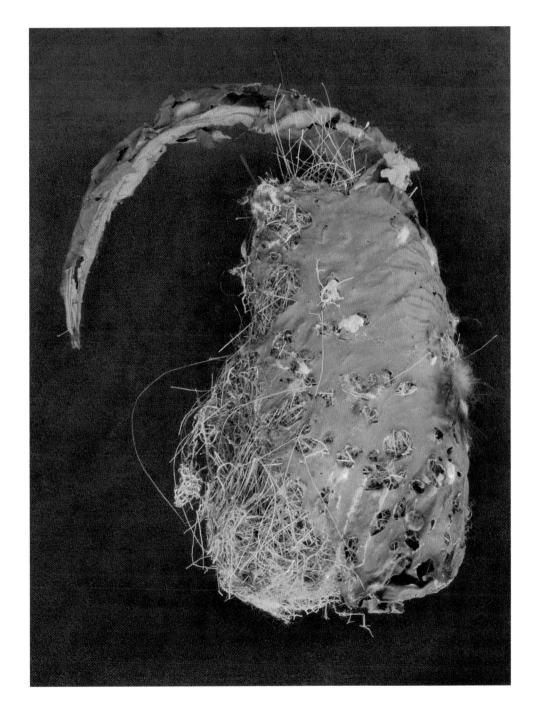

African Tailorbird (*Artisornis metopias*), nest
Collected from the Uluguru Mountains, Tanzania, on December 1, 1961, by G. Heinrich. This is another example of a sewn nest.

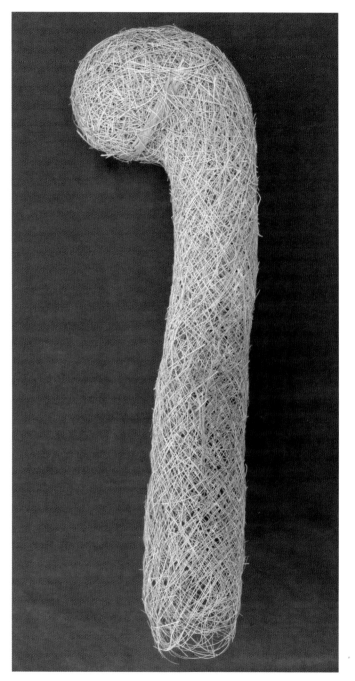

Black-throated Malimbe (*Malimbus cassini*), nest
Collected west of Kabunga, in the western Kivu
District, Belgian Congo, on June 12, 1957, by
N. E. Collias. This long nest is 650 × 130 mm. It
demonstrates the weaving prowess of some birds.
Nicholas Collias and his wife, Elsie, are well known
for their important observations of nest construc-
tion behavior by African weaverbirds. Many of their
ground-breaking insights into nesting behavior
came from their observations of captive weaver-
birds in aviaries at the University of California,
Los Angeles, as well as from their work in the
field. (See detail on facing page.)

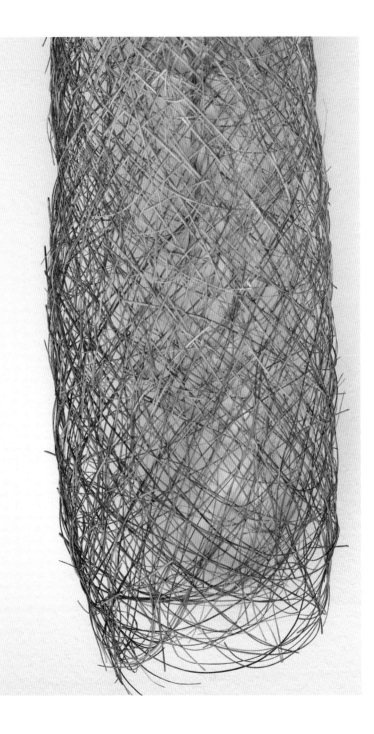

Black-throated Malimbe (*Malimbus cassini*), detail of nest on facing page

Collected west of Kabunga, in the western Kivu District, Belgian Congo, on June 12, 1957, by N. E. Collias. Note that the plant fibers are elaborately woven throughout this nest.

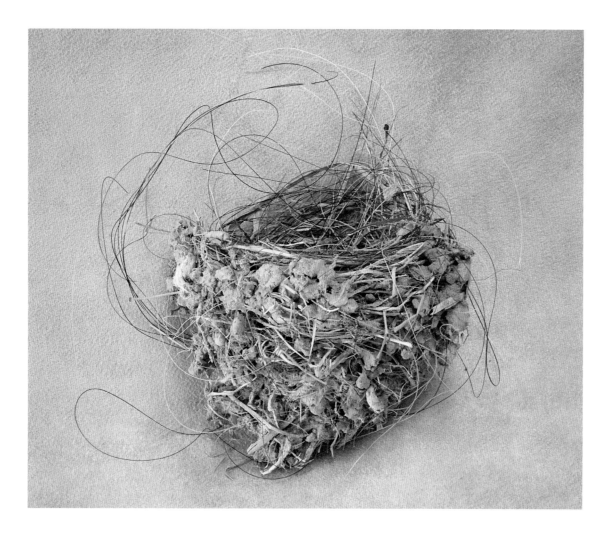

Black Phoebe (*Sayornis nigricans*), nest
Collected in Casitas Springs, Ventura Co., California, on April 22, 2003,
by L. S. Hall. The nest is 90 mm in diameter. The cup is composed of
horsehair with mud on the outside.

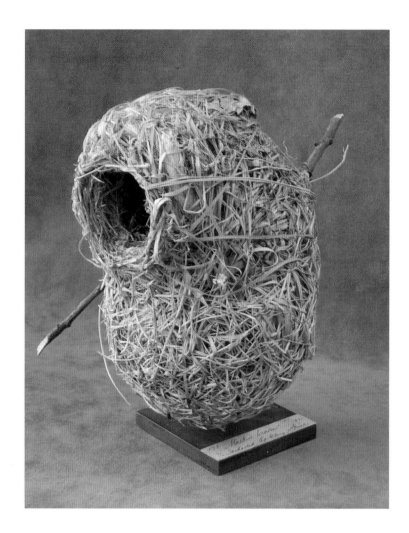

Lesser Masked Weaver (*Ploceus intermedius*), nest
Collected from the Eastern Cape of South Africa on
November 1, 1921, by an unknown collector. This nest is
180 × 130 mm. It is composed of stiff dry grass and stems.
Note that the entrance points downward when the nest is
hanging in the field.

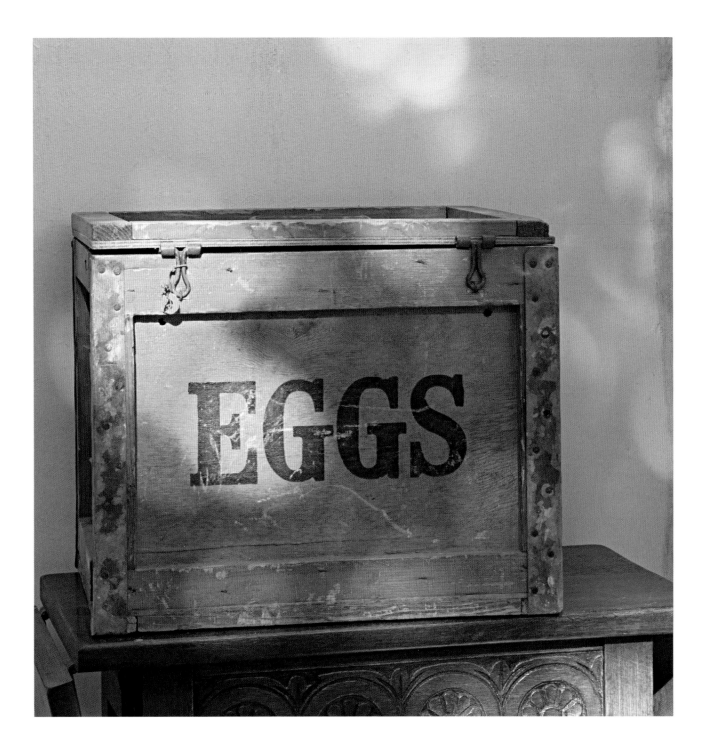

Six

OF SIZE AND SHAPE

BIRD EGGS COME IN A VARIETY of sizes, from the tiny hummingbird egg to the enormous egg of the extinct Elephant Bird. Shapes also vary, from the typical oval of a chicken egg, to the almost round egg of the owl, to the pointed egg of the Common Murre. Egg size and shape are genetically controlled, and both are constrained by the overall size of the bird, the shape of the pelvis, and the impacts of the environment on successful hatching over time.

An egg-collecting box used by Donald Bleitz, creator of Bleitz Wildlife Foundation, which merged with the Western Foundation in the early 1990s.

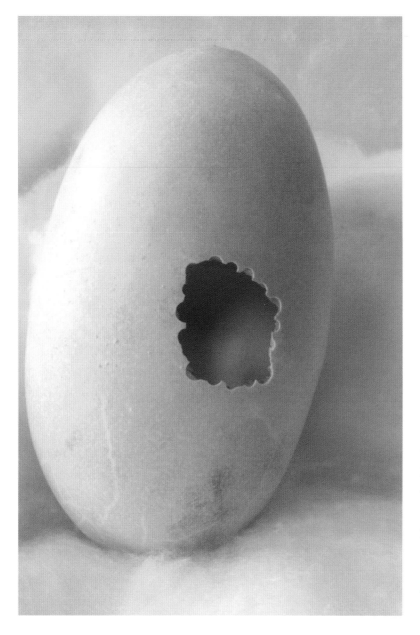

Chicken (*Gallus domesticus*),
egg inside egg

Deformities in eggs can occur for several reasons. Surface irregularities may indicate the presence of disease, genetic defects, or harmful substances such as chemicals in the diet. In this case, concentric shells ("egg within an egg") indicate that the passage of the first egg was interrupted as it moved down the oviduct, causing a second layer of shell to be deposited on top of it (Burley and Vadehra 1989: 22–23).

Chicken (*Gallus domesticus*), deformed egg

The wrinkled surface of this deformed egg may indicate a copper deficiency or an infection in the female; sealed cracks in the shell may indicate that it was broken in the female's uterus but repaired before laying (Burley and Vadehra 1989: 22–23).

Resplendent Quetzal (*Pharomachrus mocinno*), eggs

Collected from Oaxaca, Mexico, on April 12, 1964, by W. Rook. Eggs average 36 × 30 mm. All species in family Trogonidae are cavity-nesting birds, which mostly lay white eggs. The quetzals are exceptions, as are the Hispaniolan Trogon (*Temnotrogon roseigaster*) and the Slaty-tailed Trogon (*Trogon massena*), which lay blue eggs (Johnsgard 2000). The protection afforded by cavities presumably has made camouflage coloration unnecessary for most trogons and for other cavity-nesting bird species. The whiteness of the eggs may also make them more visible to incubating parents in the relative darkness of a cavity.

Long-eared Owl (*Asio otus*), eggs
Collected near Encinitas, San Diego Co.,
California, on March 26, 1940, by E. N. Harrison.
Eggs are 41 x 33 mm.

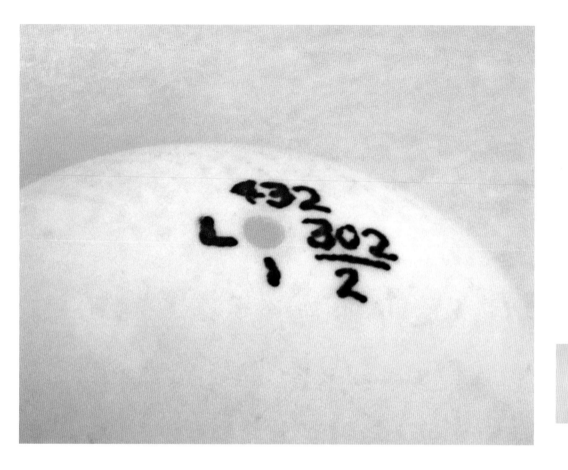

Broad-tailed Hummingbird (*Selasphorus platycercus*), eggs

Collected from Miller Canyon, Huachuca Mountains, Arizona, on May 30, 1973, by R. Quigley and L. F. Kiff. Eggs average 13 × 9 mm (about the size of a tic tac candy!).

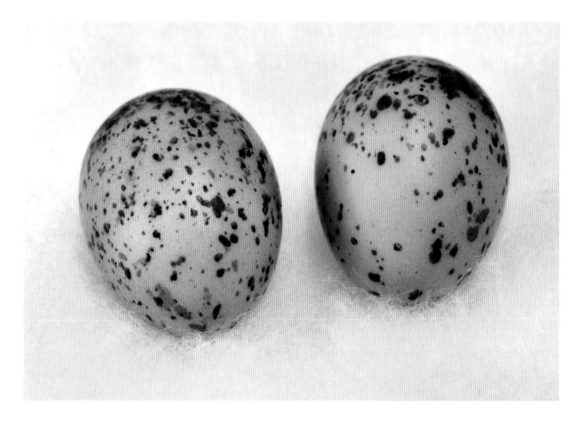

Long-tailed Manakin (*Chiroxiphia linearis*), brown-speckled eggs
Collected from Rancho Sol y Luna, Oaxaca, Mexico, on May 19, 1966, by
J. S. Rowley. Eggs average 23 × 16 mm. John Stuart Rowley was born in
1907 in Oakland, California, and became interested in ornithology at a
young age. In the 1950s, John and his wife, Estelle, conducted many bird-
collecting trips to Mexico, sponsored by the American Museum of Natural
History, the California Academy of Sciences, and the Western Foundation
of Vertebrate Zoology.

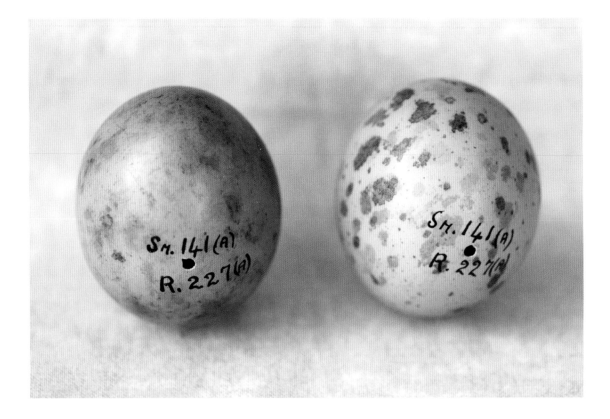

Black-bellied Bustard (*Lissotis melanogaster*), brown-speckled eggs

Collected from Wankie National Park, Zimbabwe, on November 17, 1963, by W. R. Thomson. Eggs average 55 × 47 mm. Note the roundness of these eggs; in general, bustards and owls tend to have the roundest eggs of any bird species in the world.

(top) Common Potoo
(*Nyctibius jamaicensis*), egg
Collected in Morazán,
Department of El Progreso,
Guatemala, on April 9, 2002,
by R. Corado.
(bottom) Lesser Nighthawk
(*Chordeiles acutipennis*), egg
Collected from Somerset,
Bexar Co., Texas, on May 15,
1930, by A. J. B. Kim.
Both birds are in the same
family but lay eggs with very
different markings (discussed
in more detail on page 150).

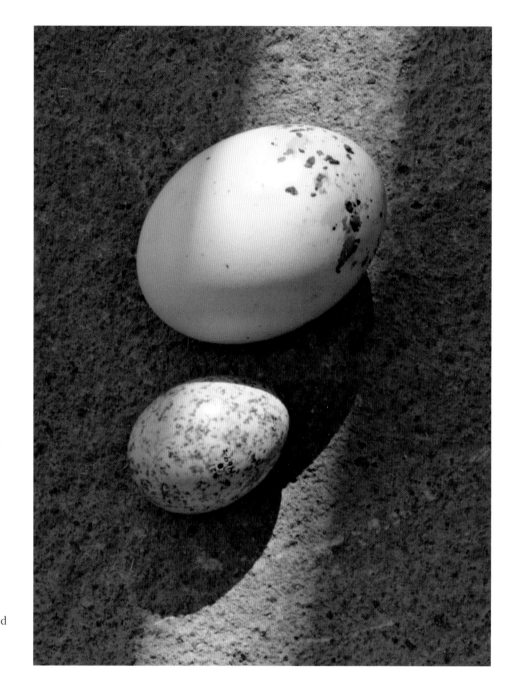

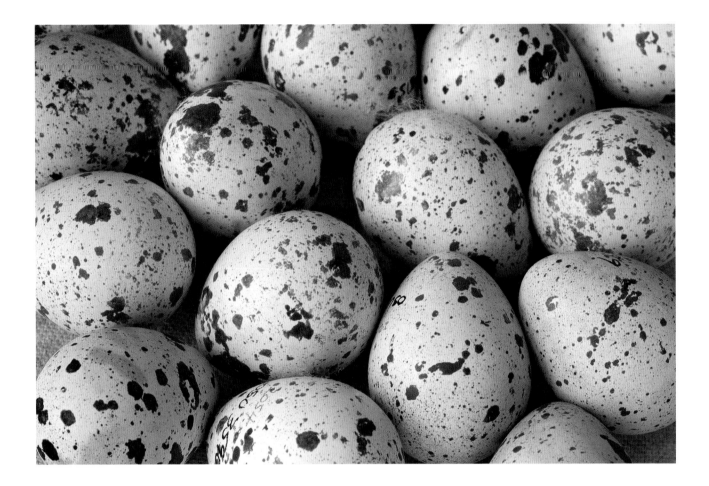

California Quail (*Callipepla californica*), eggs

Detail of California Quail eggs in a single set. Eggs average 31 x 24 mm. Quails
and pheasants lay many eggs in a single clutch, and the young are precocial,
meaning that they hatch "ready to run." Compared with non-precocial species
of the same size, these birds also tend to lay bigger eggs that contain more yolk.
The eggs even take a bit longer to hatch, allowing the embryos more time to
develop before they emerge.

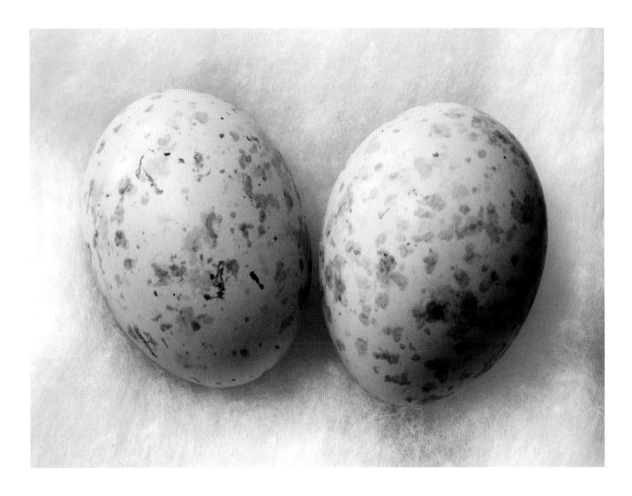

Common Pauraque (*Nyctidromus albicollis*), eggs
Collected from Helechales, Puntarenas Province, Costa Rica,
on April 6, 1972, by E. Fiala. Eggs average 30 × 22 mm.

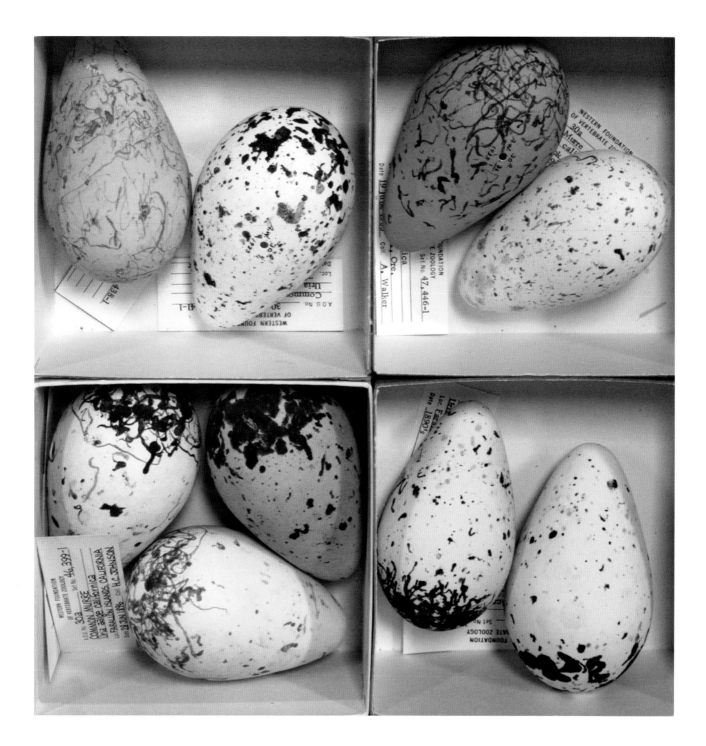

Seven

NATURE'S CALLIGRAPHY

MANY OF THE EGGS in the collections of the Western Foundation boast elaborate markings. The lines and dots are not actually inscribed onto the eggs; rather, they are caused by pigments secreted by the female bird's body before she lays an egg. The markings resemble calligraphic art and beg a search for patterns and meaning in the scrawl.

Common Murre (*Uria aalge*), eggs in boxes

Common Murres nest on cliff ledges and in breeding colonies that can contain tens of thousands of eggs. In this case, distinct, individualized markings and egg colors help adult murres recognize their own eggs among a sea of others. The pyriform shape helps prevent the eggs from rolling off cliff edges.

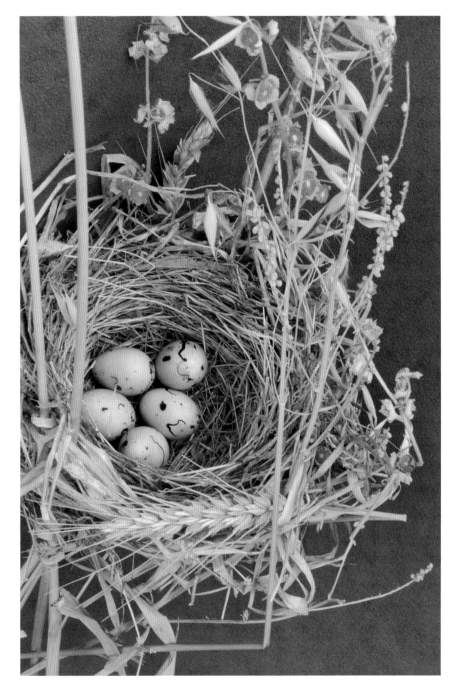

Red-winged Blackbird (*Agelaius phoeniceus*), eggs in nest

Collected at Buena Vista Lake, Kern Co., California, on May 14, 1969, by L. F. Kiff. Eggs are 25 × 18 mm; nest is 120 × 120 mm. This semi-colonial species of blackbird usually breeds in marshes, swamps, or next to slow-moving streams. The nest has a deep cup and is made of long leaves and stems of grasses and other plants. It is lined with fine plant material.

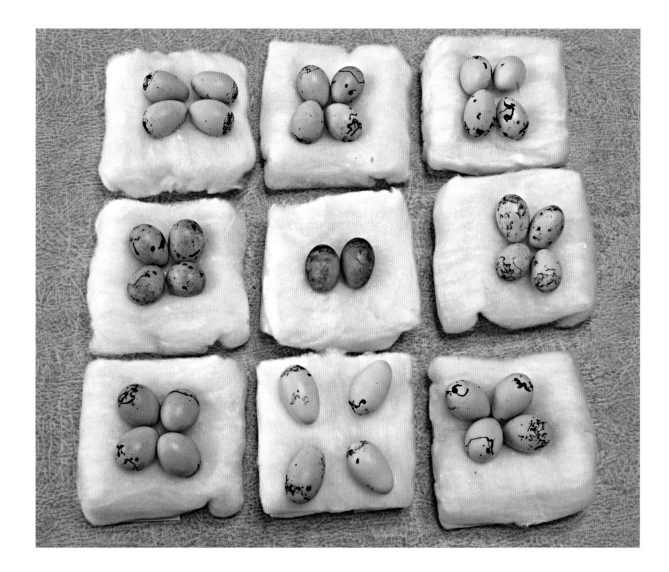

Red-winged Blackbird (*Agelaius phoeniceus*), egg sets

Only birds lay eggs with colored shells. Egg color can vary dramatically within bird families, genera, and species. This photograph is an example of variation among eggs within a species—note the wide range of background colors and markings. Color is put on the eggs in the oviduct of the female bird; the "ground" color pigment is deposited first as the shell forms. The markings are added later to the cuticle that covers the eggshell.

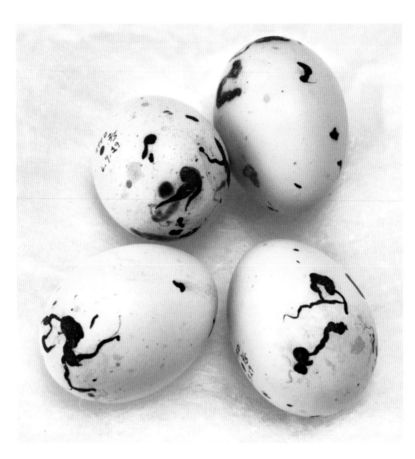

Red-winged Blackbird (*Agelaius phoeniceus*), eggs

Collected in Marion Co., Illinois, on May 14, 1945, by B. W. Knoblock. The shape, size, and background color of eggs are genetically determined, as, to a certain extent, are the surface markings. Among some species, however, markings can vary from bird to bird, location to location, and day to day. For example, the first egg laid in a clutch is usually darker than the last egg, presumably because the female has more pigments available when she begins laying. In addition, older females apparently lay lighter-colored eggs than do younger females. In areas where calcium is not plentiful, the eggs of some species are intensely speckled, which may make the eggs less brittle (Gosler et al. 2005).

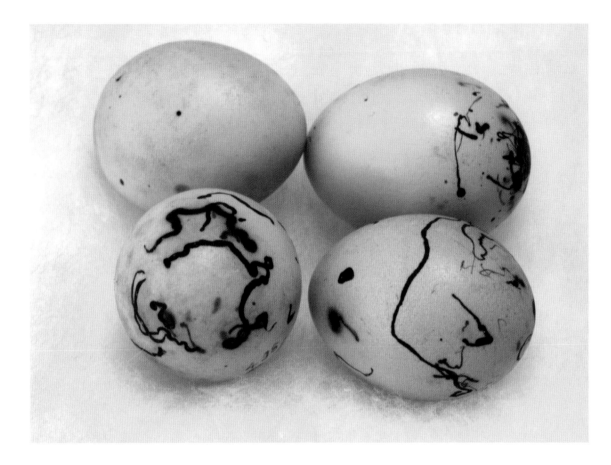

Red-winged Blackbird (*Agelaius phoeniceus*), eggs

Collected in Santa Margarita, San Diego Co., California, on May 13, 1956, by F. Truesdale. Fred "Kelly" Truesdale was a farmhand and cowboy from central California renowned for his collecting of California Condor (*Gymnogyps californianus*) eggs. Kelly sold the eggs for approximately $350 in 1904—that's about $7,500 in today's dollars (Henderson 2007: 33). He was so well known for his egg-collecting prowess that he was welcomed "with fanfare" into England's prestigious Oologists Exchange Club in 1932 (Kiff 1989).

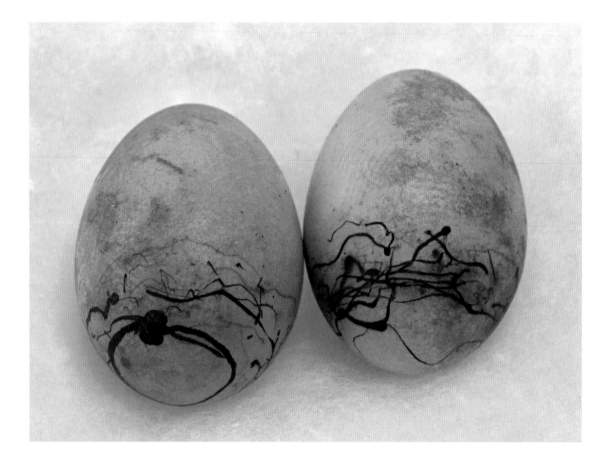

Red-winged Blackbird (*Agelaius phoeniceus*), gray eggs with markings

(No collecting data available.)

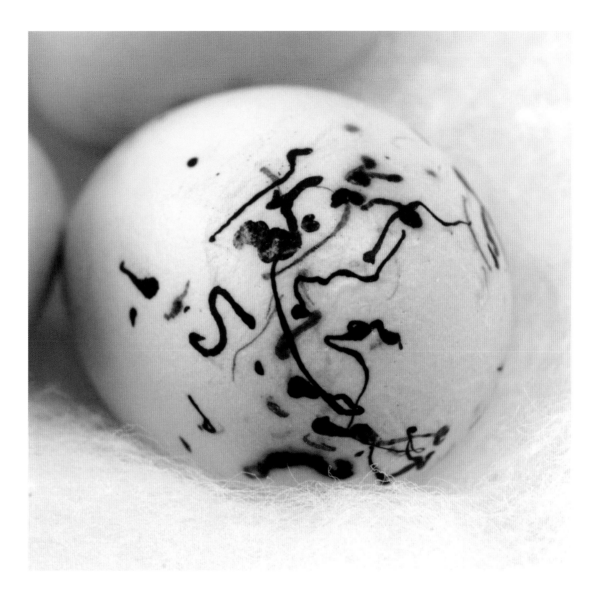

Red-winged Blackbird (*Agelaius phoeniceus*), close-up of egg

(No collecting data available.)

Red-winged Blackbird (*Agelaius phoeniceus*), close-up of egg

(No collecting data available.)

Red-winged Blackbird (*Agelaius phoeniceus*), eggs
Collected in Tulsa, Tulsa Co., Oklahoma,
on May 21, 1924, by G. W. Morse.

Tawny-flanked Prinia (*Prinia subflava*), eggs

Collected in Gonda Oupe, India, on August 10, 1918. From the collection of
G. Stewart. Eggs are 16 × 11 mm. These four eggs show the variation that is
possible within a clutch of an individual bird. Birds in the genus *Prinia* have
highly variable eggs, both within and among species. (See detail on facing page.)

Tawny-flanked Prinia (*Prinia subflava*),
detail of eggs on facing page

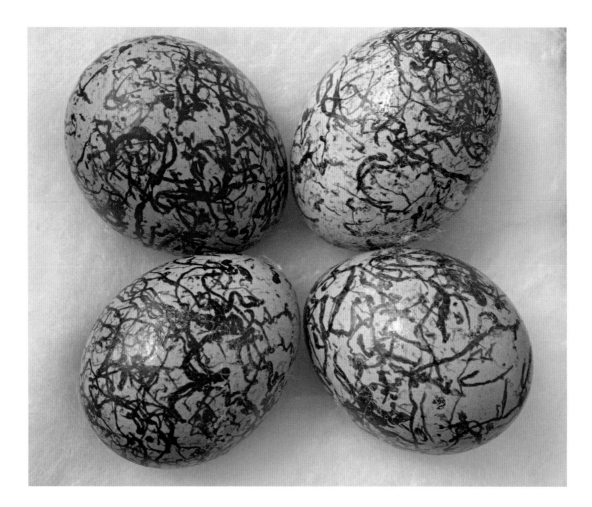

Northern Jacana (*Jacana spinosa*), eggs

Collected in Tamaulipas, Mexico, on June 26, 1896, by A. C. Licia. Eggs are 30 × 23 mm. The markings on these eggs serve as camouflage. Note the glossiness of the eggs as well. Lines on an egg are created as it turns in the uterus of the oviduct; spots are created when it stops turning. Northern Jacanas frequent freshwater marshes with floating or emergent plants, and they nest on a thick pad of floating vegetation.

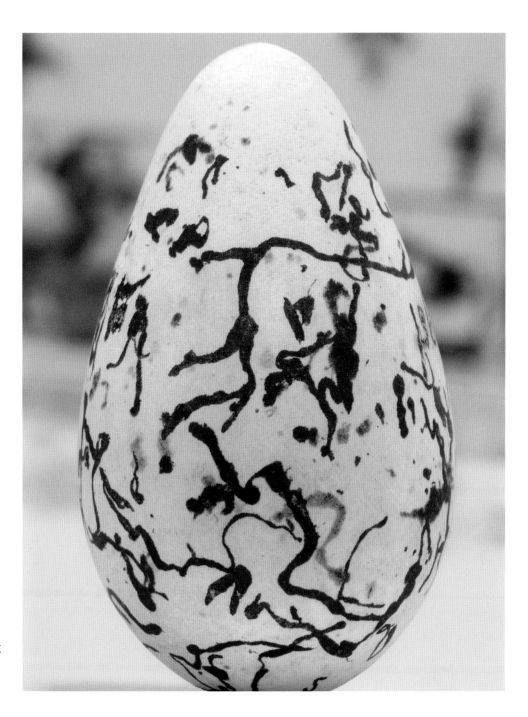

Common Murre
(*Uria aalge*), egg
Egg is 81 × 50 mm.
The eggs of the Common
Murre vary greatly among
individuals.

Eight

COLOR AND CAMOUFLAGE

BIRD EGGS DISPLAY remarkable differences in coloration, from white to completely pigmented. Pigments may be dark (browns and blacks) or light (pastels and blue-greens). They help camouflage eggs and make them more durable; they can even moderate temperatures within the shell by reflecting infrared wavelengths. In some species, pigment differences also help incubating birds recognize their own eggs. The two main eggshell pigments, protoporphyrin and bilverdin, are secreted onto the egg in the "shell gland" of the female bird's oviduct.

Guira Cuckoo (*Guira guira*), detail of egg shown on page 144

Collected in Dores do Indaia, Brazil, on September 17, 1935, by C. G. Chagas.

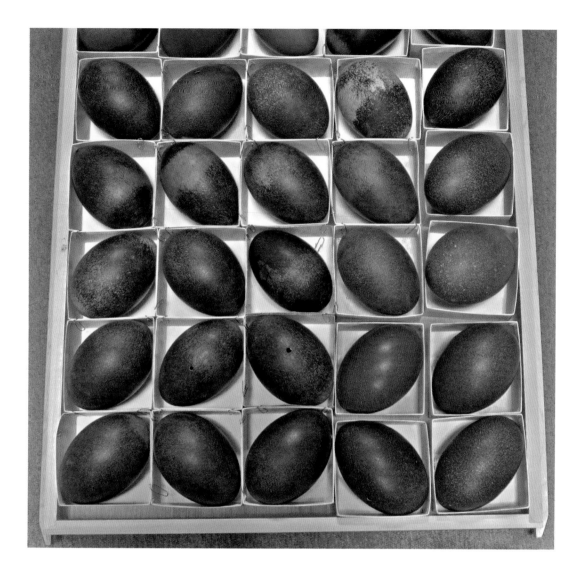

Emu (*Dromaius novaehollandiae*), tray with eggs

These eggs show variation in colors and textures that may appear even within a single clutch. Wild male Emus incubate mixed clutches of eggs from several females, hence the large number of eggs in a single nest. The eggs shown here are predominantly from one clutch that was collected on March 12, 1997, from captive birds in Camarillo, California, by L. Eichner.

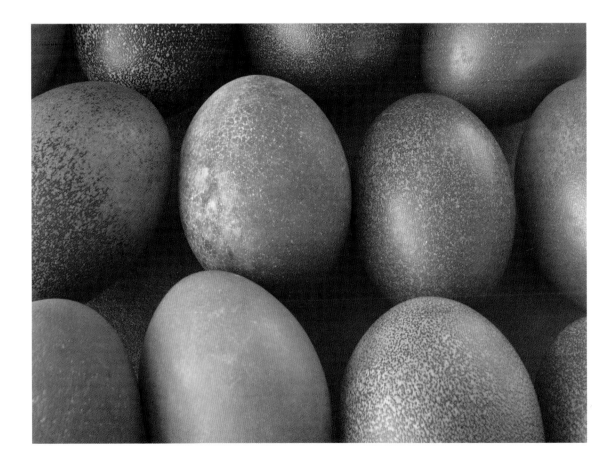

Emu (*Dromaius novaehollandiae*), close-up of eggs
Note the variety of color and texture within
this single clutch.

Tinamou eggs, top to bottom: Great Tinamou (*Tinamous major*); Red-winged
Tinamou (*Rhynchotus rufescens*); Elegant Crested Tinamou (*Eudromias elegans*);
and Andean Tinamou (*Northoprocta pentlandii*)

Eggs are 53–62 × 36–46 mm. Tinamous (family Tinamidae) are chicken-like
birds that range from Mexico to Argentina. Their eggs are the glossiest in the
bird world, and Great Tinamou eggs are considered the brightest blue of all
birds' eggs (Gill 2007: 420). The color of the eggs helps the birds to conceal them
in the diverse environments where tinamous live, including tropical rainforests,
savannahs, grasslands, and alpine tundra.

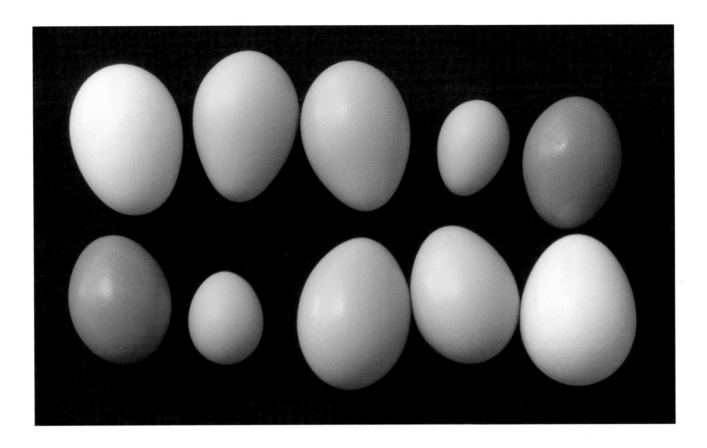

Blue eggs, top row, left to right, and bottom row, right to left: European Starling (*Sturnus vulgaris*); Crissal Thrasher (*Toxostoma crissale*); American Robin (*Turdus migratorius*); Dunnock (*Prunella modularis*); and Gray Catbird (*Dumetella carolinensis*)

Although the bird species whose eggs are shown are not in the same families, the eggs exhibit some of the variation found among blue-colored eggs. Some studies have linked the intensity of the blue-green color of the eggs to improved female health (Moreno et al. 2006). Others, however, have also linked it in some cases to increased levels of the chemical DDE (Jagannath et al. 2007).

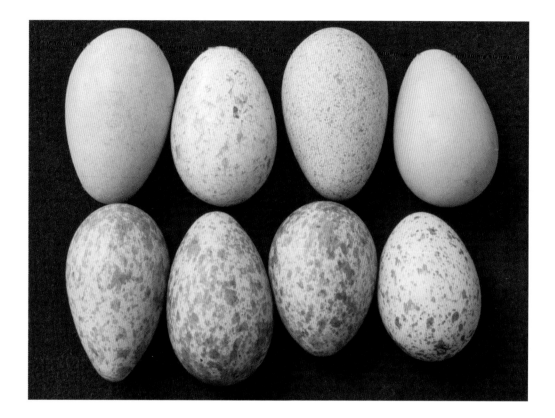

American Crow (*Corvus brachyrhynchos*), eggs

The pink eggs in the top row were collected in Green Co., Pennsylvania, on May 1, 1934, by J. W. Jacobs. The bluish eggs (bottom row), more typical for this species, were collected in McMinn Co., Tennessee, on April 22, 1901, by W. R. Gettys. Egg collectors commonly searched for unique egg sets, with the consequence that atypical eggs are often overrepresented in collections compared with their frequency in the wild. This pink set of crow eggs is one such example; another is the prevalence of very small, non-viable "runt" eggs in collections.

American Crow (*Corvus brachyrhynchos*), close-up of egg

Eggs average 41 × 29 mm.

Guira Cuckoo (*Guira guira*), eggs

Collected in Dores do Indaia, Brazil, on September 17, 1935, by C. G. Chagas.
Species in orders Pelicaniformes (pelicans, boobies, cormorants) and
Podicipediformes (grebes), as well as some species in Cuculiformes
(cuckoos and anis), lay eggs that have an extra, protective layer of calcium
carbonate on top of the cuticle, referred to as a "cover." In the eggs of this
Guira Cuckoo, the cover appears as a beautiful white lacy coating over the
blue egg. (See detail on page 136.)

Brown Booby (*Sula leucogaster*), eggs

Collected on George Island, Sonora, Mexico, on March 15, 1926, by G. Bancroft. Note that the white color has worn off these eggs, exposing the light-blue ground color underneath. Researchers have determined that the cover of eggs can be adversely affected by the use of some insecticides. For birds that nest near the water, this may mean eggs that are more susceptible to water damage.

Banded Wren (*Thryothorus pleurostictus*), white and blue eggs

Blue eggs: Collected in Oaxaca, Mexico, on July 6, 1961, by W. Rook. White eggs: Collected in Hacienda Palo Verde, Guanacaste Province, Costa Rica, on May 18, 1985, by F. G. Stiles. The eggs average 20 × 14 mm. Among perching birds (passerines), the occurrence of both blue and white eggs in a species is uncommon but not unheard of, as in this *Thryothorus* genus of Central and South American wrens.

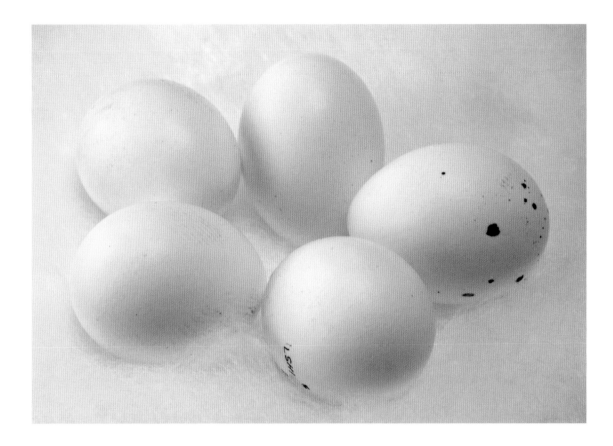

Black Phoebe (*Sayornis nigricans*), white eggs

Collected in Casitas Springs, Ventura Co., California, on April 22, 2003, by L. S. Hall. Eggs are 19 × 14 mm. Flycatchers like the Black Phoebe have highly variable egg colors, ranging from completely white to brown-streaked.

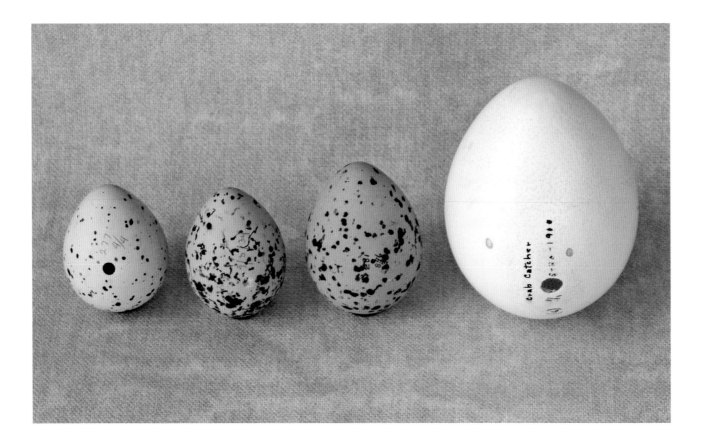

Plover eggs, from left: Piping (*Charadrius melodius*); Snowy (*Charadrius alexandrinus*); Mountain (*Charadrius montanus*); and Crab (*Dromas ardeola*)

The Crab Plover, which is in its own family (Dromadidae), occurs along the coasts of the Indian Ocean. It is the only plover with a white egg and the only wader that nests in burrows (Rands 1996). The other three plovers are in the same family (Charadriidae), produce similarly patterned eggs, and nest in simple scrapes in the sand (Snowy and Piping) or on bare ground with minimal materials (Mountain). Piping, Snowy, and Mountain Plovers have all declined in the United States over the past century; Snowy and Piping Plovers are now federally protected within the United States.

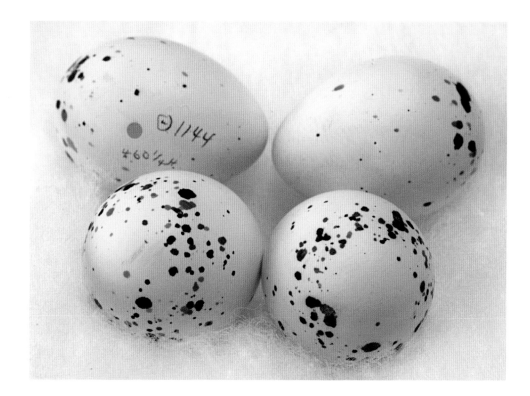

Greater Pewee (*Contopus pertinax*), eggs

Collected in the Chiracahua Mountains, Arizona, on June 6, 1900, by O. W. Howard. Eggs are 21 × 16 mm. These specimens are another example of the variability in flycatcher eggs; they differ significantly from those of other flycatchers, such as the Black Phoebe. Note the collector's "setmark" here, a circle with a long dot inside. Setmarks, which are placed on eggs (as well as on the data cards) to show who has collected them, are unique to each collector. They are as variable as the eggs they mark.

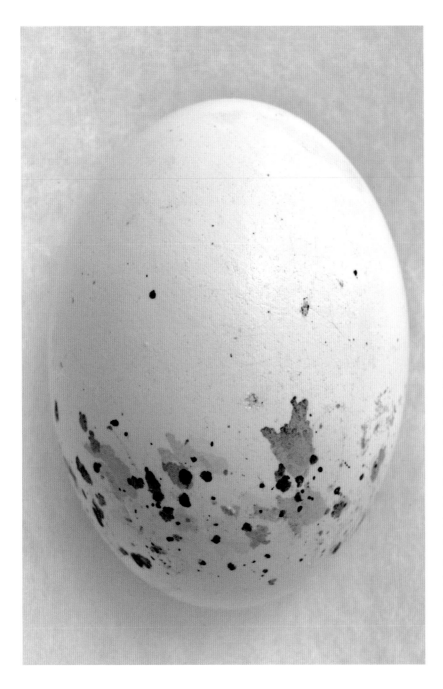

Common Potoo (*Nyctibius jamaicensis*), egg
Collected from Los Tablones, Department of El Progreso, Guatemala, on April 9, 2002, by R. Corado. Egg is 42 × 31 mm. Chuck-Will's-Widow, Common Nighthawk, and Whip-Poor-Will (shown on the following pages) lay their two eggs on bare ground, sometimes on leaves or pine needles, among rocks, on stumps, or on flat roofs. The Common Potoo, by contrast, lays its single egg precariously on a flattened branch or on the tip of a branch, high above the ground. The Potoo egg shown here was found about 10 m (30 feet) above the ground in a difficult-to-reach area. The find confirmed that the species was breeding at an elevation heretofore unrecognized as part of the Potoo's range in Guatemala.

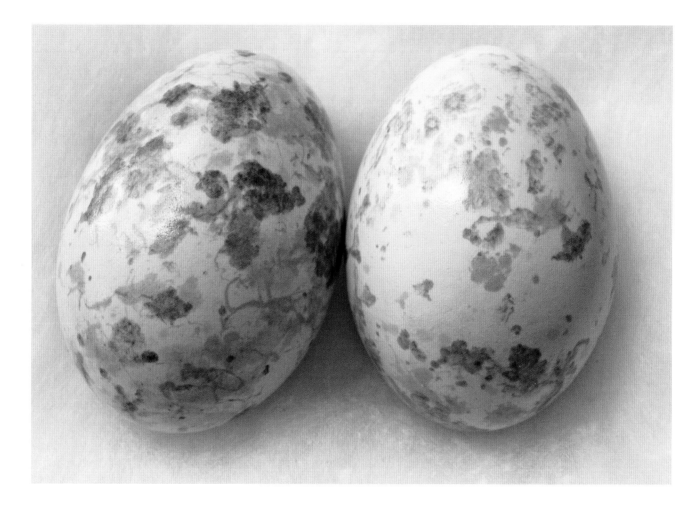

Chuck-Will's-Widow (*Caprimulgus carolinensis*), eggs
Eggs collected in Lee Co., Florida, on May 24, 1916,
by J. B. Ellis. Eggs average 36 × 26 mm.

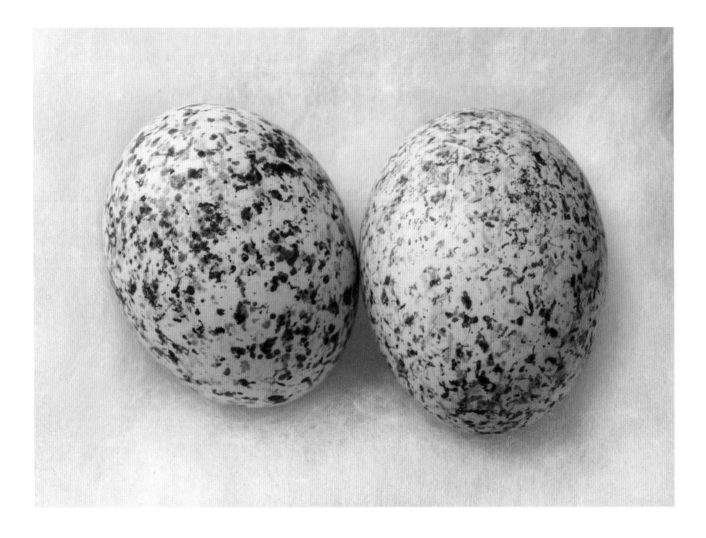

Common Nighthawk (*Chordeiles minor*), eggs

Collected three miles southwest of Sand Lake, Oregon, on June 27, 1951,

by W. M. Batterson. Eggs average 30 × 22 mm.

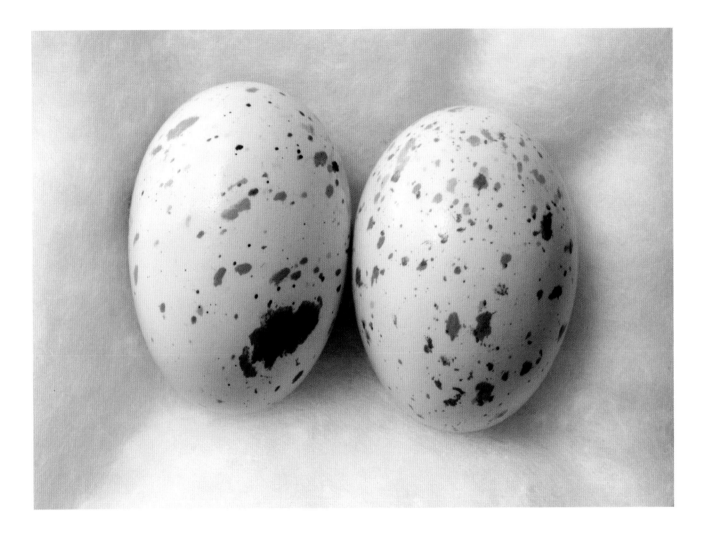

Whip-Poor-Will (*Caprimulgus vociferus*), eggs
Collected from Orange, New Haven Co., Connecticut, on
June 10, 1898, by H. W. Flint. Eggs average 29 × 21 mm.

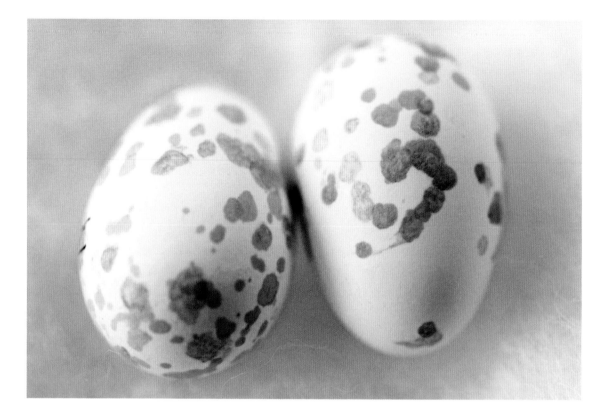

White-chinned Prinia (*Schistolais leucopogon*), eggs

Collected near Yaounde, Cameroon, on June 16, 1957, by J. C. Voisin. Eggs average 19 × 13 mm. Eggs of birds in genus *Prinia* (which are a kind of Old World warbler) are among the most variable within and among species. (See detail on facing page.)

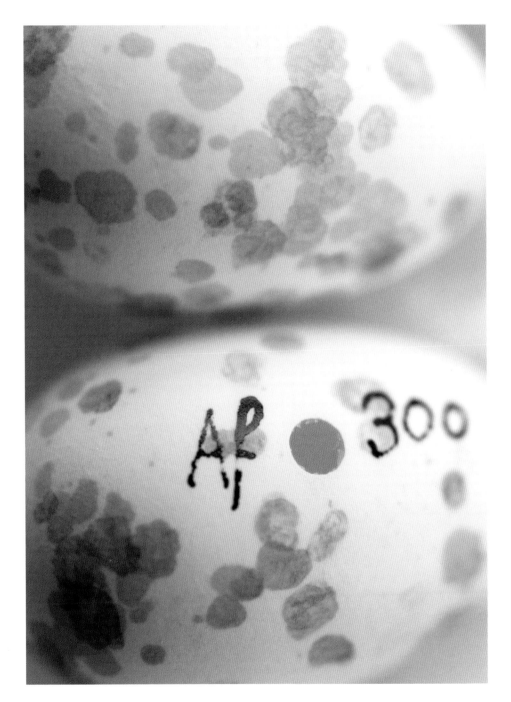

White-chinned Prinia (*Schistolais leucopogon*), detail of eggs on facing page

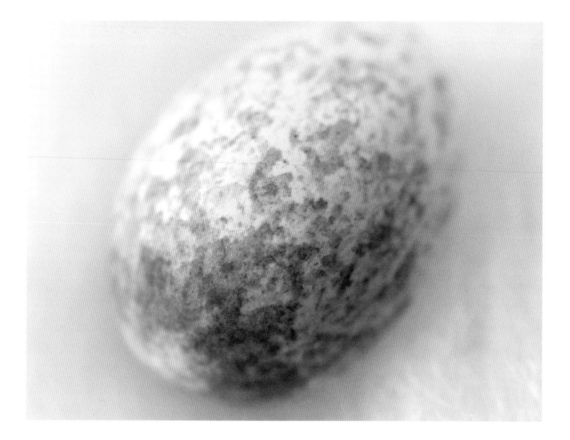

Hill Prinia (*Prinia atrogularis*), egg

Collected at an elevation of 1,515 m (5,000 feet) in the Khasia Hills of India on May 29, 1913, for C. H. Gowland. Egg is 18 × 13 mm. Prinias are known for the high color variability of their eggs, or "color polymorphism." One theory is that the markings help protect the birds from parasitism by their own kind, since females are known to lay their eggs in multiple nests (Kiff 1991).

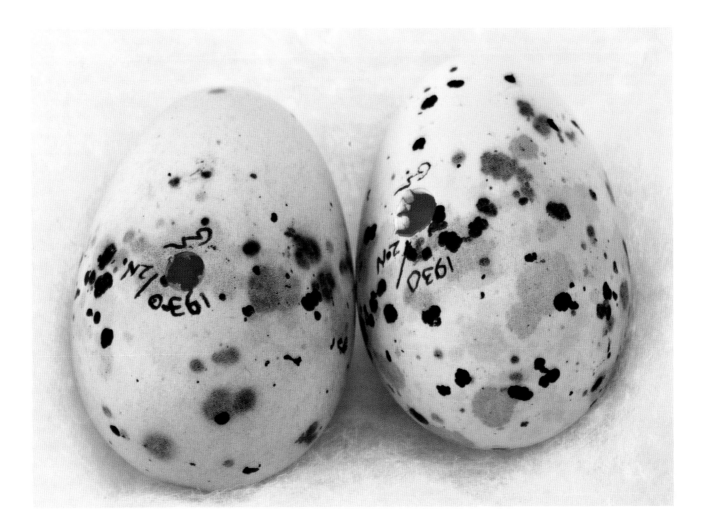

Long-tailed Silky Flycatcher (*Ptilogonys caudatus*), eggs
Collected near Villa Mills, Cartago, Costa Rica, on
March 27, 1983, by F. G. Stiles. Eggs average 26 × 17 mm.

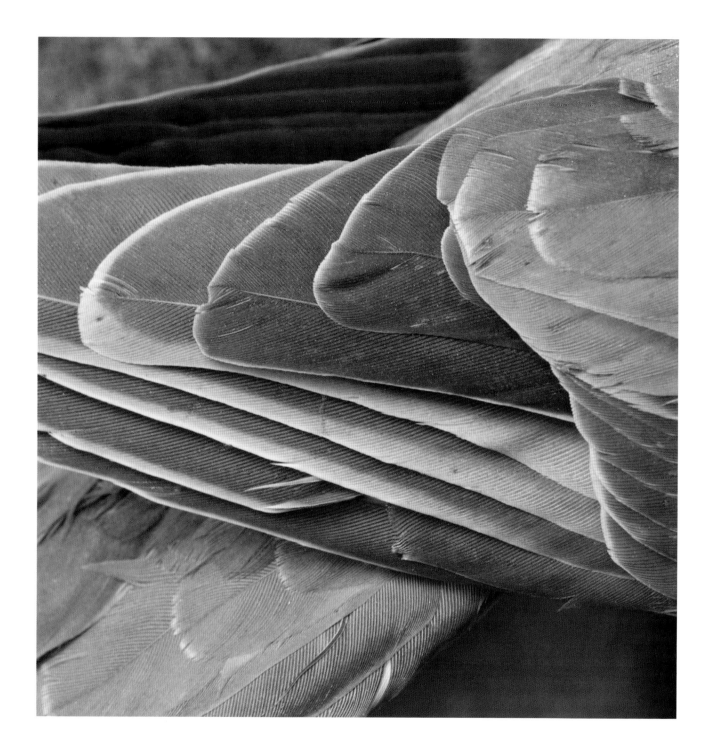

Nine

GHOSTS OF A FEATHER

THE SPECIES IN THIS section were not able to cope with the impact of humans on their habitats and are now (by all appearances) extinct. At least 131 bird species have become extinct since the year 1600, all as a result of human activity (Gill 2007: 636).

Passenger Pigeon (*Ectopistes migratorius*), detail of bird shown on page 160

Collected in Merchantville, Camden Co., New Jersey, on April 16, 1876, by R. Smith.

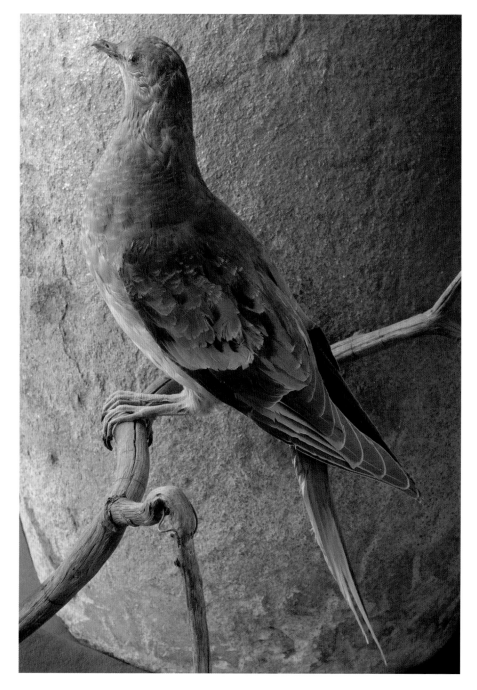

Passenger Pigeon
(*Ectopistes migratorius*)
Collected in Merchantville, Camden Co., New Jersey, on April 16, 1876, by R. Smith. Extreme hunting pressure and the rapid clearing of eastern U.S. forests to make way for agriculture and housing caused the extinction of this species between the mid-1800s and the early 1900s. The last nesting birds in the wild were reported in the Great Lakes region in the 1890s. The last Passenger Pigeon, named Martha, died at the Cincinnati Zoo on September 1, 1914. Although possibly the most numerous bird on the planet at the time the pilgrims settled on the eastern shores of America, the Passenger Pigeon became extinct as a result of human overuse and destruction of its habitat within the relative blink of an eye—a sobering lesson about our precious wildlife resources. (See detail page 158.)

Passenger Pigeon (*Ectopistes migratorius*), egg
Collected from Sparta, Monroe Co., Wisconsin, on
May 15, 1881, by M. Bertting. Egg is 38 × 27 mm.

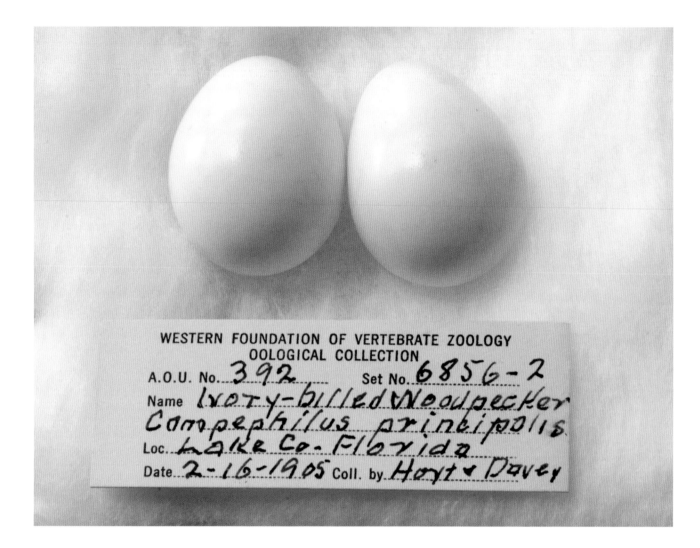

Ivory-billed Woodpecker (*Campephilus principalis*), eggs

Collected in Lake Co., Florida, on February 16, 1905,

by R. D. Hoyt and J. R. Davey. Eggs average 35 × 25 mm.

Ivory-billed and Imperial Woodpeckers
(*Campephilus principalis,*
Campephilus imperialis)

Ivory-billed specimens (left and middle, male and female, respectively) and Imperial Woodpecker specimen (right). The Ivory-bill has been considered extinct in the United States and Cuba as a result of degradation of forested habitat, or possibly shooting (Snyder 2007). Surveys to determine if individuals still survive in the southeastern United States are currently being conducted, and some evidence exists that a few individuals may survive in Louisiana, Florida, and Cuba. Sightings of the Imperial Woodpecker have not been recorded since 1956. Habitat alteration and hunting have most likely driven the species to extinction. Ornithologists are still searching potential habitats in Mexico for the Imperial Woodpecker, but chances are slim that a population of the birds will ever be found (Winkler and Christie 2002).

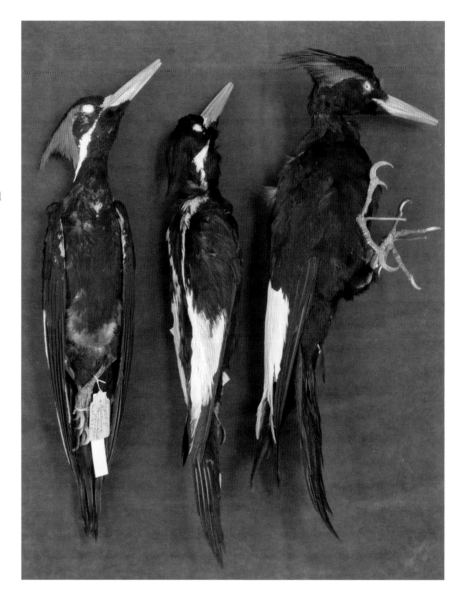

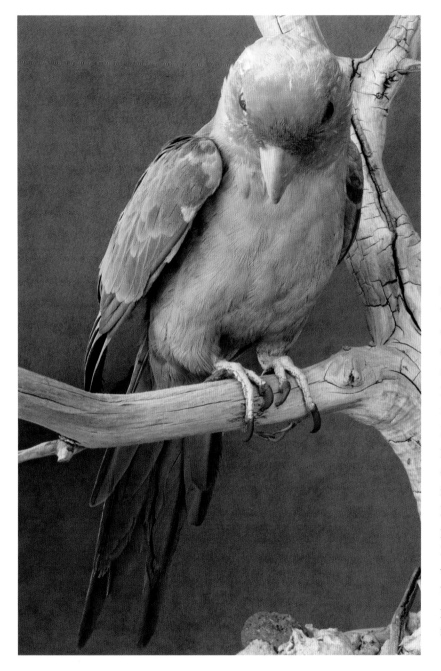

Carolina Parakeet (*Conuropsis carolinensis*)

The reasons for the decline and eventual extinction of the Carolina Parakeet in the early 1900s in the United States are not as clear as for the extinctions of the Passenger Pigeon and the Heath Hen (see pages 160 and 168). Perhaps the Parakeet's decline was due to outright persecution by humans as well as to diseases transmitted by domesticated fowl or other animals associated with human habitation (Snyder 2004). This parrot species and the Thick-billed Parrot (*Rhynchopsitta pachyrhyncha*), which is also essentially extinct in the United States, were most likely the only parrot species ever to have occurred naturally in the United States.

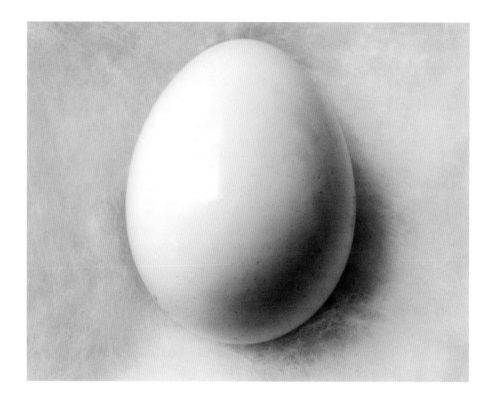

Carolina Parakeet (*Conuropsis carolinensis*), egg

Collected in the 1890s. This egg of a captive Carolina Parakeet
is from the collection of Colonel Cherry. Egg is 34 × 28 mm.

Elephant Bird (*Aepyornis* sp.), eggs

Collected in Madagascar. The Elephant Bird, which stood nearly 4.2 m (14 feet) tall, lived on the island of Madagascar, off the coast of southern Africa. This flightless, vegetation-eating giant laid the largest egg of any bird known to humans. It survived into the mid-1600s but became extinct as a result of over-hunting. The WFVZ has 7 whole *Aepyornis* eggs. Today only egg fragments remain strewn across the sands of Madagascar's beaches.

Elephant Bird (*Aepyornis maximus*), eggs

Collected in Madagascar. Eggs are approximately 310 × 220 mm.

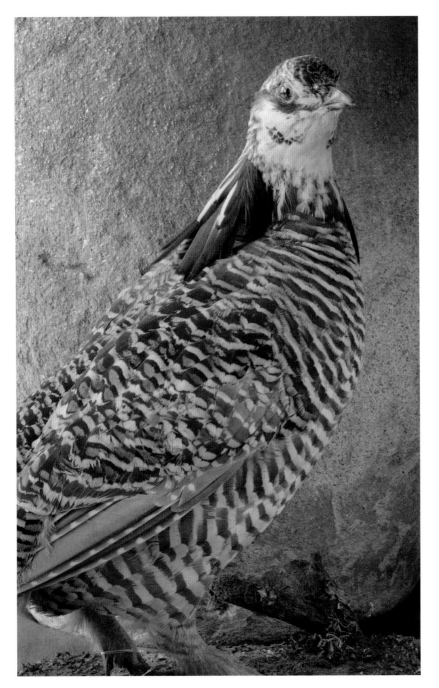

Heath Hen (*Tympanuchus cupido cupido*)

The Heath Hen (a subspecies of the Greater Prairie-chicken) was once common from Massachusetts to Maryland in scrub-oak woodlands mixed with grasslands. The bird declined quickly, primarily because of overhunting. The last Heath Hen died in 1932 (de Juana 1994).

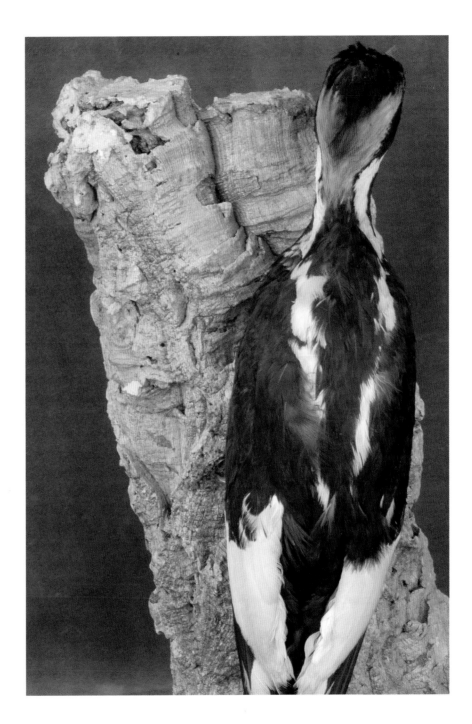

Ivory-billed Woodpecker
(*Campephilus principalis*)
Dorsal view of male woodpecker.
(No collecting data available.)

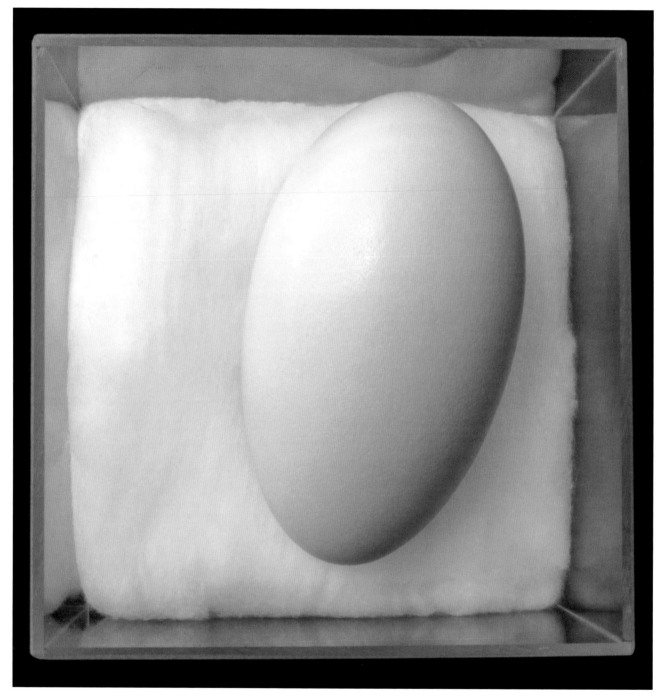

[170]

Ten

UNDER SIEGE

CURRENTLY, 532 BIRD SPECIES (of approximately 9,700 known species) are listed as endangered, and another 674 are listed as vulnerable (Gill 2007: 636). The primary reason for species decline is habitat alteration by humans. By modifying the landscape, adding chemicals to the environment, and introducing exotic species that compete with native species, we compromise the welfare and viability of native birds and other wildlife. The speed with which we alter habitats makes it nearly impossible for many species to adjust or adapt. If we commit to slowing down, using fewer chemicals, and being mindful of the plants and animals we bring into an area, we can begin to make a difference.

California Condor (*Gymnogyps californianus*), egg
Collected from Santa Paula Canyon, Ventura Co., California, on March 16, 1939, by M. C. Badger. The egg is 110 x 67 mm. California Condors experienced dramatic declines from the 1960s through the 1980s, so much so that the last 22 condors were brought into captivity by 1987. A captive breeding and release program was initiated in the early 1990s, and now there are more than 150 birds in the wild. Although egg production currently appears normal, breeding in the wild has not been highly successful because of factors ranging from trash ingestion to lead poisoning. The long-term prognosis for the species is uncertain (Hall and Mee 2007).

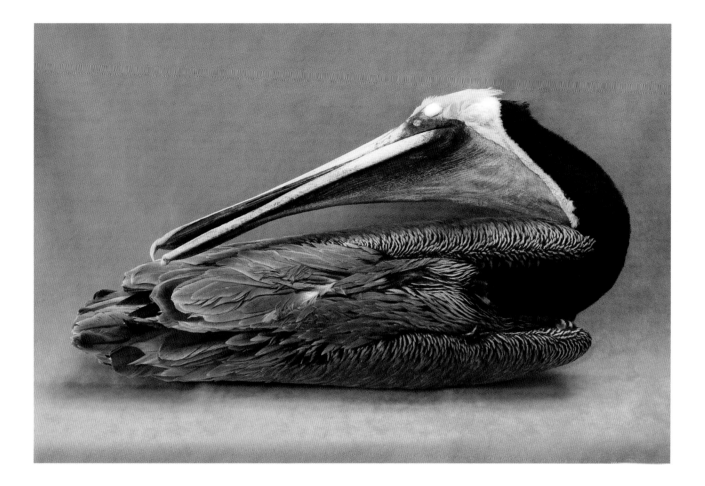

Brown Pelican (*Pelecanus occidentalis*)
Collected at Pt. Magu, Camarillo, Ventura Co., California,
on April 23, 2002. Collector unknown.

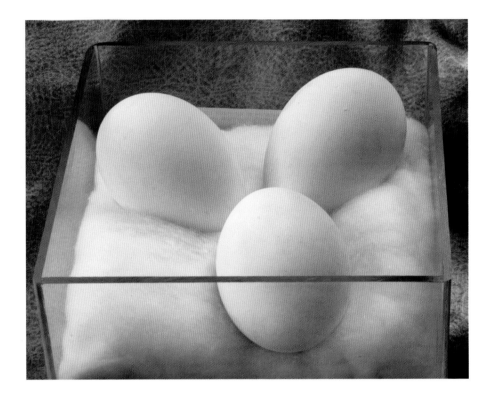

Brown Pelican (*Pelecanus occidentalis*), eggs

Collected from Anacapa Island, Ventura Co., California, on March 1, 1936, by E. N. Harrison. Eggs average 75 × 50 mm. Compare these "normal" Brown Pelican eggs, collected before the use of the insecticide DDT, with the eggs in the next two photographs.

Brown Pelican (*Pelecanus occidentalis*), damaged eggs

Collected from Anacapa Island, Ventura Co., California, on May 13, 1969, by L. F. Kiff. DDT was an effective insecticide used on crops and around homes from the 1940s through the 1960s. We now know that DDT accumulates in the food chain, ultimately resulting in high concentrations of DDT residues in the tissues of top predators. The breakdown product of DDT, called DDE, causes eggshell thinning and weakening in many species of predatory birds; DDE has had devastating effects on the reproduction of such species as Brown Pelicans, Peregrine Falcons (*Falco peregrinus*), and Bald Eagles (*Haliaeetus leucocephalus*). (See detail on facing page.)

Brown Pelican (*Pelecanus occidentalis*), detail of one egg shown on facing page

In 1972, the Environmental Protection Agency banned DDT production in the United States. Since the ban has been in effect, many species, including Brown Pelicans, have made a dramatic comeback, but it has taken more than 30 years. Unfortunately, DDT is still used outside the United States and can still be found in many U.S. waterways.

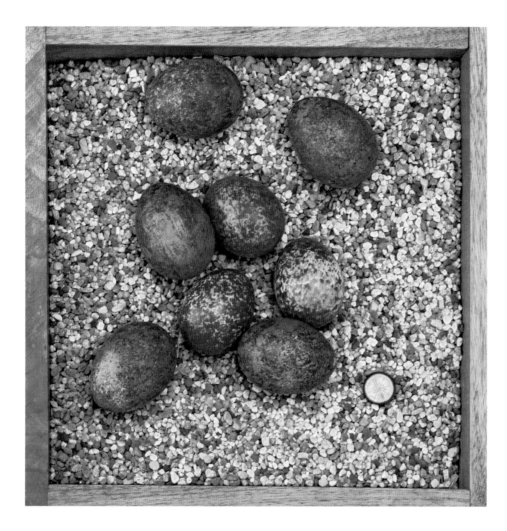

Peregrine Falcon (*Falco peregrinus*), eggs

The 3 brighter eggs in the center are artificial, or "dummy," eggs; the other 5 are real. The real eggs are part of a set that was collected in Souk Co., Wisconsin, on April 21, 1933, by L. R. Wolfe.

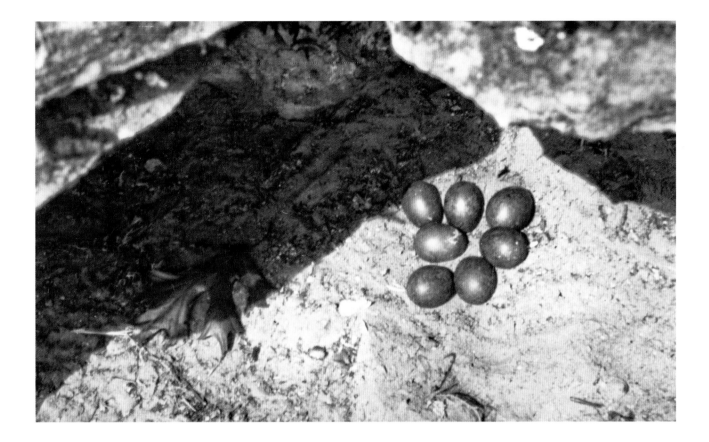

Historical photograph of falcon eggs. (No collecting data available.) From the archives of the WFVZ.

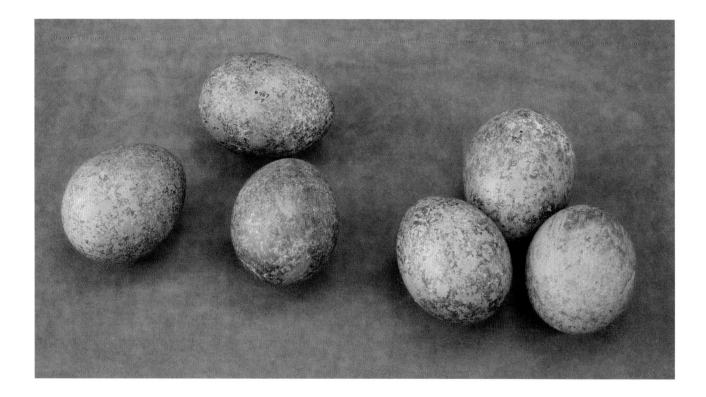

Peregrine Falcon (*Falco peregrinus*), eggs

Collected in the Elan Valley, Wales, on April 25, 1950, by W. Hobson. Eggs average 53 × 41 mm. The breeding of Peregrine Falcons was severely affected by DDT. As with Brown Pelicans, the ban on DDT use in the United States has aided the recovery of these birds in many areas, as have the efforts of concerned individuals. Techniques such as "swapping" real eggs for fake ones in the field, hatching and rearing young Peregrines in captivity, and releasing birds back into the wild (a practice known as "hacking") have also helped this species make a comeback.

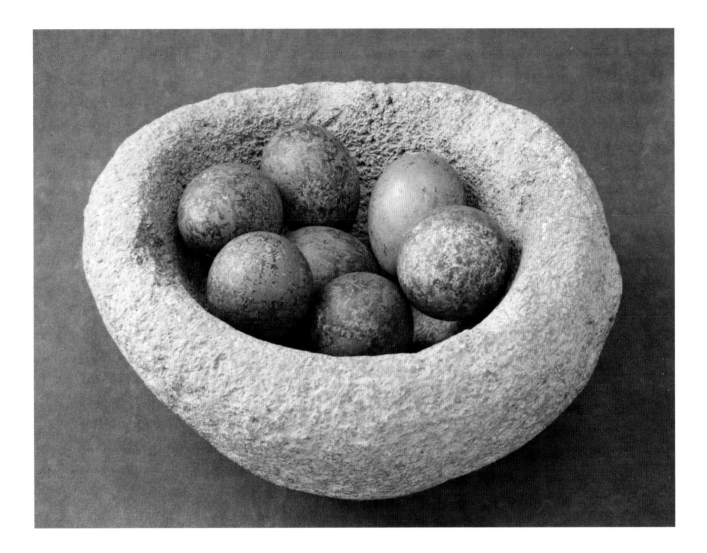

Peregrine Falcon (*Falco peregrinus*), eggs

Collected in Souk Co., Wisconsin, on April 21, 1933, by L. R. Wolfe.

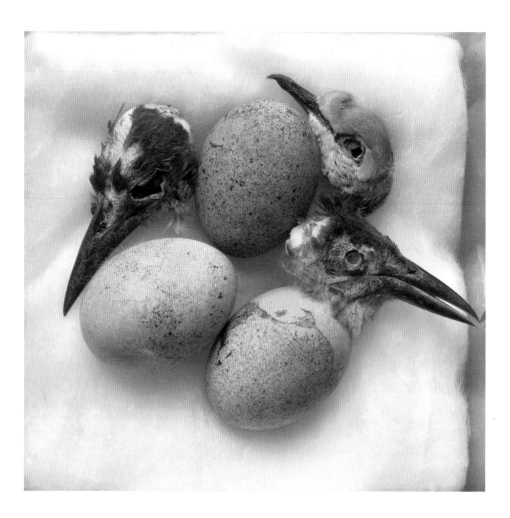

Aplomado Falcon (*Falco femoralis*), bird heads and eggs

Collected from Veracruz, Mexico, on April 11, 1959, by T. C. Meitzen. The heads found with this clutch are likely remains of prey left by the adults.

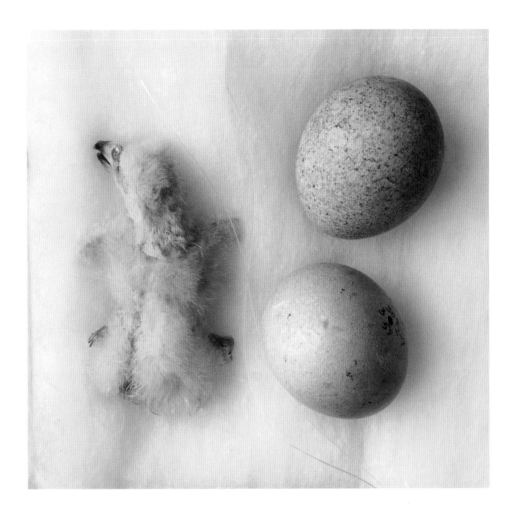

Aplomado Falcon (*Falco femoralis*), chick and eggs

Collected from northern Veracruz, Mexico, on April 14, 1959, by T. C. Meitzen. Eggs average 45 × 33 mm. Aplomado Falcons were once widespread in southwestern North America, but by the mid-1900s their numbers had been significantly reduced because of habitat alteration. In the 1990s, the Peregrine Fund began breeding Aplomado Falcons in captivity and releasing them in southern Texas. By the early 2000s, a wild population of about 40 pairs had been reestablished, with more pairs added in southern Texas and New Mexico (Peregrine Fund 2007).

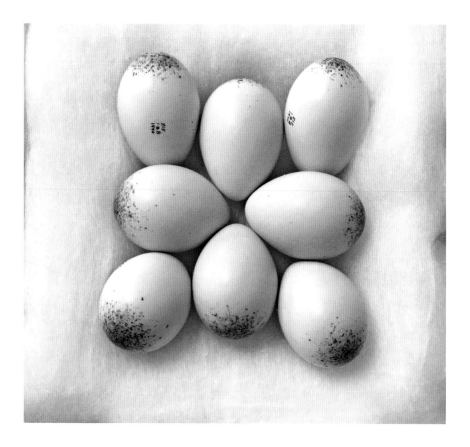

Yellow Rail (*Coturnicops noveboracensis*), eggs on cotton

Collected from Oconto Co., Wisconsin, on May 28, 1940, by C. H. Richter. Eggs average 28 × 21 mm. Yellow Rails breed in marshes and wetlands in northeastern North America. They used to breed in northern California, Florida, and Louisiana, too, but they are no longer found there. The main reason for the birds' decline in the United States is the draining of wetlands, which has also affected the amount of habitat available to breeding populations in Canada (Taylor 1996). Over the past 200 years, approximately 95 percent of wetlands in the western United States have been lost to draining, grazing of livestock, and development, to the detriment of many wildlife species. As a result, many species have been given formal protection under the Endangered Species Act.

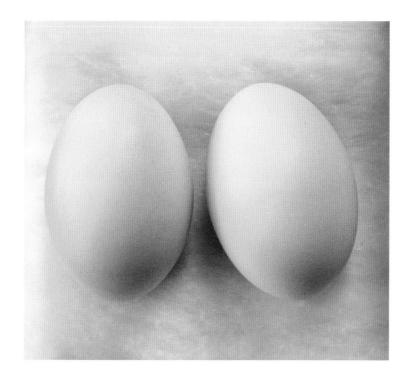

Highland Guan (*Penelopina nigra*), eggs

Collected in Oaxaca, Mexico, on April 12, 1964, by R. Galley. The eggs average 75 × 49 mm. Populations of this species, which occurs from southern Mexico to northern Nicaragua, have been reduced as a result of alteration of the birds' highland forest habitat (del Hoyo 1994).

UNROLLING THE EGG

THE HEAVENS ARE LIKE a hen's egg and as round as a crossbow bullet; the earth is like the yolk of an egg and lies alone in the centre. Heaven is large and earth is small. Inside the lower part of the heavens is the water. The heavens are supported by chihi (vapour), the earth floats on the waters.

—CHANG HÊNG, *first-century astronomer*

THE FIRST EGGS I encountered in a local museum collection were locked in wooden cabinets. They came singly in tissue-lined boxes, each glass lid covered with dust. After some complicated negotiations, I was granted permission to photograph the eggs—provided I did not touch them.

"Well, I suppose," the curator said, "if the lids come off, you may adjust the paper."

In the dust of the first box was inscribed "September 6, 1971"—a date almost fifteen years earlier, but with the dust from *that* day already thick enough to be written in by what looked like the blunt end of a finger. Inside was an albatross egg. The next box held an elongated flamingo egg, almost gray under the glass, with a gray paper label beside it. A pelican egg came next, a gibbous moon partly sunk in cotton. And under the next filthy lid jammed tight, a clutch of four ibis eggs.

The glossy surface of six eggs of the Andean Tinamou
(*Nothoprocta pentlandii*) reflects the ambient scene (see detail page 211).

Ibis eggs under
a dusty glass lid.
From Rosamond
Purcell and
Stephen Jay
Gould, *Illumina-
tions: A Bestiary*
(New York:
Norton, 1986).

Taking courage from the visitor from 1971, I dragged my fingers in a semicircle through the venerable grime on the wavering glass and placed the box into a patch of sunlight. Where the dust was gone the eggs gleamed: through the viewfinder they were—unlike any ibis eggs seen before or since—striped.

TWENTY YEARS AND many museum collections later, we step with awe into the vast and chilly strong-hold of eggs and nests at the Western Foundation of Vertebrate Zoology. In state-of-the-art cabinets the specimens, often accompanied by remarkable amounts of field data, are laid out with utmost care and concern. There are many ways to "read" this collection of or-nithological holdings, which represent nest-building and egg-laying strategies of birds from every possible species and clutch size, egg shape and pattern, as they vary within each clutch and between closely related species of birds. I imagine the oologist must marvel at

the completeness and diversity gathered under one roof. The nidologist, too, would find a wealth of comparative data for the nests, which also come from all over the world. Formed out of mud, guano, spider webs, grass, stones; made of industrial scrap metal or scrapes of gravel; deposited in cacti, trees, caves, tin cans, lanterns; they range from elaborate and colorful weavings to delicate mud and web cups, from huge thatched baskets to bare sand flats.

René Corado and I get to work. At first, René helps with every move. A photographer himself, he watches my struggles with the tripod and digital dials like a hawk. We make our way down the list of essential photographs that he and Linnea Hall will need to prepare their texts. Until they have seen the first photographic results, they remain reserved. Thereafter, René is still watchful but, I like to think, not quite so worried. As the outsider, I am searching for the aesthetic and metaphoric ideas inherent in almost every natural history specimen, anywhere, irrespective of its scientific "significance," and even of any obvious beauty. Fortunately, the act of pointing up those qualities on film does not usually obscure the science. How could it?

Between one haul and the next, we make brief forays into these archives of exoticism. It is difficult to pass by what seem like endless drawers of precious bird skins without opening every one.

The birds themselves, the *sine qua non* in the egg-and-nest game, do not appear in the searchlight that scans and will focus our attention on the perfection of the egg and the structure of the nest. So we make the most of what is here—this immense collection of intentions—and I try not to refer too often to what has been suspended.

As in all well-run natural history collections, there are rules at the Western Foundation. The handling and interpretation of the specimens occur within boundaries prescribed by the experts themselves. No visitor may touch or move an egg or nest without permission; no egg may be introduced into a nest for the sake of a photograph. I talk myself into staying within these rules as inside a bubble.

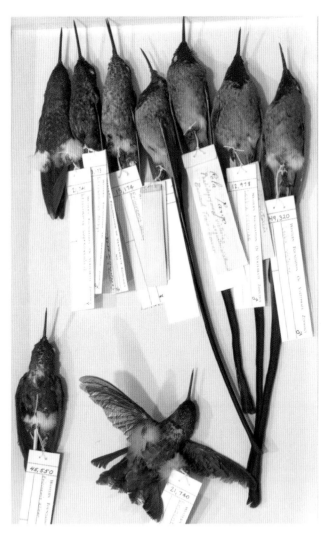

Four species of hummingbirds in a drawer at the Western Foundation. Included is the Black-thighed Puffleg (*Eriocnemis derbyi*), or "White Panty."

Red-shouldered Hawk (*Buteo lineatus*) in protective wrapping.

The nests are kept in special bags and boxes to control the traffic of parasites, the eggs tidily emptied and placed unbroken in compartments. Occasionally René produces a bonanza of eggs found in the original nest and then—only then—do I photograph eggs *in situ*. Safe within the collection, they seem optimistic when in a nest. René brings on clutch as clutch, nest as nest. And nothing leaves the building.

The elements for this made-to-order story come from all corners of the archives, which contain so much. It is a struggle for me—moving beyond tens of thousands of glimpses to establish ways to *see*.

I find natural light filtering into a staff member's office and trespass accordingly. I follow the diurnal passage of light around from window to window, building staircases out of cardboard boxes and fabric to better isolate some of the more Baroque constructions. The best light for me is always natural, the backgrounds neutral. A quasi-Netherlandish illumination informs these still lifes as befits such captive treasures; the light a bit brighter on one end, raking subdued across the whole without descending too far into deepest shade. The background cloth is often bent like a book opening sideways to the lens, darker or lighter at top or bottom. This gives a nest, eggs, and sometimes birds the space in which—photographically speaking—to breathe.

The late-afternoon light through the windows inspires the Dutch still-life approach for the birdhouse covered by a paper wasp nest; the hummingbird eggs with egg of the Elephant Bird; the stuffed skins of Passenger Pigeons; and even such detritus as cactus cavities, excavated by woodpeckers to safeguard their eggs and now calloused over. These artifacts resemble the leather or wooden shoes worn for centuries in the Netherlands.

Not infrequently I am moved by the presence of an extraordinary specimen. The extinct Passenger Pigeon, with its sunset colors and history of massacre, is a relic that evokes great melancholy. In one nineteenth-century contest the prize went to the hunter(s) who shot 30,000 Passenger Pigeons in a single day, a number nearly four times greater than that of the 8,000 soldiers killed in one day in the battle of Gettysburg. The two birds before me—thanks to the light and despite tell-tale identification tags—levitate above the stage. According to one witness who saw a Passenger

Pigeon flying low and nearby, "it passes like a thought, and on trying to see it again, the eye searches in vain; the bird is gone."[1]

Make no mistake—over every egg and nest hover the ghosts of birds, plaiting straw, plastering crevices, punching holes in leaves . . .

One after another, we examine and marvel at the pristine eggs of the Passenger Pigeon, the Ivory-billed Woodpecker, and the Carolina Parakeet. There is something about the empty egg of an extinct bird that is even more moving than the bird itself. A hollow shell is the ultimate symbol of the end of the line.

* * *

RENÉ PULLS OUT the pliable wooden tray holding Ostrich eggs and a few soft gray body feathers (or semi-plumes) from the bird. We are in the main hall, where the light emanates from sodium-vapor lamps and through skylights set at regular intervals along the roof of this industrial hanger. I am uncomfortable, as the illumination on these eggs, while adequate, is not eloquent. Artificial light rarely is. René offers to bring some of the eggs to the warm sunlit side of the building, but as this is the famous clutch that Ed Harrison salvaged while guarding himself against lions, and as René has already transported so much to the other side of the building, we decide to stay.

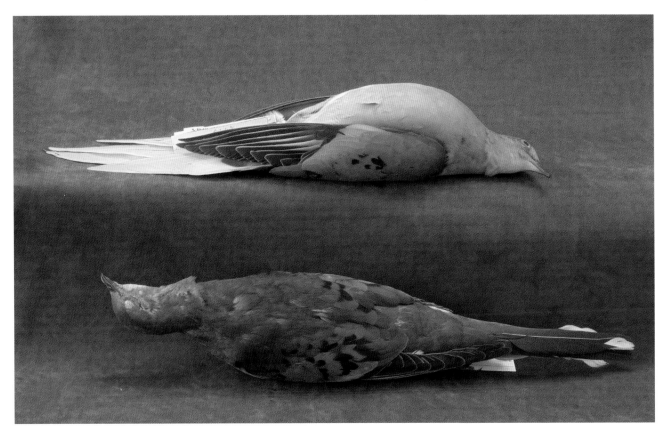

Study skins of Passenger Pigeons (*Ectopistes migratorius*), with feathers and colors intact.

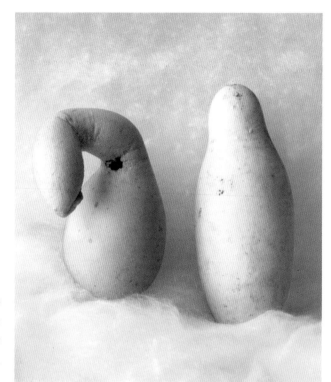

Deformed eggs of the common chicken (*Gallus domesticus*).

The Ostrich and its egg have long cultural and religious histories. According to ancient naturalists, at an auspicious moment, the Ostrich received a warning from a star named Virgil that it was time for its chicks to hatch. The bird then released them from the prodigious task of cracking their own thick shells "with a single ardent look that summon[ed] them to life."[2] In medieval times the birds were thought to coat the shells with honey and their own blood to help soften the way. Later, Coptic monks believed that the sun broke the shell, bringing spiritual redemption along with it. Christian symbolism compares the hatching of the chick to the opening of the door to Christ's tomb, and the bird itself—which never turns but walks straight ahead—to a pilgrim moving ever toward God.

Certain eggs were powerful symbols in ancient cultures, enclosing holy or demonic forces. According to the Sioux legend, the thunder bird, "a creature so vast in size it could swallow whales whole and its voice was the storm and the tempest," laid an egg that also contained within it very bad storms—and thus had to be hidden away.[3] From mythology came "accursed" eggs, like the one produced by the unnatural union of a snake and a rooster, a rooster that "when old gave birth to an egg out of itself."

The photograph (see page 9) shows the eggs as lit by the ambient lamps. Each egg reflects a skylight at the same interval, for these eggs are wonderfully rounded. The ivory gleam of the surfaces is muted by the yellow light, so that even in the final print, glowing undershadows linger around the base of the eggs—and not from ancient traces of yolk. What a distance there is between light cast by sodium vapor lamps and the shadows cast by lions.

Having written that the Ostrich shells *gleam,* I must add that over the entire surface they also display fine brown pits through which the embryonic chick would receive oxygen. It is a testament to fine engineering that that which is pierced is also smooth.

UNDER CERTAIN CIRCUMSTANCES, an egg descends from the bird's oviduct shaped like a small funnel or a softened bottle. René brings out examples of these anomalies in tiny boxes. They lend themselves to a pale lineup secured by cotton—a Morandi-like arrangement of fragile alembics, otherworldly vessels on the windowsill.

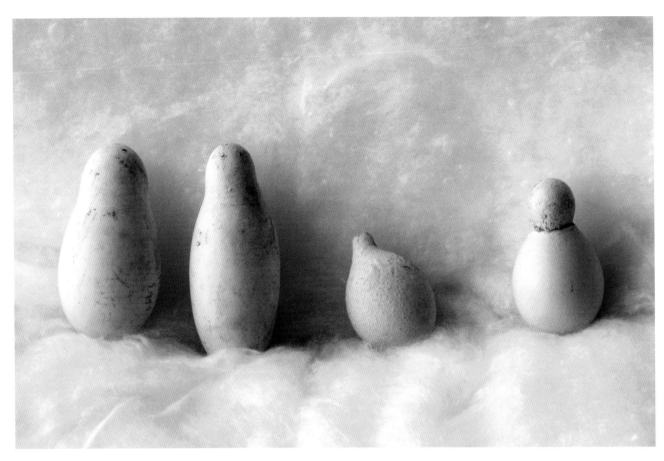

Deformed eggs of the common chicken (*Gallus domesticus*).

Through the viewfinder I survey the lay of the land. I size up the surface. Each egg offers up a singular vocabulary of topographical features. The minutiae on the surface of an antique bird egg—raised roughened hills or shadowy hollows—change it into a landscape. There is no single "best" view of an egg. It is endless. It has no front or back—no boundaries—and any number of possible horizons. Through the lens, it is like a planet rising or, as in the egg of the Guira Cuckoo, the cracked surface of one of Jupiter's moons.

Optically speaking, a nest of cotton is to the egg as a cloud is to the moon. A macro lens will concentrate the image—from what is there into a lunar landscape.

The wonders just keep coming. René helps make a selection from the drawers of Emu eggs—dark purple, blue-gray, green, and black—each an ovoid planet with its singular atmosphere.

The jade-green Emu egg tinselating like a lush world, Shangri La in space, is armored against imperfection.

An egg, when healthy, is perfect. But when poisons from the environment attack the shell, it collapses into a ruin of membrane and yolk. In one particular damaged

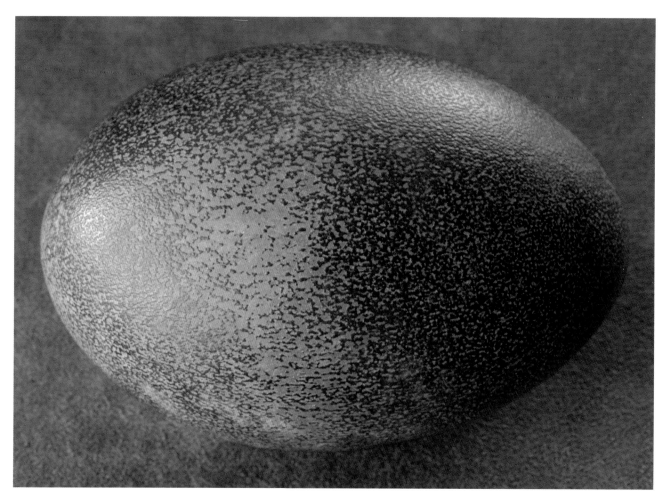

Egg of the Emu
(*Dromaius
novaehollandiae*)
in the light of day.

egg of the Brown Pelican, the ectoskeletons of maggots become part of the forensic history of the egg. Now it is like a dead world, a planet fallen in on itself. Scattered among the shards of rough-textured and corroded shell, the insects look like fossils from the Solnhofen limestone, perfectly preserved.

Sometimes an egg hatches that contains within itself an intact egg. This *ovum ex ova*—egg from an egg—occurs when, in descending the oviduct of the bird and in gathering layers of shell in its descent, the egg, for no known reason, stops or even retreats. A second egg, descending, surrounds the first, forming two concentric shells. The phenomenon is described by Aristotle and so known to collectors for millennia.

There is such a specimen at the WFVZ. Through a rough-chipped window in the outer shell a smaller, intact egg appears. The sugar Easter eggs we received as children had an opera window at one end and scenes

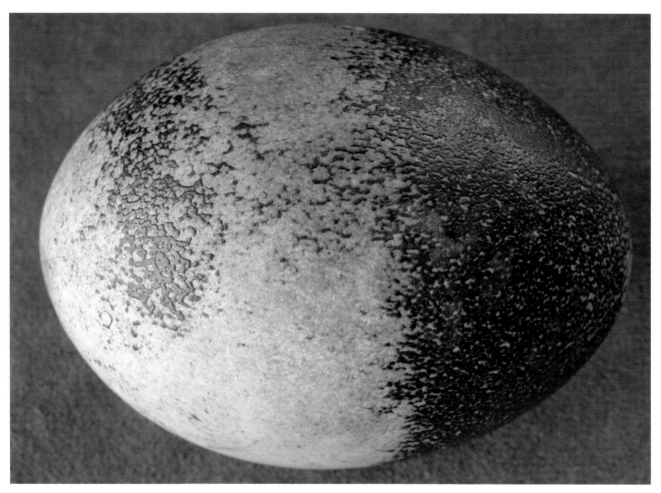

Egg of the Emu (*Dromaius novaehol- landiae*) evoking the Arctic tundra.

inside—paper trees and rabbits. Peering at an egg within an egg affords an austere and solemn sight—a peep-hole view onto classical marble architecture, walls within walls—an inner sanctum surrounded by a courtyard.

AMONG A MYRIAD of natural historical treasures, Sir Hans Sloane (1660–1753) possessed more than 270

eggs, of which the following (in his own words) is an excerpted sample:

Fulmers egg, perfectly white. A Scotch honey buzzard . . . Land tortoises egg. Crocodiles egg. A salamanders egg from the East Indies. The young ones seen in it. Awks egg. An egg [with] a horseshoe naild on it. An ostriches egg? from Mr. Burnett from Buenos

Portrait of the egg of a Brown Pelican (*Pelecanus occidentalis*) destroyed by environmental poisons. The carapaces of maggots are visible in a detailed view of the same egg (page 175).

aires? Much lesser an Condors? a smaller sort of Ostridge, whose feathers are of no value. A Kings fishers egg. The small bird without a name like the stopparola Aldrovandi, Willughby's ornithology, p. 217. eggs w' a nest. A humming bird large mantis and scorpion. Mr Maidstone. A Maccaws egg. The egg of a large Duke [?] owl laid in my garden. A common hens egg shell [which] was said to have 2 yolks from Dr Grews collections. Four eggs from the China pheasant. An ostridges egg from Sir Nicholas Garrards in Essex, smooth. They were eaten by that family as other eggs given me by Lady Garrard. A very odd furrowed guinea hens egg given to me by my daughter Cadogan.[4]

Such blurring of lines between species and indeed between genera—such elision of categories—has a venerable precedent in early natural history collections. For Sloane, an egg was an egg: lizard, crocodile, Kingfisher, mantis, chicken, double-yolked, or as unidentified and nailed to a horseshoe. His was not just a collection of birds' eggs. From some other perspective, it might want sorting.

It is a cliché that human beings are fascinated by size—mountain peaks, high buildings, and whales. We are also amazed by miniatures—a flea on a mouse, a flea on a trapeze, the Last Supper carved on the head of a pin.

René opens the cabinet containing seven of the biggest and thickest bird eggs known to the world—those of *Aepyornis,* the extinct Elephant Bird from Madagascar. In a combination that is, by now, also a cliché, I photograph two of the smallest eggs possible, from the family of Trochillidae, the Broad-tailed Hummingbird, with a cast of the egg of the *Aepyornis.*

Hummingbirds, with their insect-like proboscises and whirring wings, seem mysterious to us, but we do know them—they exist. Hummingbirds and their nests fill drawers at the WFVZ, but there is no known nest for the rare egg of the *Aepyornis,* a species of ratite that vanished several centuries ago. There exists from the year 1670, however, a lurid account (by a man simply named "Ruelle") of an encounter with a fierce "dragon" near a French outpost on the island of Madagascar. According to Ruelle, "While hunting with a soldier one day we saw a winged dragon at the base of a tree . . . that rose up as soon as he saw us with a horrible whistle and eyes redder than fire." Ruelle shot the monster as it prepared to crush the men. The soldier finished it off. It fell at their feet, "thrashing around in a frightening way." Ruelle de-

scribed the beast as fifteen feet tall, with "the head and body like a calf, narrowing from wings to tail." Its wings measured three feet; its "scales" were black and yellow; and its enormous rough feet were covered with calluses. The skin, which the men delivered to their superior, M. le Marquis de Montdevergue, vanished somewhere between Madagascar and France.[5]

A nest is designed to hold unhatched eggs and often unfledged chicks. But unless it is the type of nest used over again by the same bird (as in the case of the Osprey [*Pandion haliaetus*], which adds yearly to its edifice or finds it co-opted by another species), its pur-

Ovum ex ova: egg inside an egg. The chipped-away hole made in the outermost layer of the shell of the exterior egg has left the inner egg intact.

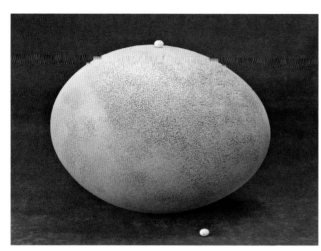

A cast of an Elephant Bird (*Aepyornis*) egg with eggs of the Broad-tailed Hummingbird (*Selasphorus platycercus*).

encrusted with calcium carbonate that drip by drip turned them into stone. Animal, vegetable, and mineral have fused into a single object.

No matter how skillfully made, most nests are messy: hairy tendrils, mud-daubed lumps, randomly affixed feathers, bug-streaked down. In this place, out of the context of forked limb or forest glade and permanently detached, some with raw chopped ends, many of these nests possess ungainly, eccentric shapes—miniature stick compounds, mud mountains, a bonnet, a Yankee Doodle cocked hat. It is clear that each bird has its own style, as no two nests—even by the same species of bird—are truly alike.

There exists, of course, a blueprint for each type of nest, but as birds are energetic improvisers when it comes to substituting one material for another, original solutions abound. When it comes to where to live, birds that select prefabricated shelters make—to us—some amusing choices. Thrushes, wrens, flycatchers, and hummingbirds can be flexible about where a nest should be: making in turn ingenious use of a cooking pot, a sardine can, an old lantern, a ship's rope, or a green glass insulator.

In a barn in seventeenth-century England, swifts were discovered to have built their nest on a dead and petrified owl. The author Gilbert White writes, "This owl with the nest on its wing and with eggs was brought [to a local collector] as a curiosity worthy of the most elegant private museum in Great Britain." White explains that the enthusiastic gentleman then offered up a large conch shell as recompense for having acquired the owl with the nest on its wing. The swifts, White writes, built a new nest inside the shell.[6]

* * *

pose is soon satisfied—and it becomes obsolete.

René checks the master list and sprints off to retrieve in swift succession the designated nests from storage. Woven, mud-daubed, scraped, hollowed, bewreathed, or austere, many come shrouded in heavy plastic to prevent moss, twigs, and reeds from escaping each friable microcosm.

Removed from these protective layers, even carefully handled nests react: twigs break, leaves shrivel, dried mud cracks, long-dead parasites drop from the straw. Here at the WFVZ, every errant pod or withered leaf, no matter how insignificant, stays with its source. The nest of the Rock Pigeon, composed entirely of discarded industrial metal strips, urban detritus, leaves, and colorful rods from fireworks, is wrapped to its museum board so that the general configuration of the strips stays in place. Only the petrified nests with petrified eggs intact do not threaten to shed any bits, though they still come wedged between tissue-paper rolls in snug containers. There are two of these curious calcifications. Found in a cave in Clermont, France, they are

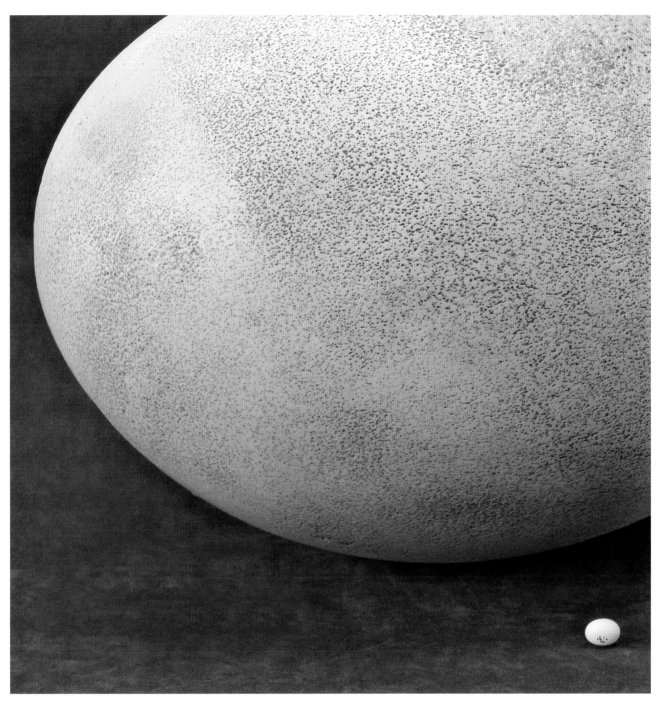

Egg of the
Broad-tailed
Hummingbird
(*Selasphorus
platycercus*) in
the shadow of an
Elephant Bird
(*Aepyornis*) egg.

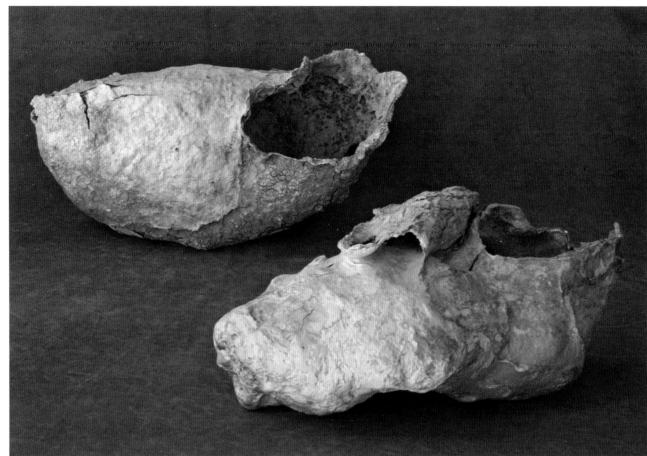

Pieces of hollowed-out cactus used as nests by the Gila Woodpecker (*Melanerpes uropygialis*).

IF HUMAN BEINGS have stolen birds' nests, they have also lured birds in by building shelters for them. Some, like the fabulous dovecotes in England, served as a kind of free-range destination for pigeons. The birds were enticed with "delectable baits" in order, in turn, to be eaten by their keepers. But in Turkey since the Middle Ages, sympathetic citizens have provided songbirds with miniature stone houses, mansions, and even castles that include staircases, balconies, and runways. These respectful architectural offerings, designed to protect and comfort birds destined to live on the wing, enduring cold and loneliness, are incorporated into the outside walls of private houses, churches, and mosques. But those are houses, not nests. For nests, birds are the sole creators.

The architecture critic John Ruskin, in describing a single nest shown to him by the great ornithologist of the day, John Gould, argued that the bird's artistic abilities could not be ascribed to its nervous system alone: "It was a bullfinch's nest, which had been set in the fork

of a sapling tree, where it needed an extended foundation. And the bird has built this first story of her nest with withered stalks of clematis blossom; and with nothing else. These twigs it had interwoven lightly, leaving the branched heads all at the outside, producing an intricate Gothic boss of extreme grace and quaintness, apparently arranged both with triumphant pleasure in the art of basket-making, and with definite purpose of obtaining ornamental form."

Ruskin addresses his reader: "I suppose the only error you are likely to fall into is that of supposing a bullfinch is merely a mechanical arrangement of nervous fibre, covered with feathers by chronic cutaneous eruptions and [is] impelled by a galvanic stimulus to the collection of clematis."[7]

Not every nest resembles a small Gothic church; nor has every bird the resources or the need to construct one. Consider the swift that uses its own bodily

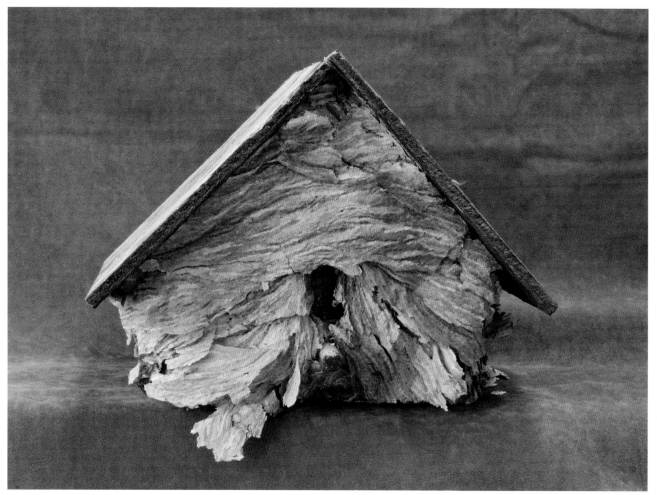

Traditional wooden birdhouse covered by paper wasp nest.

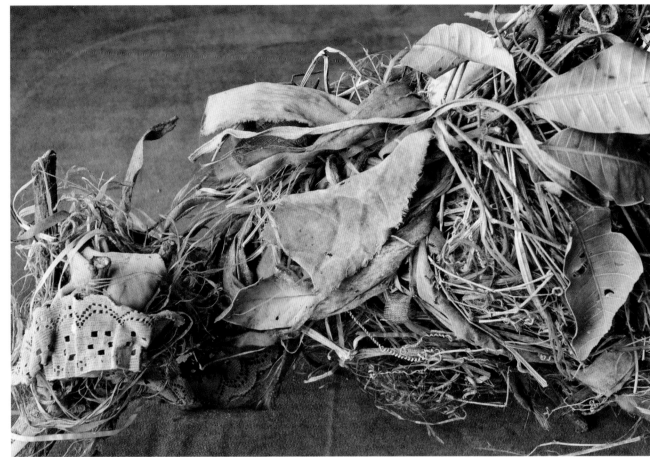

Detail of a nest made by the Great-tailed Grackle (*Quiscalus mexicanus*) showing lace, audiotape, and other fragmented cast-offs from the lives of humans (see page 99).

resource—saliva—as mortar and glue to build its nest. For many years the source of the mysterious material used by swiftlets (building on inaccessible cliffs by the sea) was poorly understood. The "blind seer of Ambon" and detective of natural history, Georg Rumphius, after a thorough examination of these nests, likened the viscosity and periodic hardening of the stuff to the "wrack, slime and jelly . . . cast up by the sea to form its edge."[8]

I wander into the preparation lab of the Western Foundation and, from a dark shelf, retrieve an ordi-

nary wooden birdhouse rendered into an anomaly, the façade covered by striped masticated paper laid on by wasps, which—like the swiftlets—use their vital juices to build. It may be that a full colony once lived inside this house, driving out, perhaps even killing, the resident birds. To point up the appropriating nature of wasps, René brings forth a chicken egg. Through the chipped hole in its side a small paper wasp nest is visible—an opportunistic *nidus in ovum*.

Even though the ability to construct a nest is part of a bird's genetic imperative, human beings take seriously the strategies it employs for building, stacking, shaping, weaving, plaiting, and stitching. Some argue that birds are architects in the human meaning of the word, building up a mud structure daub by daub, weaving lengths of spider silk together with plant fiber, animal or human hair, or pop-riveting holes from leaf to leaf before stitching them together with lengths of yarn. A bird will substitute a piece of wire in place of a stick; wood shavings or cloth strips in place of leaves; and, in the case of flycatchers and titmice, "insulation and cellophane as a probable substitute for snakeskin."[9]

Birds will use second-hand cotton fabric fibers or newspaper for insulation and bedding, and in the case of the Great-tailed Grackle shown at left—a decorative potpourri of cultural and natural elements, including vines with curling tendrils, leaves, audiotapes, shoelaces, cotton strips, and, as a particularly festive flourish, raffia and lace.

The strip of newspaper delicately draped across the woven exterior of the Bell's Vireo nest reads, "capital stock and . . . dolph S. Ochs . . . Chattanoog . . . ecome the publishe." I reconstruct these names. It seems the bird had confiscated a shredded detail from a story involving Adolph S. Ochs, newspaper baron and one-time owner of the *New York Times* and the *Chattanooga Times*. As the details are fragmented and as so many members of Ochs's family were also publishers (including his son-in-law, his grandson, and his granddaughter), the story could be about any one of them. But most of these particular words apply to the career trajectory of Ochs's granddaughter, Ruth Holmberg,

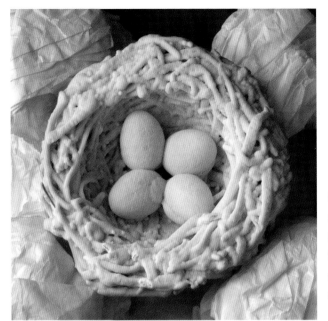

Calcified eggs and nest of an unknown Passerine species found in a limestone cave in Clermont, France.

who became the publisher of the *Chattanooga Times*. I figure that the term "capital stock" applies favorably across at least three generations of the Ochs dynasty. Since the story comes from Tennessee but the nest was found in Texas, I wonder, too, if the newspaper had been transported by the vireo across state lines.

The grackle, the vireo, and the oriole are three examples of birds that will substitute artificial for natural objects and incorporate cultural artifacts into their nests. In a list of what may serve as substitutions for twigs, leaves, and branches in nest building, Baicich and Harrison cite (among much else) "a Chihuahuan Raven [*Corvus cryptoleucus*] nest built completely of barbed wire; a colony of Double-crested Cormorants [*Phalacrocorax auritus*] that used a sunken vessel to supply their nests with pocket knives, men's pipes, hairpins and ladies combs."[10]

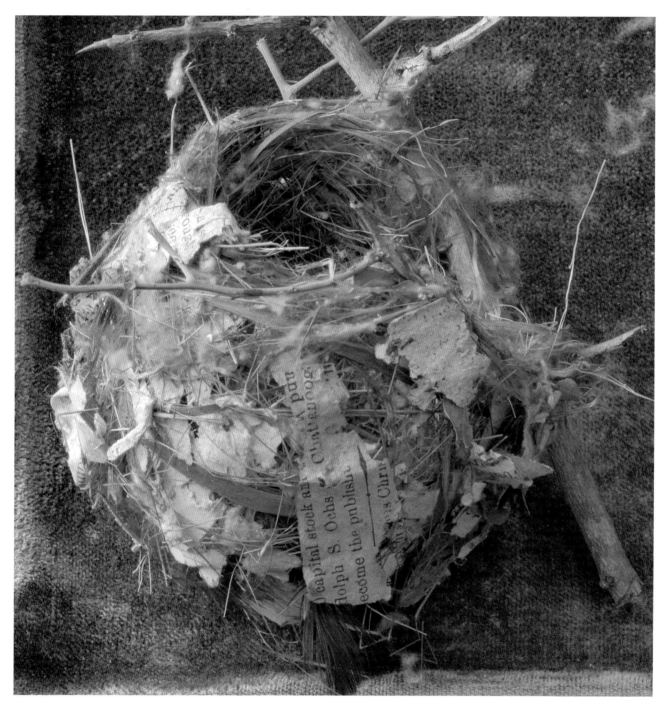

Nest of Bell's Vireo
(*Vireo bellii*) made
with strips of news-
paper from the
recent past.

Over a century ago, on a well-staffed expedition to India, the hunter, taxidermist, and journal writer William Hornaday came across two nests of the Egyptian Vulture (*Neophron percnopterus*), called the Scavenger Vulture in India. He was lowered on a rope over a cliff onto the ledge that held one of them. There he removed and measured two dirty gray eggs, "minutely dotted over with dull brownish red." One of the eggs measured 2.65 inches by 1.90 inches. His list of the contents of the nest reads like a collection of anthropological treasures—a remarkable conglomeration of materials:

"The groundwork was an armful of twigs from the thorny acacia, some of great size considering the smallness of the bird, and upon this was laid a bunch of long, black Hindoo hair (cut from the head of some man going into mourning), a square foot of dried goat-skin, a human humerus, buffalo and goat's hair, cotton in small quantities, a dorsal plate, two metacarpal bones, and eight inches of caudal vertebrae of some of our gavials, the back of a sheep's skull, an assorted lot of rope fragments, and rags of every color and degree of dirtiness. No wonder such a builder of such a nest is called the scavenger vulture."[11]

Detail of Rock Pigeon (*Columba livia*) nest shown on page 58. Note the incorporation of urban debris, including fireworks, plant stalks, rocks, and wood.

Feet and claws of a Vulturine Guineafowl (*Acryllium vulturinum*).

From the second nest, one of Hornaday's helpers removed a pair of eggs and carried them down a steep cliff face in a case that held the hunter's field glasses. In how many different kinds of containers have eggs been transported from their nests to end up in museums cradled in cotton?

ACCORDING TO *Palmer's Handbook of North American Birds,* there are four principal shapes of birds' eggs: "at one extreme is the *elliptical* shape, elongated with equally rounded ends." Other shapes include the sub-elliptical, elongated, round or oval, pyriform, or pear-shaped.[12]

An egg, whether smooth or pitted, glossy or dull, lends itself to being cradled—in the hand, in the hands, sometimes in the crook of an arm. No matter how thick or thin the shell, an egg is self-contained.

I size up a clutch of owl eggs; almost completely round, each edge curves around a private void. I cannot maneuver the eggs close enough to form an uninterrupted field of shell. There is always light and space

between them as one curve accommodates no other.

I concentrate the lens on their proximities. After all, the shells and the space between them constitute the building blocks of this collection. I prefer to focus on the problem of how to organize space by focal length and f-stop than to accommodate the awe-inspiring acres of amassment from which they came.

René brings forth Red-winged Blackbird eggs in great profusion. The scribblings on many of the elongated shells have the uncanny effect of a drawing from an artist's brush or pen. Often from the random strokes gestural forms emerge with varying degrees of articulation: an acrobat on a high wire, a spider, a dancing man—these simulacra are usually positioned near the broad end of the egg.

The blackbird had no such images in mind when the egg, moving down the birth canal, received its background color and the stains imprinted from broken blood cells: dark purple, gray, brown, or black on a pale or dusky matrix. As the albumen itself is applied in translucent coats, even paler colors appear beneath one or more of these layers.

Detail of a nest of the Great Crested Flycatcher (*Myiarchus crinitus*) showing snakeskin.

Detail of markings on egg of a Red-winged Blackbird (*Agelaius phoeniceus*), with fainter markings visible beneath the top layer of shell.

THE PYRIFORM murre eggs are reassembled in an antique egg-collectors' crate, and each is cradled in an elegant felt-lined cup, the broader ends facing up, the narrow tips concealed. Variations in color and markings on these eggs are dramatic, ranging from white to pale blue, dark blue with black splotches, honey-colored fine lines, and smoky smears. These markings suggest visual connections to other worlds, from the lines made by a ceramicist's glaze, to canvases by Jackson Pollock or Franz Kline, and even to what looks like a celestial map over an imagined pole.

The calligraphic effects so pronounced on blackbird eggs may appear over the entire surface of the shell on certain eggs of the Common Murre, dancing and twisting in lines reminiscent of Japanese writing or Chinese brush painting, executed with flourish and grace. In the example shown on pages 208–209, first the egg and then the egg "unrolled," the dark-gray color has deposited vibrant leaping forms. I photograph the circumference of this egg one section at a time. We then assemble the pieces into a "Mercator" projection.

The effect of stitching together these slices creates a large mural of acrobatic monkeys swinging from vines, a young chimp riding a unicycle, gibbons in free-fall. But then, looking again, a "vine" becomes the outline of the back of a bull, emerging now like an ancient creature from the walls of Lascaux. I begin to think about the connections between avian and human art. In 1964 as a self-portrait, Robert Rauschenberg made a pen-and-ink drawing of his fingerprint for a *New Yorker* profile. The whorls of the print are like patterns on an egg. The shape of the impression is itself like a bird's egg—slightly elongated, with one end narrower than the other.

And then, one day, while reading a book about the painter Francis Bacon, I opened a page to the artist's drawings from an exhibition catalogue of the work of Chaim Soutine. These quick sketches of human figures were like the markings made when the egg turns or pauses as blood (for paint) lays down these traces. Bacon's drawing seemed to mirror, if not the content, then certainly the calligraphic style, of this particular egg.

* * *

ON ONE OF the last days of our visit to the WFVZ, concerned that I had not adequately captured salient details of some of the less striking specimens, I had the luxury of revisiting them. Once again, René produced a particularly unprepossessing nest, a hollow scoop of dried and matted guano and palm fruit made by the Oilbird, a stunningly patterned creature that builds its nest in caves inhabited by bats. Undeterred by the unappetizing ingredients, René, veteran adventurer of high tree-tops and remote corners of the egg- and nest-collecting world, demonstrated the appeal of its sweet, spicy flavor by breaking off and consuming a small edge. He made it look really tasty.

As this particular nest is still better seen than photographed, I asked to reconsider some of the more spectacular specimens for a lingering look.

Six glossy eggs of the Andean Tinamou rest in a ring, their contours melting into cotton shadows. They are on a table below the skylights that admit warm light into the lobby of the WFVZ. Reflections bend or stretch

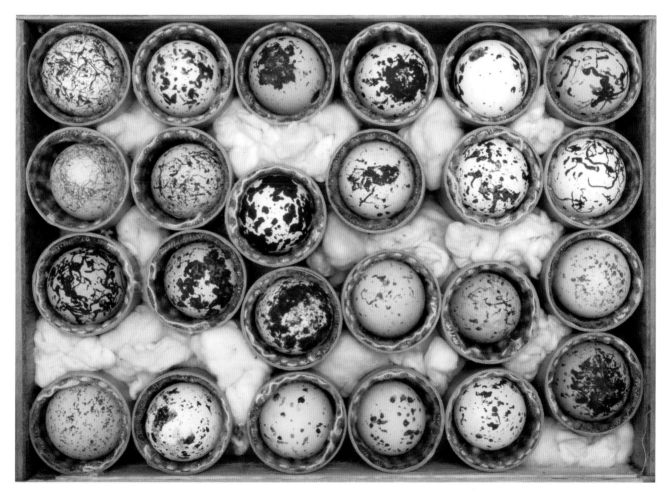

Murre eggs in a collecting case. Before eggs can be brought back from the field, they must be swaddled in protective wrapping. The broad end of each variously tinted egg shows unique markings. This group was assembled at random and arranged for the photograph to demonstrate the diversity of design.

Egg of the
Common Murre
(*Uria aalge*)
unrolled in a
Mercator
projection.

according to the angle of curvature on the egg that catches them. On some shells the four-paned window looks like a diamond, on others the four-spot on a die. Close up, the window becomes four dice aligned. The reflected grid of the larger window is more radically stretched. The color of the eggs is disrupted and changed by the mirrored gleam of blue sky, a line of green trees, spectral sunlight, and its glow off the wooden walls. I imagine that in the forest, where the tinamou (elusive, and of a very ancient lineage) lays its eggs, the shadows and shapes of leaves, vines, and trees would reflect in and deflect off the surfaces of the polished curves, disguising the perimeters, melting the edges into whatever the landscape, rendering the

Francis Bacon, untitled painted sketch, late 1960s, black paint on endpapers of catalogue from 1950 MoMA exhibit Chaim Soutine, 25.8 x 19 closed. © 2008 The Estate of Francis Bacon/ARS, New York/DACS, London.

whole less visible and, as contours morph and are re-aligned, less vulnerable to predators.

Reflected in the brown-red shells, as in a silver ewer or wineglass of a Dutch still-life, are intimations of human beings. In one I think I see René, and I am certainly in there, too, with the tripod. In another egg, I find the illusion of a solitary figure sitting at a table, perhaps drawing or playing chess. Of course, most any apparition will be interrupted by a perfectly round blow-hole, a notation in pencil or black-inked collection code on every shell.

Isn't it amazing how we always have to put our mark on things? And how, from the natural world, we find evidence over and over again that reminds us, not so much of the birds, but of our own stories and our own kinds of art?

ROSAMOND PURCELL

Detail of tinamou eggs.

Detail of egg of
the Andean
Tinamou (*Notho-
procta pentlandii*).

NOTES

1. J. J. Audubon, as quoted by E. Fuller in *Extinct Birds,* rev. ed. (Ithaca: Comstock, 2001), p. 34.

2. Louis Charbonneau-Lassay, *The Bestiary of Christ,* translated and abridged by D. M. Dooling (New York: Parabola Books, 1991), pp. 275–286. The "ardent look" quote can be found on page 276.

3. From Michael Walters, *A Concise History of Ornithology* (New Haven: Yale University Press, 2003), p. 11.

4. Quoted in *Sir Hans Sloane: Collector, Scientist, Antiquary, Founding Father of the British Museum,* ed. Arthur MacGregor (London: British Museum Press, 1994), p. 85.

5. Anecdote kindly provided by L. R. Godfrey, from her forthcoming book with K. Fitzgerald, *Ghost Bones of Madagascar* (Oxford University Press). The description resembles that of the Ostrich, a phylogenetic relation of the *Aepyornis,* except that the Elephant Bird stood at least ten feet high and weighed at least three times more than the 300-pound Ostrich.

6. Gilbert White, *The Natural History of Selborne* (orig. ed. London, 1879), p. 137.

7. John Ruskin, "The Eagle's Nest," in *The Oxford Book of Nature* (1887), pp. 82–83.

8. "The Poison Tree," in *Selected Writings of Rumphius on the Natural History of the Indies,* ed. and trans. E. M. Beekman (Amherst, MA: University of Massachusetts Press, 1981), p. 236.

9. Paul J. Baicich and Colin J. O. Harrison, *Nests, Eggs, and Nestlings of North American Birds* (Princeton: Princeton University Press, 2005), p. 18.

10. Ibid.

11. William T. Hornaday, *Two Years in the Jungle: The Experiences of a Hunter and Naturalist* (New York: Charles Scribner's Sons, 1929), p. 61. Hornaday's account of the nests of the Scavenger Vulture was first published in 1885.

12. As quoted in Baicich and Harrison, *Nests, Eggs, and Nestlings,* p. 20.

The Great Egret (*Ardea alba*).

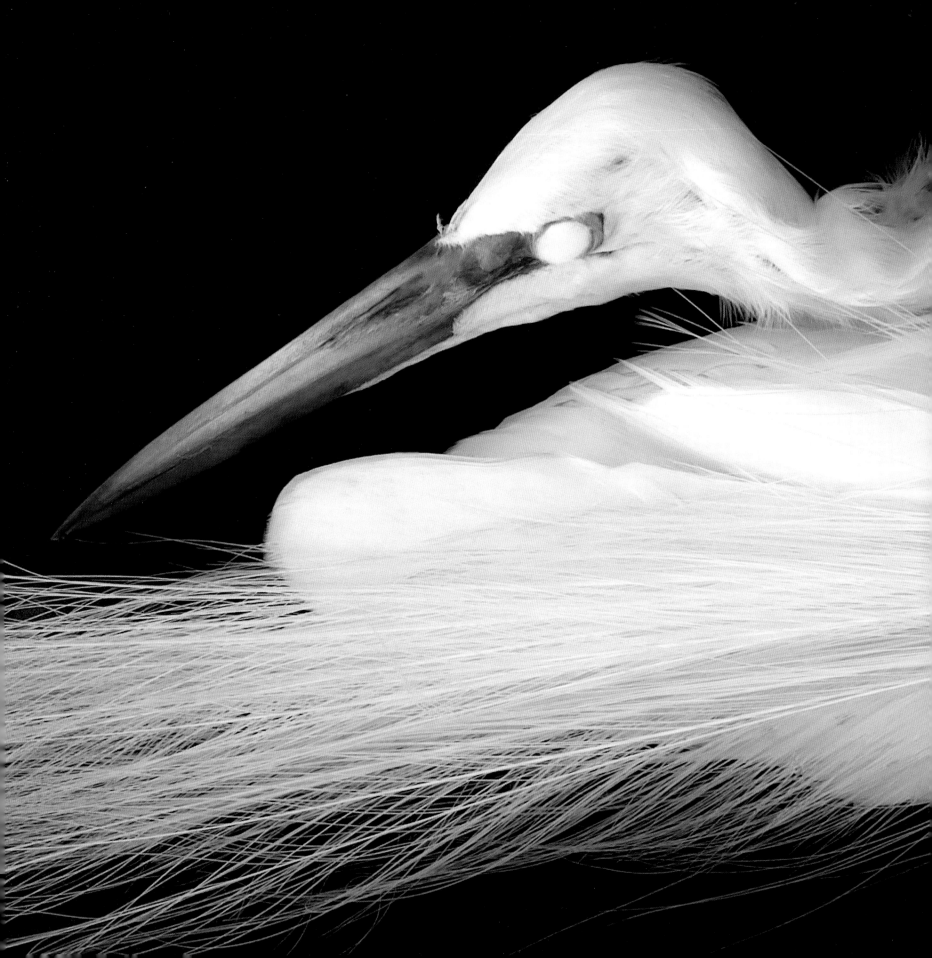

REFERENCES

Baicich, P., and C. J. O. Harrison. 1997. *A Guide to the Nests, Eggs, and Nestlings of North America*. San Diego, Calif.: Academic Press.

Burley, R. W., and D. V. Vadehra. 1989. *The Avian Egg: Chemistry and Biology*. New York: John Wiley and Sons.

Collias, N. E., and E. C. Collias. 1984. *Nest Building and Bird Behavior*. Princeton, N.J.: Princeton University Press.

Chantler, P. 1996. "Family Apodidae (Swifts)," in J. del Hoyo et al., eds., *Handbook of the Birds of the World*, vol. 5, *Barn-Owls to Hummingbirds*, p. 434. Barcelona: Lynx Edicions.

del Hoyo, J. 1994. "Family Cracidae (Chachalacas, Guans and Curassows)," in J. del Hoyo et al., eds., *Handbook of the Birds of the World*, vol. 2, *New World Vultures to Guineafowl*, p. 355. Barcelona: Lynx Edicions.

de Juana, E. 1994. "Family Tetraonidae (Grouse)," in J. del Hoyo et al., eds., *Handbook of the Birds of the World*, vol. 2, *New World Vultures to Guineafowl*, pp. 409–410. Barcelona: Lynx Edicions.

Ehrlich, P., et al. 1988. *The Birder's Handbook: A Field Guide to the Natural History of North American Birds*. New York: Simon and Schuster.

Gill, F. B. 2007. *Ornithology*, 3rd ed. New York: W. H. Freeman.

Gosler, A. G., et al. 2005. "Why Are Birds' Eggs Speckled?" *Ecological Letters* 8: 1105–1113.

Hall, L. S., and A. Mee. 2007. "Introduction," in A. Mee and L. S. Hall, eds., *California Condors in the Twenty-first Century*. Series in Ornithology no. 2.

Hall, L. S., and M. L. Morrison. 2003. "Nesting Phenology and Productivity of Birds in the White and Inyo Mountains, California, as Assessed with Nest-Boxes," *Western North American Naturalist* 63(1): 63–71.

Hansell, M. 2000. *Bird Nests and Construction Behaviour*. Cambridge: Cambridge University Press.

Henderson, C. L. 2007. *Oology and Ralph's Talking Eggs*. Austin: University of Texas Press.

Jagannath, A., et al. 2008. "Eggshell Pigmentation Indicates Pesticide Contamination," *Journal of Applied Ecology* 45(1): 133–140.

Johnsgard, P. A. 2000. *Trogons and Quetzals of the World.* Washington, D.C.: Smithsonian Institution Press.

Kiff, L. F. 1989. "Oology: From Hobby to Science," *Living Bird Quarterly* (Winter), pp. 8–15.

—— 1991. "The Egg Came First," *Terra* 30(2): 5–19.

—— 1996. "Egg Color in the Genus *Sclerurus* (Furnariidae)," *Ornitologia Neotropical* 7: 153–154.

Moreno, J., et al. 2006. "Experimental Evidence That Egg Color Indicates Female Condition at Laying in a Songbird," *Behavioral Ecology* 17(4): 651–655.

Peregrine Fund. May 10, 2007. "Aplomado Falcon Restoration–Conservation Projects," http://www.peregrinefund.org/conserve_category.asp?category=Aplomado%20Falcon%20Restoration.

Rands, M. R. W. 1996. "Family Dromadidae (Crab Plover)," in J. del Hoyo et al., eds., *Handbook of the Birds of the World*, vol. 3, *Hoatzin to Auks*, pp. 304–305. Barcelona: Lynx Edicions.

Snyder, N. F. R. 2004. *The Carolina Parakeet: Glimpses of a Vanished Bird.* Princeton, N.J.: Princeton University Press.

—— 2007. *An Alternative Hypothesis for the Cause of the Ivory-Billed Woodpecker's Decline.* Monographs of the Western Foundation of Vertebrate Zoology no. 2.

Taylor, P. B. 1996. "Family Rallidae (Rails, Gallinules and Coots)," in J. del Hoyo et al., eds., *Handbook of the Birds of the World*, vol. 3, *Hoatzin to Auks*, pp. 108–209. Barcelona: Lynx Edicions.

Thomas, B. T. 1999. "Family Steatornithidae (Oilbird)," in J. del Hoyo et al., eds., *Handbook of the Birds of the World*, vol. 5, *Barn-Owls to Hummingbirds*, pp. 248–251. Barcelona: Lynx Edicions.

Winkler, H., and D. A. Christie. 2002. "Family Picidae (Woodpeckers)," in J. del Hoyo et al., eds., *Handbook of the Birds of the World*, vol. 7, *Jacamars to Woodpeckers*, pp. 296–555. Barcelona: Lynx Edicions.

well-marked set

—dpiper
—e June 20-1907
—o. So. Manitoba,
—on about 1/3 — Can—
— & s—
— N — —
— b —

Totanus glareola. L.
Fennia.
Vuolijoki
15—

No. XX Name Redshank
Collector Bob Gowland
Locality Ainsdale Lancs
Dates 23. 5 -1926
Set 4 Identity Sure Incubation fresh
Nest in grass tuft in
small rise in swamp
OSU 8—21

to coll CRWood in Lot 260 on 8 5 1928

/29/ Peregrine Falcon c/4
coast of Kerry. Ireland
May 8th 1903. nest in
sea cliff 60 feet from to—

—56D
A.O.U. No.)
Mark /59

—ing. H. S. mBou—

SPECIES Peales Falcon
—ng peali—
—" .2 downy —
R. C. Fell—
—top a 200—
—o nest ma—
—h on ledge

of
J. C. B—

NEST COLLECTED
WESTERN FOUNDATION OF VERTEBRATE ZOOLOGY
OOLOGICAL COLLECTION

—ET MARK RC113
—O. OF EGGS 2

—PECIES: White-Winged Dove
Zenaida asiatica

—OCALITY: Guatemala: Depto El Progreso; Morazan, Aldea El chical

—ATE: 29 May 2005 IDENTITY: Adult flushed from nest

—UBATION: Egg #1 - 8.4g; 2 - 8.4g; egg #1 fresh, #2 showing blood.
Nest about 2.5 m up in "Lengua de Vaca" cactus by side
of road leading to Rio Motagua from aldea in
thorn scrub vegetation; Rene carried both eggs in
his mouth in his way down.

—LECTOR: René Corado & Linnea S. Hall

—Tamia —

—., off Baja Calif. ALTITUDE:

—positive

—SMALL EMBRYOS: LARGE EMBRYOS: INFERTILE:

(Common —found —
Locality Hancock County, Iow—
Date May 16 - 1899 Nest

ACKNOWLEDGMENTS

We wish to thank Ann Downer-Hazell for initially approaching the Western Foundation of Vertebrate Zoology with the idea of doing a book on its avian materials, and for her dedication in bringing the project to fruition. We would also like to to thank designers Tim Jones and Eric Mulder and editor Christine Thorsteinsson for making *Egg & Nest* so lovely.

—LINNEA S. HALL and RENÉ CORADO

Ann Downer-Hazell, science editor at Harvard University Press, suggested this project to me after she visited the Western Foundation of Vertebrate Zoology. Her enthusiasm for the place was infectious and her support for my work unwavering. I accepted the assignment with alacrity, sharing the results of a first trip to the archives in Camarillo with my designer friend Marianne Perlak. As a longtime fan of Marianne's work, I am grateful for her positive reactions.

Over the past months I have been introduced to one expert after another at Harvard University Press. It is my great luck that each has spent much time and attention on *Egg & Nest*. Reader, remember when you admire the typeface and the elegant sizing and placement of the plates that designers Tim Jones and Eric Mulder are the ones to thank. Christine Thorsteinsson patiently went over every syllable of text and then reworked my corrections of it. For those who have not yet had the privilege of working with an exacting and patient editor, it may constitute one of life's pleasures. Thank you to editorial assistant Vanessa Hayes, and to the sales and publicity departments of HUP—the link between *Egg & Nest* and the rest of the world.

In Camarillo, René Corado cheerfully brought forth so many spectacular specimens that choosing among them became a happy chore. Linnea Hall demonstrated imagination and goodwill. Both Dennis Purcell and I feel that working at the WFVZ was a great privilege.

This project constituted my first official foray onto the playing fields of digital photography. Dennis's expertise and kind counsel in digital affairs is imprinted on every one of these images. He has worked for unheralded hours to uphold their original integrity.

—ROSAMOND PURCELL

Data cards from the collections of the Western Foundation.

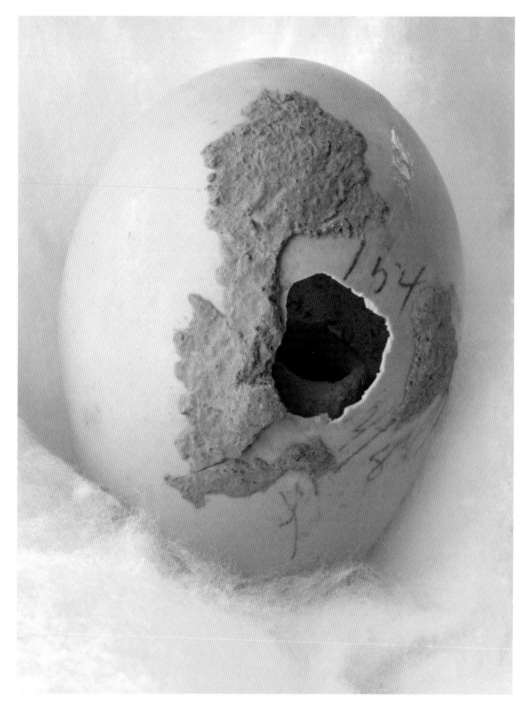

Nest in an egg.

SPECIES INDEX

Eggs of the Emu (*Dromaius novachollandiae*)